AN ARTIST IN ABYDOS

THE LIFE AND LETTERS OF MYRTLE BROOME

LEE YOUNG

The American University in Cairo Press
Cairo New York

First published in 2021 by
The American University in Cairo Press
113 Sharia Kasr el Aini, Cairo, Egypt
One Rockefeller Plaza, 10th Floor, New York, NY 10020
www.aucpress.com

Dar el Kutub No. 26217/19
ISBN 978 977 416 992 2

Dar el Kutub Cataloging-in-Publication Data

Young, Lee
 An Artist in Abydos: The Life and Letters of Myrtle Broome / Lee Young.—Cairo: The Amer-
ican University in Cairo Press, 2021.
 p. cm.
 ISBN 978 977 416 992 2
 1. Broome, Myrtle, 1888–1978
 2. Archaeologists
 930.1092

1 2 3 4 5 25 24 23 22 21

Designed by Adam el-Sehemy
Printed in the United States of America

AN ARTIST
IN ABYDOS

CONTENTS

ILLUSTRATIONS

Bushey Museum (BM)
Griffith Institute (GI)
Palestine Exploration Fund (PEF)
Sybil Rampen, Joshua Creek (JC)
Oriental Institute, University of Chicago (OI)
Egypt Exploration Society (EES)

FOREWORD

In this remarkable account, Lee Young tells the story of Myrtle Florence Broome (1887–1978) largely through her letters and artwork, which have fortunately been preserved and record in detail the life of a pioneering Egyptological artist. Broome came from an artistic family and studied at University College London (UCL) under the legendary Sir William Matthew Flinders Petrie and Margaret Murray between 1911 and 1913. In 1927, she was invited to join the excavations at Qaw al-Kebir as an artist under the direction of Petrie and Guy Brunton for the British School of Archaeology in Egypt.

In 1929, Broome went to work at the Seti Temple at Abydos with Amice Calverley (1896–1959) for the Egypt Exploration Society. Miss Calverley had studied art and design and music but had met Sir Leonard Wooley at Oxford and he engaged her to work on some illustrations from the Ashmolean Museum. While there, she also worked with A.M. Blackman on photographs of the Seti Temple at Abydos. Blackman and Sir Alan Gardiner, who was also working on the publication of the temple, both felt that the photographs alone did not do justice to the delicate relief work of the temple and so they dispatched Calverley to collate the photographs and make facsimiles of the decoration and inscriptions in January of 1928. During her season she was visited by John D. Rockefeller, Jr., who was so impressed with her beautiful copies that he agreed to fund a lavish publication of the work through the Oriental Institute of the University of Chicago. It also enabled her to employ additional help and in 1929 Broome joined the expedition. Broome spent eight seasons copying some of the finest painted scenes in the temple for the publication with photographic accuracy.

Broome's last season at Abydos was in 1937, having to return to England to care for her aging parents. The Second World War interrupted work at Abydos, but Calverley was able to return in 1947 for one more season. She worked on the publication of the temple right up until her death in 1959. In his memoir, Sir Alan Gardiner noted, "It is impossible to exaggerate the ability of these two ladies." Broome and Calverley ranked among the greatest of the copyists working in Egypt in the twentieth century who left us an invaluable record of some of ancient Egypt's most beautiful monuments.

Peter Lacovara, November 2019

INTRODUCTION

U pon first reading the letters of Myrtle Broome at the Griffith Institute Archive in Oxford where they are housed, I could not believe the amount of detail contained within them. These letters give us such a valuable insight into the life of two women working and living in the desert of Egypt in the early twentieth century. Not only were the letters detailed, there were so many of them, 415 in total, spanning the years 1927 to 1937.

As I read, researched, and transcribed them, I began to know Myrtle and empathize with the challenges she faced in her life abroad. The letters were written with great humor and vitality, and they contain a genuine and endearing love for the local people. When she described a scene, it was with the eye of an artist, which of course she was.

When collating these letters for this book, my first problem was simply how to fit them all in. Myrtle's correspondence spanned eight seasons in Abydos and one season in Qaw al-Kebir and her letters were sent with an impressive regularity.

Myrtle's first season at Qaw al-Kebir in 1927 is tremendously important. The letters show Myrtle's reaction to and her impressions of living in Egypt for the first time and warrant inclusion for that reason alone. The richness of her account is both informative and entertaining and sets the tone for future seasons.

Myrtle then spent eight seasons at the ancient site of Abydos, near the modern town of al-Araba al-Madfuna, approximately 11 kilometers from the Nile in Upper Egypt. In the first season alone she wrote sixty-five letters and I wanted to include every one of them.

Myrtle recorded every facet of her life, writing about her living arrangements; the local people and their ways; the work of the local artisans and

craftsmen, recording such things as weaving and pot making. She wrote about the important work they conducted in the temple, and their visitors—friends, colleagues, even royalty—who were each entertained according to their status. There were also the less welcome visitors, resonating for the modern reader—the tourists.

When you read her letters you really are there with her, you experience the life she led, you see the local people as she did, with understanding and respect for their ways. Shades of colonial paternalism show through, of course, but her thoughts and words were of her time.

She also gave us insights into the important work she was doing, describing how the work was approached and carried out, the working conditions and her own thoughts on their endeavors. She greatly underplayed her own role, being very modest about her contributions to the epic task undertaken.

So, from this wealth of material, I had to make a decision: to either cut, edit, and curate the letters, trying to capture the essence of all 415 letters and nine seasons' experiences in one book, or to concentrate on the first season alone.

I decided to focus on the first season, rather than leaving out so many letters that I consider to be so central to Myrtle's story. The first season in Abydos is so comprehensive that the following seasons could be seen as simply reinforcing the initial content, so take my word for it, you will not feel shortchanged.

Myrtle is a fluent letter writer. I very much hope that as you read the letters you will imagine yourself there with her, as I did. I also must add that we have included many of her typos and incorrect spellings, such as when she spells "Tutankhamun" as "Tutankhamen." This better reflects how the actual letters appear and read. Myrtle was so eager to get everything down rapidly that sometimes she wrote a name in different forms, as in "Ahmed" versus "Ahmud"; where this appears, we have chosen the most common usage throughout. Some minor punctuation has also been introduced in the editing process, such as periods and commas, to improve readability; all other errors have been intentionally left.

Cultural warning: Users of this material are warned that some letters document observations of people and cultures using scientific research models and language from the earlier twentieth century that may be considered offensive today.

1

THE EARLY YEARS

O n February 22, 1888, in the district of Holborn in London, Washington and Ellen Broome became the proud parents of their first and only child, a baby girl they named Myrtle Florence, a much-loved and cherished daughter. The first few years of Myrtle's life were spent in Holborn with the family moving to Bushey, near Watford in Hertford-shire, in 1905. It would be easy to say she grew up in a typical middle-class home in suburbia, but that would not be strictly true.

Little is known about Myrtle's mother, Ellen Dench Broome, but we can assume that, in keeping with the time, she stayed at home and cared for the house and her daughter. From Myrtle's letters, one gets the idea that she was perhaps not the strongest of ladies. She was frequently ill and always required help around the house. This dependency might have influenced Myrtle, whose strong character and ability to put herself forward for responsibility is apparent. This was borne out when Myrtle eventually gave up her career to care for her father when he became ill, her mother not being able to cope. Her mother would eventually succumb to dementia. There was no doubt that Ellen was very close to her daughter and Myrtle cared for her deeply.

Her father, Washington Herbert Broome, was described as a music and book publisher. He worked for a period at William Morris's Kelmscott Press, which operated from 1891 to 1898.

Kelmscott Press produced books heavily influenced by the illus-trated manuscripts and early printed books of medieval and early-modern Europe. William Morris was a man of many talents, being an English tex-tile designer, poet, novelist, translator, and social activist. He was also one of the prime movers in the Arts and Craft movement, the international

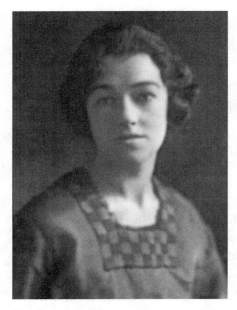

The younger Myrtle

movement in decorative and fine arts from about 1880 to 1920. It was based on traditional craftsmanship that used simple forms often using medieval, romantic, or folk styles of decoration. His press produced books that he considered to be beautiful, often using friends like Edward Burne-Jones to illustrate them. The press not only published works by Morris but also by Keats, Shelley, and Ruskin amongst others.

In 1902, Broome set up his own enterprise with James Guthrie called The Old Bourne Press using the same principles as Morris, with Broome and Guthrie also heavily influenced by the Arts and Craft movement.

Guthrie would go on to found the Pear Tree Press in 1905, although the Old Bourne Press was still publishing in 1915 and the two men continued to work in conjunction with each other.

Broome was himself a master craftsman whose great love was working in wood and metal, something he shared with his keen daughter. Myrtle loved nothing better than spending time with her father learning these crafting skills, going on eventually to add many more to her portfolio.

These skills were put to good use when the family moved to Bushey, where father and daughter (now seventeen years old) worked on the interior of their new home called Avalon, renting a house on their arrival while Avalon was being built. Unsurprisingly, the house was in the late Arts and

Craft style so popular at the time. An architect was employed to work under Broome's direction and Historic England now describes the house as being "a building created for a designer and craftsman of the Arts and Craft movement, containing a rich variety of decorative elements of the period designed by Broome and his daughter." They make special mention of the fact that "Myrtle created painted panels and decorations throughout the house."

The house is full of the most exquisite decorative carving and metalwork done by the pair; it was said that two whole Hertfordshire oaks were used in the ornate woodwork, much of which still survives today. Craftsmen were even brought in from as far afield as Italy to do the work that could not be done by father and daughter, for instance the tiling around the fireplace, and the house is a monument to this immensely talented duo.

While researching Myrtle, I had the great pleasure of spending a night there a few years ago and sleeping in Myrtle's own room, where her initials are carved into the bedpost together with the date of 1911 and friezes are painted on the walls in classical subjects. Myrtle would add her own distinct touch to the carvings in Avalon; for instance, the mantle shelf she created, signed, and dated 1907 is still in evidence today.

The current owners have done a terrific job of restoring the house, using the original plans to do so, and many views are recognizable from the early paintings done by Myrtle.

Father and daughter would eventually use their skills to set up a business from Avalon called Designers and Workers in Metal and Enamel. The talented Myrtle would also design textiles for the Liberty department store in London. The store was renowned for its textile design and still trades today. Of course, Myrtle also designed the textiles that would be used in the house.

Over all others, there was one skill in particular that would shape Myrtle's future life: her talent as an artist. She studied at the art school set up in Bushey by Bertha Herkomer, a cousin of Sir Hubert Herkomer and a former pupil of his from 1886. Sir Hubert Herkomer (1849–1914) was a well-known British artist with German origins. His paintings can be found in the National Collection of the Tate, and in many other collections throughout the UK. He set up an earlier art school in Bushey and his teaching methods were quite unique for the time. He believed in free expression, giving his pupils the freedom to develop their own styles. He believed competition and exams were bad for them and did not encourage a house style. Bertha, being a former pupil, would likely have followed in

his footsteps, which I believe would have suited Myrtle perfectly as she was not a by-the-book person.

Myrtle's Certificate and Flinders Petrie

In 1911, aged twenty-three, Myrtle enrolled in the classes of the eminent archaeologist Sir William Matthew Flinders Petrie, at University College London (UCL), studying for the Certificate in Egyptology that was to take her two years. She followed in the footsteps of other notable women copyists and archaeologists who worked in Egypt, all passing through the hallowed corridors and going on to establish careers in this comparatively new field. Flinders Petrie has to be credited with giving many women artists and archaeologists the chance to live and work in Egypt, an opportunity usually denied the women of the time.

When these classes were set up in 1893, they were unusual for a number of reasons. Firstly, they were the first classes in Egyptology in the country. Egyptology had previously been taught in Germany, France, and Italy but never in Britain. Secondly, the classes were to be open to both sexes. At that time, the University of London was the only institution that actually awarded degrees to women. Oxford didn't follow until 1920 and Cambridge, unbelievably, not until 1947.

These classes were life changing for Myrtle. She had always had a strong fascination with the ancient civilization of Egypt. There are photos of her dressed in Egyptian costumes as a young woman, and her abilities as an artist soon brought her to the attention of Mr. Petrie. She would soon find herself working in Egypt as a copyist, firstly for Flinders Petrie himself at Qaw al-Kebir, and then for the Egypt Exploration Society, in conjunction with the Oriental Institute of the University of Chicago, at the great temple of Seti I at Abydos. The work at Abydos would be over a period of eight seasons and would be the most enjoyable of her life, though sadly to be cut short by the ill health of her parents. Myrtle was indeed very close to her parents. While in Egypt she would write over four hundred letters detailing her work and life there. She very much wanted them to be part of her time there. These letters are documents of social history, records of a life long gone, with customs and rituals recorded like seldom before.

We all know the names of the important players in Egyptology, we know the sites excavated and cataloged, and of course the fruits of their labors are now on display in museums around the world. I am not so sure,

however, that we are fully aware of the great contribution made by an intrepid band of artists and epigraphers. Records they made of monuments now lost and gone forever are, and have been, such an invaluable aid to researchers past and present, that the importance of these records cannot be underestimated.

And what of the people themselves? Those artists and epigraphers, many of them women, whose names we see on paintings and in excavation reports? They are mentioned in passing, if at all, with the focus being on their work, quite rightly so, but we know next to nothing about them. What motivated them to go out to Egypt? Why did they want to work and live there, producing these paintings and records that would prove so important to future generations?

Middle-class women of the interwar period were better educated due to the Education Acts of 1902 and 1918, and by the 1930s about a third

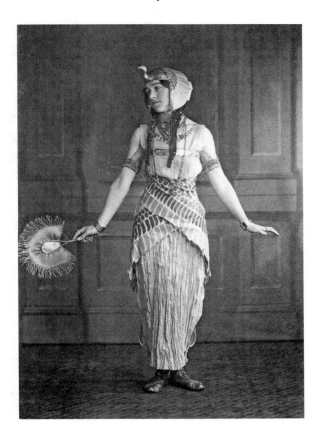

Myrtle dressed as Cleopatra

of women in Britain worked outside the home. But married women were still expected to stay at home, with only a tenth of them working. There were more job opportunities for women, but they were mostly confined to working as clerks, teachers, and nurses and upon marriage were generally expected to give up their jobs. This was still a time of greater confidence and independence though, which was reflected in the new fashions; hair and dresses were shorter and women were starting to drink, smoke, and drive cars. Myrtle was part of this generation that must have felt they could achieve anything, and how exciting this must have been, especially as their mothers could still remember the restrictions imposed on them and past generations. This excitement comes through again and again in the letters.

So, I would like to give you a flavor of life living and working in the desert of Egypt in the 1930s through the words of Myrtle. Not just the important work that was carried out there but the everyday life too; I want to take you back in time with her help.

2

QAW AL-KEBIR

Having gained her Certificate of Egyptology from University College London in 1913, Myrtle is all set for a life of exploration and adventure. However, with the outbreak of the First World War, nothing much happens on that front, the ensuing chaos of war curtailing much of the excavation work in Egypt.

Instead, we find the very middle-class Myrtle living in Bushey with her parents, equipped with her unusual skill set and remaining consumed by her passion for ancient Egypt. She kept in touch with her Egyptology contacts, undertaking occasional drawing projects for Flinders Petrie and

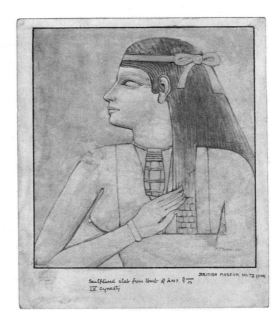

Drawing by Myrtle Broome from the Tomb of Ant

others, but her life working with her father carried on as normal. The house in Bushey was an ongoing project in which she was closely involved.

In her spare time, she continued to paint, and this was something she would do throughout her life, well into her old age. At home in Bushey, the garden at Avalon was a favorite subject, alongside the surrounding neighborhood. Her paintings give us a good idea of how the area looked in the 1920s, with a little more countryside than we see now.

Myrtle's life in Egypt did not begin until 1927, when she was thirty-nine, a full fourteen years after finishing her Egyptology course. She was asked by Flinders Petrie to join an expedition to the site of Qaw al-Kebir as a copyist. Although the project would only be for a few weeks, one can imagine Myrtle's excitement at the thought of finally going to Egypt after all these years.

Petrie had been working at Qaw al-Kebir during the 1923–24 season, recording the rock-cut tombs that had belonged to the high officials of the Middle Kingdom (2050–1700 BC), including the nomarchs Wah-Ka (Uakha' in earlier publications) and Ibu. These were massive rock-cut tombs cut into the cliff along the east bank of the Nile with porticos and passages leading into inner pillared halls with the burial chambers deep within the rock itself. The tombs had been of a high quality, but by Petrie's time, the tomb paintings were in a poor state of preservation and covered in bat droppings that had to be carefully removed with damp cloths. To take photographs of the ceiling paintings, an ingenious device for the reflection of sunlight was used. This consisted of cookie box lids nailed together!

However, work had halted in 1924 for several reasons. This was mainly due to focus shifting to the prehistoric Badarian cemeteries a few miles north of Qaw al-Kebir, and also because Petrie had been taken ill in 1925. Another important factor at the time was the changes in the Antiquities Law, which restricted the divisions of finds from excavations. This had been imposed by Pierre Lacau, the director general of Antiquities, and the restrictions on the export of finds impacted greatly on activities in Egypt. It caused the withdrawal of funds and grants from the museums and private benefactors who had contributed greatly in the past. Therefore, in 1926, Petrie, on behalf of the British School of Archaeology in Egypt (BSAE), reluctantly made the decision to transfer his excavations from Egypt to Southern Palestine.

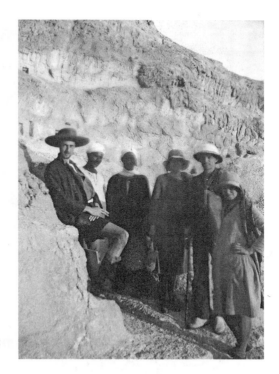

On the cliffs near Qaw al-Kebir, from left to right: Lancaster Harding; Hofny, an antiquities guard; Mrs. L. Risdon; Lt. Comdr. R. Risdon; and Myrtle Broome

Despite these issues, Petrie remained aware that he needed to finish his Qaw al-Kebir project, hence the expedition in 1927. It was to be a small undertaking, lasting only for five weeks in November and December that year. The tomb paintings had originally been copied on paper, but now Petrie wanted these copies to be revised.

For this expedition, he was able to maintain a team from a previous expedition in Palestine. With the exception of newcomers Myrtle and Olga Tufnell, they had all worked together for some time. Indeed, the visit to Qaw al-Kebir was designed to be a prelude to the upcoming season in Palestine for them.

Olga Tufnell had been Mrs. Petrie's secretary for the BSAE and was a well-known figure at the university. Petrie, who was always on the lookout for artists to send to Egypt as copyists, had recognized her artistic talent. Olga would become one of Petrie's students in 1930 and eventually make her name in Palestine, but like Myrtle, this was to be her first taste of field archaeology.

A pair of fresh adventurers, Myrtle and Olga traveled out to Egypt together to meet the rest of the team at the site. They crossed the Channel

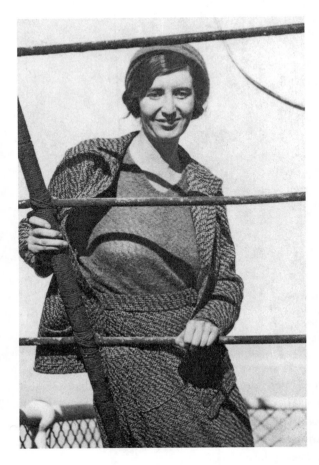

Olga Tufnell

from Folkestone to Boulogne and from there took the train through France to pick up the boat in Marseilles. Traversing Marseilles they traveled in what Olga described as "a vehicle of hoary antiquity" and arrived at the quay to embark on the French ship the *Mariette Pasha*.

Myrtle always enjoyed her journeys and described them enthusiastically in her letters. A prolific writer, she wanted her parents to know every facet of her life away from Bushey and wrote in detail about everything she thought would be of interest. Her letters were passed around to family and friends, much like the modern equivalent of writing a travel blog.

On this, her first trip, she talks about the food, her fellow passengers, the facilities on board, and the places seen or visited en route. She talks excitedly about passing the island of Stromboli.

Broome MSS1
The night before last was very exciting we passed Stromboli at 2
o'clock AM – so Miss T & I got the night steward to call us, it was
worth going on deck to see the flames from the volcano shoot up at
intervals & once we saw a stream of lava flow down the side – We were
up again at 5am to see the Straits of Messina, we could see the outline
of the Italian coast on one side & that of Sicily on the other.

You can imagine their excitement as they traveled on one of the major
shipping routes of the time. Myrtle's descriptions combine the enthusiasm
of a born traveler with the very British sensibilities you would expect from
a respectable lady.

Broome MSS1
The Mariette Pasha is a very beautiful boat as far as decoration & fuss
goes, but the lavatories are very inferior & accommodation generally
not so good as on the P & O. Meals very wonderful & endless although
I am tired of French cooking already – there is just too much of it!

Over the coming years, Myrtle would become familiar with the ships that
plied the route to India and beyond. She would identify which would stop
at Alexandria or Port Said to let passengers off and—as with all things—
Myrtle had her favorites. The ships were of diverse nationalities and highly
distinctive, as suggested by her descriptions of the French ship the Mariette
Pasha and the Japanese ship SS Hakozaki Maru that she would return on.

Over time, she would come to choose her ships carefully, exploring
their different routes, and during her years of working in Egypt she tried to
visit as many countries as she could.

Arrival in Egypt

Through Myrtle's letters we get a sense of what life was really like on the
ground in Egypt in the 1920s and 1930s.

Upon their eventual arrival in Alexandria, they were delayed in the cus-
toms shed and began their journey by missing the intended three o'clock
train to Cairo. In her first letter from Egypt, Myrtle paints a picture of the
excitement and novelty of arriving in a truly foreign port, conveying all the
details with the heady buzz of such a strange, exhilarating experience.

Broome MSS2

21 November 1927

Dear Mother & Father –

I have seen the Pyramids & the Sphinx & Tutankhamen's glorious golden coffin & all the treasures from his tomb & many more things beside. I am telling you this rather out of order but I feel I must announce the wonderful news before I continue my adventures where I left them in my last letter.

We arrived at Alex. had our passports examined on board & had to pay 15 piastres to the health officer before we were allowed to land. We were fortunate in getting one of Cooks porters who helped us through the customs, we had forms to fill up & I was charged 35 piastres on what I declared. I had to open my trunk, but they only glanced inside & did not disturb anything. We were bundled into a taxi & made a rush for the station as there was a train at 3. The next one was 6 o'clock & we were anxious to get the first so as to go through to the delta in daylight. Just as we reached the station the train steamed out & our taxi Arab offered to overtake it & get us on it at the next station for 40 piastres. So we said yes – & we did have an exciting chase but we succeeded in catching the train – Wonderful ride through palm trees & fields of sugar cane & little mud houses with flat roofs. Donkeys, oxen, & camels, all passed along the dried mud roads with their various loads, it was just a series of pictures that might have happened in Bible Times.

Mr Wainright[1] met us at Cairo station & took us to our rooms – at Miss Bodmin – 5 Sharia Suliyman Pasha, very posh. We shared a double bedded room – with balcony over a real Eastern street.

At dinner we were waited on by Arabs in white with scarlet sash, fez & shoes.

Sunday morning Mr Wainwright called at 9 o'clock & escorted us to the museum where we saw the Imp. He has promised to show me the sights when I return & says he can get me a room any time without much notice – we spent the morning in the museum. I will not attempt to describe it now – but I can only say it more than surpasses my imagination.

1 The Mr. Wainwright mentioned is Gerald Wainwright who had also studied with Petrie and Margaret Murray at University College London (UCL). He was by the time of Myrtle's adventures retired but was still writing and continuing with research.

Mr Wainwright came back to lunch with us & in the afternoon he took us to the Pyramids – we had a glorious time – they are amazing. I had never realized they could be so big when you stand near to them. The Sphinx is very beautiful & not as battered as the photos lead one to believe. There was some excavating going on near the Temple of the Sphinx & the Arabs were carrying baskets of sand up a slope, & running it away in trucks. A small boy stood by the edge of their track & sang as they worked, & they all joined in the chorus it was really beautiful – We had tea at Mena House & then met Norman de G Davis[2] who was staying there for a while. His wife was there & has asked us to call on them when we go to Luxor.

We spent the evening preparing for our eventful journey into the desert, we had decided to go by day train to Assyut, stay the night there & go on to Tema in the morning.

There is no really European hotel in Assyut, it is a real Egyptian town & it was suggested that we should go to the American Mission & ask if they had a room they could let us have for the night, otherwise we should have to go to the Arab Hotel.

Mr Wainwright kindly met us again in the morning & put us on our train – there was another gentleman in our compartment so Mr Wainwright asked if he would be travelling far as there were two English ladies going up country alone & it turned out that he was in charge of the Canadian Mission in Assyut & when he heard we were breaking our journey there he offered us their guest room, & as he was getting out of the train a few stations before Assyut he gave us a letter to his wife & full instructions how to get there, of course when we got out of the train we were besieged with porters who fought over our baggage & yelled for more baksheesh, but we only gave them what Mr Black told us & waved to our driver to start & got off alright.

At the Mission Mrs Black very kindly took us in – in a tall house in a native street & while the room was being got ready for us one of the young missionaries took us out in their car right to the foot of the

2 Norman de Garis Davies was in charge of the Metropolitan Museum of New York Epigraphic Division and his wife Nina is regarded by many as the finest exponent of the copyists of Egyptian art.

cliffs – we left the car in charge of an Arab & climbed right up the cliff to some 10th Dynasty Tombs.

The entire cliff is riddled with small tombs, in fact it's an immense graveyard, every where one goes there are bits of bones & in some of the little tombs the mummies were still there, broken up of course by tomb robbers – it was rather eerie. In one of the large tombs we saw a beautiful grey owl & lots of bats.

We had supper when we returned, grace before & prayers afterwards –

During supper one of the missionaries had to go out & stop a street fight. He returned with a strap & brass pistol with which a man had been threatening his grandmother because she had locked him out.

On our journey here we saw the step Pyramid of Sakkara – the Pyramid of Medum & the Tombs of Beni Hassan. The country is wonderful, the inundation is subsiding & the Arabs are out working in the fields – we saw them ploughing, with an ox & a camel – one of the prettiest sights to be seen is the tiny children in charge of the buffalos – quite a baby will lead a string of these great placid animals, or even ride on their backs.

We continue our journey tomorrow morning. Mr Black has promised to see us safely on our way & as we ought to be turning in I must close & seal this letter as I hope to be able to post it tomorrow.

In later years, Myrtle would continue to detail her various excursions in Egypt and the experience would become, to some degree, common-place, but at this early stage it is lovely to share her initial feelings on these first sightings. She takes us there with her and we share her world of 1920s Egypt.

As she describes, Myrtle and Olga spent their first few days in Cairo taking in the wonders. Interestingly "The Imp" she talks about in her letters is Reginald Englebach, one of her Egyptology classmates at UCL, and the then-curator at the Egyptian Museum. One can only assume the nickname had something to do with his size, as he was fairly small in stature.

After their days in Cairo, they continued to the camp in the desert. Through her letter, we can see that Myrtle was enthralled by the scenery as she traveled; she writes

Broome MSS3
Our Tomb, near Tema.
Dear Mother & Father.
I have arrived safely as you see by the above, so will now continue my
adventures from where I left off.

Our missionary friends gave us an excellent breakfast, (short
service beforehand). They would not charge anything, so Miss T &
I left equivalent to 5/. each in an envelope on the dressing table for
the Mission.

They took us & our luggage down to the station, bought stamps
for us, posted our letters, got our tickets & put us on the train.

Tema was 6 stations further on & you can imagine how anxiously
we looked out for Harding on the station, not a single European in
sight, our luggage was seized by a wild crowd of porters & we walked
round looking for him. Finally we went to consult the station master
who fortunately spoke a little English & from him discovered that
they only sent in to Tema Sundays & Wednesdays, so we concluded
the letter must have gone astray. The station master said he could get
us donkeys & a couple of guides who would take us to the camp, & as
that seemed the only thing to do we agreed to a fixed price & started.
The two of us on donkeys, our luggage on another, out into the desert
with two strange Arabs who could not speak a word of English – we
first had to pass through the village past flocks of goats, laden camels,
curious mud houses, palms, etc. & their desert road – just a dust track
winding towards the Nile.

When we reached the river we dismounted & the donkeys were
turned loose & we sat down & waited. I cannot tell you how beautiful
it was. The blue Nile with the curious native boats, the shimmering
desert, with the pink cliffs beyond & behind us the desert road, with
occasional herds of goats & sheep passing along herded by native
women & children, many of the women carrying the water jars on
their heads, strings of camels meandered by at intervals & a few buf-
faloes – or plough oxen making for the cultivation.

After what seemed a very long wait & much shouting by our
guides – one of the native boats came to the shore & we scrambled
aboard, our luggage followed & then the donkeys. It was the most
primitive boat I have ever seen, the triangular sail was full of holes

& patches, we just drifted across, our mariner was simply wonderful, a real Sinbad, there were several Arabs besides our guides, & halfway across they all gathered round us & jabbered to us in Arabic, I gather they were asking for money – but we simply shook our heads & pointed to the shore & they left us alone. When we had disembarked we paid Sinbad his 5 piastres, & got a lovely smile & a bow – we mounted our donkeys again & continued our journey. The desert is *not* flat by any means we went up & down slopes that would have stumped an English horse, but our little donks took them without turning a hair. After four hours we reached camp. Mahomed was the only one at home as the others were at the Tombs we are copying 2 miles from the Tombs we sleep in – but Mahomed was a host in himself & although he does not speak English he made us understand that Effendi Harding would be back at 5 o'clock. He got us a meal & showed us where we were to sleep. Harding & the Risdens [the other members of the team] arrived about 5 & were amazed to see us – & it seems it was entirely Miss T's fault we were not met, she had written so vaguely that they did not expect us until after Wednesday, their usual day for sending in. I am afraid she is very haphazard & we should have been in several messes if I had not thought ahead, she never thought about having small change, & things like that, but otherwise she is a very nice companion.

Camp life and work

Once settled in they quickly adjusted to camp life and the work routine. Clearly it was quite a change from Bushey, with challenges of digestion, heat, accommodation, and wildlife, which Myrtle describes thus:

Broome MSS4
28 November 1927.
Tomb of Khenti Ka
Dear Mother & Father –
There is so little time to write when we get home in the evenings that I am scribbling during our lunch interval. The first night after we arrived in camp I had a most unhappy time. I developed the Egyptian tummy Miss Murray told me about which feels like every sort of bilious attack rolled into one general discomfort, & to improve matters I

had a slight touch of the sun as well, so in the morning I took the dose of castor oil in my coffee & spent the rest of the day fasting in bed & have since been quite all right.

We rise at dawn, collect our drawing materials & set out for this tomb which is 2 miles further along the cliff from the one we sleep in, our Arab bearer Hofny follows with the basket containing our lunch & the two water filterers – our way lies along the edge of the cultivation & each morning we meet the camels & bullocks going to work in the fields carrying the great wooden ploughs on their backs. There is one camel that we meet that has a baby camel following & it jumps about like a little kid & performs the most absurd antics.

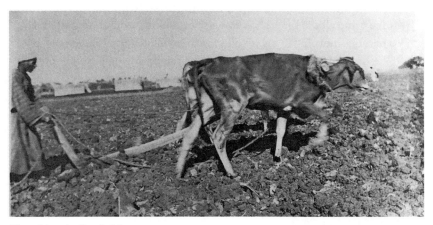

Ploughing in the fields

All the animals are so very unafraid & docile, the goats brush right against one when passing a flock of them, & the cows & buffaloes do not move as much as a step aside when one passes them.

Our sleeping quarters are in the cliff, facing us lies the whole width of Egypt with the Nile running through it – behind us beyond our cliff there is nothing but desert until one comes to the Red Sea.

Quite near to the tombs where we are working there is an Arab village just mud houses & palms & a well, every evening the women come with their water pots on their heads, tall figures draped in black from head to foot wait by the path to greet us as we go by. Since Miss T & I arrived Mr Harding has risen tremendously in their estimation, as they are convinced we are his two wives –

Yesterday they had a funeral, & from our eyrie in the cliffs we were able to watch the whole ceremony unobserved, the hired mourners made the most extraordinary noises, more like yelps than wails.

On our return this evening we are all going to sing 3 blind mice as we go along, for the edification of the villagers. Tomorrow we are giving a dinner party, the head of the local native police is invited. I am told it is polite to make awful noises as one drinks coffee to show one's appreciation. So the visit ought to be very amusing. I believe we have to make noises too!

Nov 29 I think the work here will last another fortnight, we arrive at about 7 o'clock & work until about 4 o'clock, our bearer Hofny comes with us to carry the things & comes to fetch us, Mahomed stays in the camp all the time, he is doing my washing to-day, I presented it to him this morning in my tin basin with a chunk of my Lifebuoy soap & he beamed with delight – he cooks us the most wonderful dinners each night. We always have glorious soup, some sort of meat or fish, & a sweet – his plain boiled rice is wonderful all light & flaky not sodden at all, one day we had chops from a buffalo, very nice & tender.

A wild cat visited Mr Harding in the night & drank his washing water, we also had a jackal in our dining room one night, but Mr Risden heard it & chased it out before it could steal anything.

We walked to work this morning with an Arab driving a camel, he told us she was a very good trotting camel & could go from here to Cairo in 2 days. He walked beside us & Miss Camel ambled on in front quite free, no lead or bridle or anything on her – she looked round once or twice to see if we were coming. We met the baby camel who seemed inclined to join our cavalcade, but finding it wasn't the right mama gave a squeeky grunt & tore after its legitimate maternal relative.

We are a very jolly little party & have the most ridiculous fun – one day we were practicing making goat noises in our working tomb & Harding happened to look out & saw Hofny coming up the cliff to fetch us simply doubled up with mirth. The Arabs all love a bit of fun.

Mohamed Hassan al-Gerzawy

During her time at Qaw al-Kebir, Myrtle was greatly smitten by the local police officer Mohamed Hassan al-Gerzawy. He showered her with gifts and let her ride his Arab stallion. When you read her letters, it is sometimes hard

to believe that she was thirty-nine years old, not a giddy schoolgirl. Through al-Gerzawy she is introduced to Arab hospitality rituals, and she is very aware that she is being treated as a superior being. Myrtle demonstrates that she did not share the typical outlook of the European in Egypt, many of who assumed that the "natives" were an inferior race and thus could be patronized. Myrtle made many good friends among the Egyptians in future years, but, nonetheless, she was a product of her time, and she would still no sooner consider marrying an Egyptian than any other European from the period would. Clearly it did not even merit thinking about, but certainly she still enjoyed the attention.

Broome MSS5
1 December 1927
Tema Camp
Dear Mother & Father –
Still more exciting things have been happening. The morning after our dinner party I awoke to hear gobble gobble going on outside, & on investigation saw an Arab boy on a beautiful white donkey with a great big live Turkey, a present from El Gerzawy. (our guest of the night before). He had also sent his photo & a letter in which he said, "I will be very much obliged if you accept my photo to replace me as I could not accompany you where ever you go; as my own wish – " he starts the letter, My dear friends all. Of course we were tremendously excited about Thomas as we called the Turkey.

This morning Gerzawy sent an escort to conduct us to Qau to see the parade; after the drill we were taken to see the men's quarters, on the threshold Gerzawy had written in the dust WELCOME, a pretty compliment that we very much appreciated. Then he conducted us to his house, or rather the house of the Omdah of the village that he has commandeered for the time that he is stationed here, he is a little tin god in his own way & seems to have unlimited power over the people.

We were given very sweet tea, sandwiches & Turkish delight, then the elders of the village were presented to us, also the tallest man in Egypt, a splendid fellow – 7 ft 1 inch tall who had come from a distant village by Gerzawy's special command. We were entertained by a display of horsemanship by an old Arab of 70 – on a grey Arab horse, with trappings of blue & white. After a long wait that we filled in by an exchange of compliments – a native band arrived – & we all adjourned

to the big parade ground, where we saw some wonderful horsemanship, the band played & danced about all over the place, & round them & in & out among them, danced two superb Arab horses. Gerzawy's black & the old Arab's grey. The way they twisted & turned, pranced & reared, tossed their glorious manes & tails, knelt on one knee then on the other & all in perfect time to the music – several times during the performance guns were fired, but the horses took not the slightest notice.

I liked the native music very much, it was chiefly drums & pipes, & very tuneful, it made you want to dance. We had a most ceremonious leave taking & have promised to visit another village on our next rest day.

Gerzawy has promised me a ride on his wonderful Arab horse. I wonder if I shall really go – it sounds too good to be true.

Dec 2nd We had Thomas the turkey for dinner last night, how Mahomed managed to cook him with only a primus stove passes all understanding but he was done to a turn, & stuffed too – we shall miss his cheerful gobble – but we thought it best to hurry up & eat him before we got too fond of him.

This morning at work we had a visit from Gerzawy to invite us to visit his uncle one evening when we have finished our drawing for the day. We are going the day after tomorrow, & he is sending an escort to fetch us, it is really too thrilling.

Gerzawy is very funny, he says, Oh you English people you think nothing all the time but work work work –

We gave him all the magazines we had with us including Punch & when we visited him he asked the meaning of some of the pictures, he was convinced everything must have to do with politics because English people do not seem to have any other kind of joke – from his remarks it seems the whole village had been poring over Punch trying to make out what it was all about – their conclusions were very amusing.

Tell Pat that Mahomed Hassan El Gerzawy is really a lovely sheikh, so if she wants one, she had better come out here – he's awfully keen on English people.

Myrtle was obviously smitten by all the attention and her letters are full of him. Interestingly, Olga just refers to him as "the local police officer," not singling him out with any special awareness.

Broome MSS8
11 December 1927
Tema Camp
Dear Mother & Father.
I hardly know how to tell you of the glorious time I have had today, I have done a thing that exceeds my wildest dreams I have actually ridden a glorious Arab stallion at a gallop for miles over the desert, on a real Arab saddle with all the trappings, it seems too good to be true.

El Gerzawy came for me after breakfast, he mounted me first on a white horse because I was a little nervous about the stallion, but when he saw how I could ride he said I simply must try the black, so I changed; the saddle was rather strange but the horse had the most glorious motion I have ever dreamed or imagined, smooth & swift over the roughest ground. El Gerzawy was amazed when I got going. He said he would never have believed a woman could ride astride & keep her knees close to the saddle like a policeman. We galloped out to an oasis & then swung round towards Qau el Kabir. The entire village came out to see me. I am the only European they have ever seen on horseback, & they said "That is not a woman, that is a man." I had lunch with Gerzawy in real Arab style, we had roast pigeons stuffed with savoury rice which we tore apart & ate with our fingers, he said I might have a knife but it would be better in Egypt to do things in the Egyptian way for a change.

He has invited me to stay in Qau el Kabir on my return from Luxor, he will put an entire house at my disposal & will take me round to visit the outlying villages & give me a good time generally. I have promised to spend one whole day there on my return journey, it is an opportunity that only comes to one in a million.

He has also said he will arrange to come up to Cairo with me & take me round the native quarter & show me his father's house & introduce me to his mother & sister, so that I need not go with the others & have to return back to Luxor afterwards.

 He has been very hurt because we have refused so many of his invitations on account of our work, he thinks we might have managed for one or two to accept if all were too busy to come. He was feeling that we did not want to be friendly, but now I have broken the ice & spent the whole day with him & his horses while the others explored some granaries near here. He is rather a keen judge of character &

very much surprised me by some of his deductions. He said "You are different to the others – you think independently but the others follow each other". I can't think how he found that out but it is perfectly true. Here's another strange thing. He knows Mr Anderson's brother in Alexandria, when he was in the criminal department there he had to investigate a case of forged coins & it was then that he met & became friendly with the Mr Anderson at the National Bank of Egypt. So when you see our Mr A. please tell him that my pet sheikh knows his brother.

　　We have finished all the work here and leave for Luxor on Thursday. I shall write & have all letters forwarded.

Breaking camp

The time had come to pack up the camp and return to England. Clearly Myrtle's experience had met her expectations, but it is delightful to see her focus on the human elements of her travels rather than the historic. There remained, however, sufficient time for a little sightseeing for the ever-enthusiastic Myrtle, and it becomes further apparent how she enjoyed the attention bestowed on her by the Egyptians.

Broome MSS9
15 December 1927
Thebes Hotel, Luxor.
Dear Mother & Father.
Here I am in Luxor at last. I am not quite sure how far I had got with my adventures in my last letter, I am sure I must have told you of my thrilling ride on Hassan, the black Arab horse. Well the next morning Gerzawy sent him round for me again in the charge of his drill sergeant, a glorious old Arab of 75 who had served with Kitchener in Khartoum, & who is ready to worship the ground I walk on because I am the only woman he has ever seen who can sit a horse like the mounted police. I mounted & rode out towards Qau el Kebir where Gerzawy met me & we rode into the desert again with the Omdah's son as guard of honour

　　On our return Gerzawy had to attend to some quarrel between the Omdahs of different villages, so he sent me home on Hassan in charge of his personal servant.

We were to have visited the village of the tall man the following day but we could not go because Gerzawy had to arrest a man who had stabbed another in the neck & half killed him. So we got on with our packing, & the next morning got up at 3am in order to get all the camp goods & our own luggage packed on 3 camels with the help of half the village – to the sound of the most violent arguments I have ever heard, all shouting at once. One camel load fell off & had to be retied on, but we arrived at the river without further mishap. Our donkeys were taken across with us, but fresh camels were waiting on the other side. It was market day at Tema & there was a crowd waiting to cross, there were sheep, goats, donkeys, chickens, kids & calves, on board with us, & the boat was so laden that it stuck twice & two of the men stripped naked & jumped over the side & pushed to help get if off again.

We arrived in Tema in good time & called at the Post Office where I found a letter from you. It was the one where you say you have just received my first letter from the tomb, it seems so funny to read your remarks on things that seem to have happened so long ago. We had the camp outfit dispatched to Cairo, but all our baggage went on the train with us.

It is 7 hours from Tema to Luxor, but we got off the train at Bali-ana to visit the Temple of Sety I & the Osirion at Abydos & continued by a later train arriving at Luxor about 10. By the time we got to bed we had been on the go for 20 hours & I was not so tired as I am after a days' shopping in town, that is the wonder of this climate. I have not had a single headache, or ever been more than lazily tired & yet I have never done more (except at hay making time) in my life before.

This is quite a comfortable hotel & so far we seem to be the only people staying here, it is bungalow style & cool & airy & not at all posh, we do not change for dinner.

When we come in there is a little Arab boy to dust our shoes on the mat & we are waited on by Arabs.

There are the most gorgeous roses everywhere. I have two huge pots of them on my wash-stand & in the garden there are enormous poinsettias, plants as tall as I am.

Our first visit the morning after our arrival was to Cooks where I drew out £10 without any fuss at all. Then we explored the Temple of Luxor in the morning, & visited Karnak in the afternoon, they are

both on this side of the river so we were able to reach them on foot, & the special permits that the trip provided worked like magic. Gates were flung open by bowing Arab guards & we went where we liked.

Dec 16 To-day we crossed the Nile & on the other side engaged a carriage for the day, this was rather a snag, because the 4 of us wanted donkeys, but Mr Risden would not ride a donkey because he said the one he rode part way to Tema – had made him sore – it was the same animal I had ridden all the way to Tema & back again 3 times the distance he rode & although it took the skin off my sitting arrangements I was able to ride in a hard Arab saddle at full gallop across the desert the following day, so I felt he was making rather a fuss. Especially as the hire of a sand carriage cost 250 piastres (£2-11-6) to be divided among five of us, where-as donkeys would have only cost 25 piastres each. But apart from that it was a wonderful day. We visited the great Colossi of Memnon, the Temple of Medinet Habu, the Ramessium at Thebes & the Valley of the Tombs of the Kings. We saw the outside of Tut's tomb, but it will not be opened until later in the season. We visited the tomb of Sety I, while we were there the electric light went out, & we had to wait in pitch darkness while the guide got a lamp. We saw the tomb of Amenhotep II where he still lies in his sarcophagus, also the tomb of Mer-em-Ptah, the King who was supposed to have been drowned in the Red Sea.

We had our lunch outside in a shady spot, & a very wild looking dog hovered round, we coaxed it near with food & finally got it to eat out of our hands. It was a wonderful thing to see the look of fear fade out of its eyes & give place to the look of dog adoration at the feel of a caressing hand. At the conclusion of our visits down these deep tomb shafts we felt rather done so we asked the Arab guard if we might have coffee. He brought us the most delectable coffee I have ever had, it really tasted like it smells when fresh ground. We drank with noisy sippings much to his delight.

Then drove back, visiting the Temple of Hatshepsut on the way. We crossed the Nile in a lovely little dahabaya & so back here.

Christmas Day

Myrtle continued her sightseeing and spent Christmas Day in Luxor. She gives no sign of missing Bushey! She then went to join al-Gerzawy for a few days. Her vivid descriptions of Arab hospitality bring the festive experience

to life, with her little details giving an important insight into Egypt at the time. For once we are allowed to see beyond the life of the tourist, to daily life in the villages and the rituals so important to the Arab community.

Broome MSS11
26 December 1927
Thebes Hotel, Luxor
Dear Mother & Father.
I had such a lovely Xmas day, on the breakfast table there was a greeting card from Mr & Mrs Meade [the hotel owners] & the Bey[3] gave me a box of chocolates. I spent the morning writing.

The afternoon I spent in Luxor Temple & after dinner & I went to the Winter Palace to a dance with an English man from this hotel – the Winter Palace is the Ritz of Luxor. I had a gorgeous time only missed one dance. I am going tonight again to a fancy dress dance. I got the Bey to take me to a drapers shop & help me buy some mosquito netting with which I have made a huge ruffle & pompoms, so as to transform my black dress into a black & white Pierette – it is the best I can do at a moment's notice.

A few days ago I went for a climb up the cliffs here with the aforementioned English man, he is a gay bachelor of 65, a real sport & very keen on mountaineering. He reminds me of Uncle J. it was a wonderful experience & I got some good photos. We reached the highest ridge (1600 feet from the desert level) where we had lunch. On our way down we found a mummy's head which we carefully buried with its face to the west, & put a suitable inscription on a stone over the grave.

The Bey still follows me whenever he can & mopes when he can't. Today I accepted an invitation to go for a sail on the Nile with him. I hadn't a suitable excuse, & really the invitation was rather tempting, he questioned me on English customs – specially those referring to marriage, & coolly announced his intention of divorcing his wife & coming to England to marry an English girl. It was very nearly a proposal & on the Nile too. I am invited to go to Assuan with him!! needless to say I have renounced all hope of going there now. I should not have a moments' peace.

3 A rich merchant staying at the same hotel and intent on wooing Myrtle.

I shall probably pay a farewell visit to the desert & Gerzawy & the horses before I come down to Cairo. Gerzawy has written me several letters in his quaint English. He is the nicest Egyptian I have met, with a real philosophy of his own & so anxious to exchange ideas about things. I have been able to give him a few new points of view. He told me my personality was like a magnet, (wasn't it a pretty compliment), the other Egyptians I have met here are rather uninteresting. Fancy. I am the only woman at the hotel except Mrs Meade & there were 8 men to dinner Xmas day. I did have a time, they gave us soup, fish, vegetables, turkey, sausages, cauliflower, Xmas pudding, brandy-cream-sauce mince pies, & fruit & coffee. It was a feed.

Dec.27 The Carnival at the Winter Palace was a gorgeous affair. I have never been in such a cosmopolitan crowd before. There were people of every nationality East & West. Some of the costumes were superb, many were genuine, *Howard Carter was there judging costumes for prizes.*

Cecil House Cairo. Jan 3.

The first part of this letter got mislaid, so you will probably receive the one I wrote at Qau-el-Kebir before this, unless El Gerzawy forgets to post it, I arrived here yesterday after having the most wonderful experience of my life – it was more like an exciting drama than real life. I will try to describe it, but I am afraid any description would give a poor idea of the real thing.

I think I told you Gerzawy offered me the hospitality of the police outpost for as long as I liked to stay. I was a little dubious about accepting, so I wrote to the missionary at Assiout & he replied that it was quite true that the police outposts did entertain European travellers who were visiting the villages & English ladies invariably received the utmost courtesy. Although of course such visits were rare. So I thought I should always regret missing such an adventure – so I accepted for 2 ½ days on my way from Luxor to Cairo.

It sounds a pretty desperate adventure when you realize that I was the only European woman for miles in a very lawless outpost. The guest of the only English speaking Egyptian in the whole village, but El Gerzawy is, in the full sense of the idiom "an officer & a gentleman" & I was as safe in his house as I am at home. As he was unable to

be at Tema himself to meet me, he sent his servant & an armed guard, & I was driven in an arabia [car] to the river. We crossed the Nile & continued our journey on donkeys. Gerzawy was waiting to receive me at his house, he showed me where I was to sleep & all the accommodation which was of a very primitive nature.

The walls outside were mud brick, whitewashed inside, the roof was constructed of wooden cross beam, palm branches laid over them & plastered together to form a ceiling & loose straw laid over the outside to keep it cool – all flat of course, no need for sloping roofs when there is no rain. This is the principal house of the village, & is used by the officer in charge who pays rent to the Omdah (chief man).

After I had tidied myself, the servant pouring water for me to wash, we had lunch – stuffed pigeons & native bread (eaten with our fingers of course). After lunch came the afternoon siesta. Gerzawy changed his uniform for a flowing galabia & heelless slippers, of course we had to wash again after eating, & as I had had such a long dusty ride, Gerzawy advised me to remove my shoes & stockings & he washed my feet for me himself while the servant poured the water. For about an hour & a half we rested on divans & then we received company. All the head men of the village came to be presented to me & as a special favour were allowed to sit on chairs in El Gerzawy's presence – (usually they all stand unless he specially invites them to sit with him), of course Gerzawy had to translate all the conversation, (except a few phrases) I showed them English money & all the odds & ends I had with me also sketches & photos & then as they seemed so pleased & interested, I asked them if they believed I could cut a hole in a postcard big enough for El Gerzawy to slip through. They said it was impossible, no one could do that, so I did it with my little pocket scissors right in front of them – & they clapped their hands with delight like children & said it was magic when they saw the officer step through the long chain that I had made by cutting the card in a special way. After that of course I had to do all my paper stunts, rocking horses, boxes, boats etc. & never have I had such an enthusiastic audience. It was funny to see a dignified old Arab going into raptures over a paper toy. They hoped I would live for a thousand years & spend them all in Qau el Kebir & they would serve me in any way I liked. Gerzawy said they really

meant it & that any time I went to Qau, even in his absence the head
men would treat me as if I were a chieftainess & I could stay as long
as I liked. The Omdah of Qau told Gerzawy that he knew I was of
high birth & great importance in my own country. You can under-
stand how I felt as if I was living a part of one of Rider Haggard's
novels, the lamp lit interior & the circle of turbaned Arabs sitting in
a circle round me.

Supper was then brought in, only Gerzawy, a captain from
Badary & the Omdah & myself partook of it. The others withdrew
to a respectful distance as their rank did not permit them to eat with
the chief officer.

When our visitors had departed, I was allowed to retire to a very
comfortable divan sort of bed with quilted covers & mosquito net.

The next day when Gerzawy had attended to his official busi-
ness we went for a ride. Then the usual ablutions – meal & rest. That
evening proved rather exciting, I saw a case of primitive justice. A
message came to say there was a case of assault, two men had quar-
relled over ½ a piastre & one had wounded the other rather badly,
cutting a great gash in his head. Gerzawy ordered both men & the
witnesses to be brought into the court yard of his house where he
sat on the veranda & heard the case. He finally ordered the culprit
to be beaten. The guards bound his hands & feet & they laid him on
the veranda. El Gerzawy beat him with my riding whip, so many cuts
across the back & so many on the soles of the feet. & they took him
away & locked him up. It sounds rather barbaric just written down
like this, but out there you realize the need of it. If one man injures
another he is beaten, if he steals, then he has to do some sort of hard
labour –& so on – & El Gerzawy is judge, jury & executor. He could
order the Omdah of the village to do the actual beating but he prefers
to do it himself because it increases his authority in the eyes of the
people. Although it may be less severe they are more afraid of a beat-
ing by the chief officer than by the Omdah.

That evening I received a deputation begging me not to depart
the next day. Two of them asked me to take them back to England,
one offered to sell his land for £300 so that he could accompany me
& one of them offered me his little daughter to be my servant. Can
you really believe it really happens now-a-days? I have never been

so popular in my life, & now, to crown it all Gerzawy has asked me to marry him. It has been frightfully difficult to refuse. He really is one of the finest characters I have ever met. I like him immensely, the only thing against him is his nationality. He wants to come to England & start some business, he has £3000 to invest of his own & has asked me what he can do with it in England. I have promised to do all I can to help him when I get back, but I hardly know how to set about it. He says the Egyptian government will probably send him to England in the summer. The officer who was promoted last year, went, & it will be his turn next & he thinks he may probably prefer to settle in England afterwards. I am afraid he thinks I may reconsider it if he lives in England & if he only were English I believe I would. Anyway, I am sure there are a great many Englishmen who would have behaved less honourably under the circumstances than he did. He told me he regarded me as something sacred & he treated me as such. I can tell you more about it when I get home it upset me very much when he pleaded so hard. He speaks wonderfully good English, but at times uses Arabic expressions which are very beautiful even put in English words.

I got to Cairo after a journey 7 ½ hours from Tema. (I left Qau el Kebir at 8. Train left Tema 11.49.) I got my baggage from the luggage room & got a taxi & came on here in time for dinner.

This morning I went to the Museum & saw the Imp, he is taking me to the Pyramids again Friday & Sakkara Monday. Thursday Mr Wainwright is taking me round the Mosques.

This afternoon I went to Cooks & saw Mr Jackson he was very nice & is arranging everything for me. My berth is booked on the S.S. "Hakozaki Maru" due to leave Port Said on about the 10th.

After leaving Cook's I walked about & looked at shops, dodged dragomen in brilliant galabias & purchased a cake of soap & a map of Cairo & when I had quite lost myself I just got in a taxi, said "Cecil House" & was deposited here for the noble sum of Pst. 5 (1/-).

I must dress for dinner now, this is not a swell place, but quite comfortable. I pay 70 piastres a day. (14/-)

In her next letter to her parents, she talks further of her stay with al-Gerzawy.

Broome MSS12
Happy New Year
Qau-el Kebir
Dear Mother & Father.

I am staying here on my way to Cairo, the officer here sent his servant & an armed guard to meet me at the station & bring me here, he is going to see me safely on my way to Cairo tomorrow, I am staying in a real Arabic house, learning how to eat in the Arabic way but I cannot use my fingers as deftly as they can. I wish you could see this little desert outpost & I am sure you would like to meet my host. You will remember I told you about El Gerzawy who was so kind to us when we were in camp near here. He is the officer in charge & is looking after me & making me very much at home. I have told him that I hope he will visit us if ever he comes to England. I am so sorry to leave Egypt. I have had more experiences during these two months than ever before and I am glad I did not come by one of the regular tours for then I should never have had the chance of meeting & knowing the people & learning something of their life & ways. I have bought Father an Arabic fiddle, it is not a thing that one can get in shops for each man makes his own. Mr Meade at the Thebes Hotel Luxor hearing of your interest in instruments, offered to try & get me one & sent a native servant round the cafés & he was fortunate in finding a strolling player who was willing to sell his instrument of course it is a very primitive thing, only one string, but the sound is very sweet & clear. I can just get it in my trunk so I hope to get it home safely.

My Cairo address is Cecil House Sharia Naser-el-Din № 2 but by the time you receive this it will be too late to send a letter to reach me, I will enquire at Cooks about letters to the boat.

As I write, the birds are flying in and out of the room, they nest in the beams in the ceiling & are very tame.

I will write a longer letter when I get to Cairo. There is an unfinished one in my trunk that has gone on in advance I intended to finish it here, & post it, as I thought you might like to receive a letter from such a very romantic place, but I find I have not got it in my case here so have started another.

Please give all my friends New Year greetings. Your loving daughter Myrtle.

Myrtle now set sail for home on the Japanese cruise liner SS Hakozaki Maru. The ship would later be commandeered by the Japanese government during the Second World War and sunk by a US submarine. In her letter, Myrtle compares the accommodation with her outbound voyage on the French ship, finding good and bad in both but, needless to say, enjoying both voyages and making the most of her onshore excursions.

12 January 1928
ON BOARD
S.S. Hakousaki MARU
Dear Mother & Father
I am well on my homeward way, about a days sailing from Naples. So far we have kept good time but the exact date of our arrival in London depends on how we get across the Bay.

It is rather fun being on a jappy boat. I have a very nice cabin all to myself, everything *very very* clean, all appointments very good. Lavatory accommodation better than the French boat but of course not nearly so posh or highly decorated. The only thing I do not like very much is the rather limited deck space.

The little Jap stewards are wonderful & I have a little slant eyed stewardess with a perpetual smile.

The people here are mostly English, they seem chiefly of the merchant class or connected with missions, there are very few women.

We have also some Japanese, they wear their native costume & all sit at a table together & eat with chop sticks. I have spoken to one, a very charming little lady with a complexion like sun ripened apricots I believe a great many people are getting off at Marseilles.

The food here is good in parts, the bread is the nicest I have ever tasted, their hot breakfast rolls are a dream, butter & milk also good, coffee very bitter for breakfast.

I have sampled some of their made up dishes & found them distinctly "funny". The sweets are always good, ices every night & lots of fruit. So you see I am not doing badly.

Both the Imp & Mr Wainwright were very kind to me in Cairo, but I must say I found the time I spent there on my own distinctly dull after my exciting adventures out in the desert. El Gerzawy was unable to come to Cairo while I was there, he was so upset about it he wanted

me to visit him again at Qau-el-Kebir before I came home, think of it, as far as from London to Landsend & back in one day.

He wrote me a most pathetic letter, his quaint English is rather beautiful – this is what he says.

"It is absolutely impossible for me to be able (even if I tried) to forget you, your shadow is spread all over my place, all over our villages & inhabitants; all over our feelings.

I have had noticed that I should be forgiven for my great love to you as you have *even* drawn towards you all the natives you have met. Either you may come for one day or I will be more ill than now for your absence".

He is perfectly genuine in all he says, but of course one must make allowances for the Eastern temperament, he has specially asked that I will tell you all about him, the authority of parents over their children is a great thing in Egypt even in the matter of ordinary friendship.

Yesterday was the first day I have seen any rain since I landed at Alexandria, think of it 7 weeks of sunshine & such sunshine!

The sea does not look very rough but there is a steady swing on which makes it difficult to write. It is cold in the wind, but I expect I shall find it much colder before I get home it will be strange to be among people who all speak English again. I have got quite used to hearing strange tongues & seeing weird people & I seem as if I have been away for ages – what a lot we shall have to talk about for a long time to come.

There is no doubt that Egypt made a huge impression on Myrtle and that she enjoyed every second of her time there. Her ability to notice the small details—and to recall them in total—is quite remarkable.

Broome MSS14
14 January 1928
ON BOARD
Off Corsica.
S.S. Hakousaki MARU
Dear Mother & Father.
I went ashore at Naples yesterday with a lady & gentleman & their son, we shared a guide & drove round to all the principal places of

interest including the Cathedral, modern outside, but part of the interior dates back to pagan times, we saw the old fortress of the time of the Inquisition, the Kings Palace, the Opera, Colleges, Monasteries etc. & finally went up in the funicular railway to see the view from top, said to be the best view in all Europe, it certainly was very wonderful.

The bay is very beautiful & of course I saw Vesuvius, it was pouring out thick grey smoke which hung all about it like a cloud – not half as thrilling as Stromboli, there was no red light, & even at night only a pale reflection in the sky, but still it is something to have seen it. I wish there had been time to go to Pompei but the boat only waited 3 hours so I think I did quite a lot.

Most of the people are getting off at Marseilles. There is a dear old lady returning from Japan (where she has been teaching in a mission school) who thinks it dreadful of me to think of going all across the Bay of Biscay – & travelling alone too! She wants me to join her & her husband & go across France. She sits at my table & I believe she thinks it will be improper for me to take my meals alone with another male passenger. (a most inoffensive man). What she would think if I told her of my adventures in the desert I cannot imagine.

I am glad I shall have one more glance of Africa. They say if you have drunk the waters of the Nile you will want to return one day – it is perfectly true – I have drunk deeply. I do not think any other country could have the same fascination

I expect this is the last letter I shall write before I reach home & cannot say anything more definite than that I may get home late on Jan 22 or sometime Jan 23 – it all depends on the weather.

Myrtle's letters concerning her first visit to Egypt end here. However, she was so clearly enamored with Egypt that she would return in 1929 for a holiday, taking her Uncle Jim with her, but that is another adventure.

3

ON MY WAY!

M yrtle's next letters recount her holiday to Egypt in January and February of 1929 with her Uncle Jim. We know little about Uncle Jim beyond his mention a few times in the letters and that Myrtle has traveled with him in the past.

They traveled out to Egypt on the SS Largs Bay, a one-class ship, part of the Aberdeen & Commonwealth Line. This ship operated a service between England and Australia via the Suez Canal and Colombo. As Myrtle noted, the "one class" service did not quite extend to the assisted passage travelers!

Broome MSS15
There are all sorts of people on board but take them all round they are quite nice orderly people. Those who have assisted passages are kept together & have their meals after the other passengers but otherwise they have the use of all the public rooms etc.

Time was spent with al-Gerzawy, with Myrtle even meeting his parents. Initially they had a wonderful time, but, due to the restrictions of Ramadan, it did not end well, with Myrtle returning home bitterly disappointed.

Broome MSS17
Feb 3rd 1929.
Dear Mother.
Arrived Cairo yesterday. Gerzawy arrived here this morning before we had finished breakfast having driven 50 miles from his outpost. We went with him to visit his parents both delightful, gave us a wonderful

welcome. Then we had an Arabic lunch. After lunch we drove out to
Vicha el Kobra saw the place we are to stay at, primitive but quite
all right, then visited another relative, home to Cairo in the car. The
chauffeur has just gone & I am taking the first opportunity of writing
to you, but it can only be a brief account this time as the mail goes out
8 o'clock & it is past 7.30.

 Our plans are as follows. Visit bank & Cooks tomorrow morning,
also do necessary shopping – afternoon – repack luggage, leaving what
we do not require at Vicha here until we return, then Tuesday morn-
ing the car belonging to the Gerzawy family will fetch us & take us to
Vicha – & we start our native village life –

 On Feb 12 El G. has to go to Badary (near Qua) for two days &
we are to go with him. & perhaps see some of the Qua people. Isn't it
glorious news

 I will write a full account later.

The whole trip was a series of misunderstandings with many highs and
lows and the first of these was explained in her next letter.

Broome MSS18
Cecil House
Feb 5th 1929
Dear Mother.
I am going to try to tell you my adventures in more detail – the first
start off was nearly tragic & I did not mention it in my brief letter.

 When we arrived at Cecil House I was handed a letter from
El G. I read it in absolute amazement, he had not answered any
of my questions about how to reach his outpost but he asked
me to come in my riding clothes disguised as a man because the
people had not seen a European lady, no directions or even name
of nearest railway station. We were absolutely dumbfounded &
it sounded so strange that we decided not to go. So we went out
& wired "your conditions make visit impossible letter follows".
In about two hours time a wire came back "write me tomorrow"
we began to think the man must be mad, anyway, we went to bed
intending to go to Cooks early Monday morning to see when we
could come back home.

Sunday morning we had scarcely finished breakfast before he arrived at Cecil House – & then everything was explained. The wire should have been *wait* me tomorrow. He had answered all my questions in a letter five days before (we found it had been mislaid in the hotel). The disguise he suggested was explained thus – he misunderstood my letter telling him our plans for the day after our arrival in Cairo. I had said we must do so & so, then my uncle would like to go to see the pyramids – he thought this meant I was coming to Vicha alone & Uncle J following later, so as an English woman would be a 7 days wonder in the village he thought if I was alone it would be better for me to be in riding clothes, then the people would think I was a man & would not crowd round & stare so much.

We thought his explanation absolutely reasonable & of course apologised & said we were ready to do whatever he suggested so he said he thought it would be best for us if he took us to the outpost & let us see it for ourselves, then return to Cairo & collect out luggage & return to take up our abode in the wilds the day after. Uncle Jimmie was very taken with him – he says he is so absolutely genuine – so off we started we drove through the native quarter, stopped once to get out & see a man making braid on a native loom – such a dear old chap. He gave us quite a demonstration & was delighted at our interest, then we visited his father & mother – we did not go to the big family house which is a little way out of the town part of Cairo, but to a smaller house where the younger boys live during the school term – the parents spend Sundays (which is a holiday) at that house, our welcome was wonderful, although neither could speak English their whole manner made us feel at home, we stayed about an hour. The younger boys had gone out for a walk but all the servants came in & were presented to us & sat round the room at a respectful distance, they are treated as humble members of the same family & expected to share in such an event as a visit from an English lady & gentleman.

When we left the house we were driven to an Arab restaurant for lunch (G thought Uncle J might prefer it to a meal with the family for his first introduction to Eastern ways, wasn't that thoughtful of him).

We had some sort of hors d'ouvres (can't spell it) then a bowl of wonderful rich soup, with a couple of the front legs & hoofs of some small animal like a little pig or kid. We had to fish these out & put

them on a plate, then drink the soup with a spoon & finally tackle the legs & feet with a fork – after that we had bread soaked in honey & spread with a thick crust of cream. The cream was so thick that it was folded like an omelet – then coffee, the *real* coffee, not smell only.

Afterwards I just glanced at my hands – instantly El G. said – "You wish to wash?" he beckoned a servant & I was conducted to the lavatory etc. Then we set out for the outpost. Such a drive – right across the famous barrage across the Nile – a most lovely view. Then along earth roads – through villages along by canals, across one in one part – going over a bridge made of felled trees packed with earth – no rail or edge & not much wider than the car & a right angle turn to get on to it & so on for 50 miles. – Our first view of Vicha el Kuba showed a little group of native houses, a white mosque with a pointed minaret reflected in the waters of a large lake – close to the mosque was the police quarters a whitewashed building with green shutters – all very clean & orderly. We were taken first to see the horses – I am to have a white arab this time. El G. says he is very calm & gentle – I soon made friends with him, he is a little taller than dear old Rufus & more slender –

Then we saw the soldiers quarters – the lock up cell & the office & finally were conducted to the hotel where we are to stay. You enter a courtyard, just inside is a wide wooden bench with a mat & several decorated water coolers. Then a wooden flight of steps lead from the courtyard to the first floor which we are to share with El G. it consists of 3 rooms, his room a room for Uncle J & I to share, two beds & a tin bath & we can arrange it so as to divide it with a curtain, the other room is the kitchen & servants room. I think we shall be able to settle in quite comfortably – especially as he has had a W.C. built for our own private use so that we need not go to the one down stairs that the natives use. Can you imagine any greater consideration for our comfort? It isn't many visitors have that done for them is it? Our window looks onto the roof of the mosque & we shall be wakened in the morning by the priest calling the faithful to prayer from the minaret. On coming out we paused by the open door, the floor is covered with rush mats & in a shaft of sunlight coming in from the little square window near the roof we saw a white turbaned Arab kneeling, intoning a prayer & bending down between the sentences to touch the floor with his forehead.

We like the look of the lake. El G. has the exclusive rights for wild duck shooting – & he tells Uncle J that there are lots of fish & he can fish from a boat to his heart's content & the benefit of our supper.

Time was getting short & we wanted to be back to catch the 8 o'clock post so El G. told his driver to take us back to Cecil House, to go carefully – because if we complained & said he drove like a devil, he would place him under arrest. So we were landed safely outside our hotel after one of the most wonderful days I have ever spent.

Broome MSS19
Feb 8th 1929. Vicha el Kuba
Markaz Menîef
Dear Mother.
This morning I was awakened by the call from the minaret. The morning is too beautiful to stay asleep, so I am out on the courtyard writing & watching the sunrise.

I will try to tell you the beginning of our adventures here. We arrived the day before yesterday, we were met by Gerzawy & one of his soldiers on horse back. His relation Mahomed Effendi was there also with the car & many others. The station master invited us to coffee & then we went first to the house of Mahomed Effendi & later to Vicha, then to Mahomed Effendi's again for supper. Before supper we all went for a walk around the estate. Gerzawy shot two pigeons (for eating) with two bullets, the Omdah also took aim but his birds escaped. We were conducted over the farm & saw the buffaloes in their stables being milked, we also saw the camels, goats & donkeys. We had a very wonderful supper, I am afraid I cannot describe all the dishes, we sat at a table in a large hall & had knives & forks in the European manner. We had about 5 servants to wait on us & 3 lovely big dogs waiting for bones. We drove home in the car by star light.

Yesterday we were invited to inspect the schools. We went in to the various class rooms & heard the boys recite the Koran. Then we had to partake of coffee, crystallised fruit, Turkish delight etc. then all the boys & masters were lined up & formed into a group & I had to take their photos. I was presented with a bunch of flowers & while we were having refreshment an Arab singer entertained us with native songs unaccompanied, he had a beautiful rich voice.

In the afternoon we went to tea with the only European in the district a Greek who owns the corn mill, we saw the native women bringing the corn in baskets on their heads & taking it away after it was ground. In the garden we saw some huge things like cucumbers growing & on enquiring were told they were loofah's, they picked one & stripped the skin off so that we could see the sponge like interior.

We stayed on to supper & were pressed to spend the night also but we excused ourselves & made our adieus about 9.30. A man carried a lantern to guide us & outside the house an armed guard was waiting, 10 in all. Gerzawy explained that it was not for safety but because his rank demands it.

He has arranged our room most beautifully, in fact he has turned out of his own on our account because it is the larger. The birds fly in & out of the windows, his servant caught one this morning & I held it in my hand for a few minutes. All night a guard is on duty on the roof of this house & another outside our street door.

From our window we can look inside the mosque & see the people at prayer. This morning the man who recites the prayers, came into our room & asked Gerzawy to ask me if there was one God or two. I said only one & the man went away very pleased.

I must tell you an amusing incident on our arrival, of course all the important villagers came to meet us & they followed us up into our room & stood round watching while we unpacked, finally Gerzawy had to shoo them out so that I could change my dress.

The boy has just been in to tell me the gaffir goes to the post at 5 o'clock. I understood what he told me in Arabic & he is waiting to take the letter.

It was then that things really started to go wrong.

Broome MSS20
Cairo.
Dear Mother.
Our plans seem to be altering every day, we had a glorious time at Vicha till yesterday when El G. told us that as it was Ramadan (month of fasting) in a couple of days he was arranging for us to

spend the rest of the stay in Cairo. He was obliged to go to Shebin el Kom yesterday to receive a prize for being first in a riding competition for all officers in a certain district. So he arranged for a servant to come to Cairo with us & take us to a hotel near the station saying he would join us later, as he intended to apply to have his holiday until the end of this month. I have just had a letter from him to say he is unable to get leave to be in Cairo & as it is the month of fasting he cannot have us as guests in Vicha, because his position makes it necessary to observe the Mahomedan rules very strictly himself, although he does not believe in them. When I asked him why he had not told us before that our visit was at an unsuitable time he said it would not be polite to do so, since I had said I could not arrange to come another time, & he hoped to get leave & then he could be free to be with us in Cairo.

I cannot say how bitterly disappointed we both are, we were so enjoying being at Vicha – & now everything has got messed up. We shall find out the earliest steamer & come home.

Broome MSS21
Cairo Feb 14th 1929.
Dear Mother.
We have booked our passage on a Dutch boat (its name is something like Tjerimia) [the S.S.Tjerimai] which sails from P.Said Feb 18th & is due at Southampton Feb 28th.

Since Ramadan has so abruptly ended our stay at Vicha & El Gerzawy has been unable to get the leave he applied for, we decided to return by the first boat that pleased us. This leaves us plenty of time to see all we want to of Cairo.

The last four days we have been staying at the hotel that El Gerzawy's servant conducted us to, it is entirely Arabic. Uncle J & I shared a huge room with three beds in it, evidently for the man & his two wives. My few words of Arabic were very useful, I could make the servant understand most of the things I wanted, but when he spoke to me I was lost. One time when we were getting into an awful muddle he said "Istanna shughaiya" which means, "just a minute" & rushed off. He returned with a young Egyptian, the nephew of the hotel proprietor who could speak English. This Egyptian is a Copt & has

been very kind to us. After he had translated my conversation with
the servant he told me that his uncle wished him to say that the whole
hotel was at our service, anything we wished they would do etc. That
same day he came to our room again with a lovely bunch of flowers
for me, 10 eggs & several packets of picture postcards that he insisted
on my accepting, I am afraid I have added another Egyptian to my
list, (I think it's just as well I am coming home soon), in return for
all his kindness we invited him to supper. The next day he invited us
to tea with him, he does not live at the hotel but with another uncle
who has a flat near. His home is in Alexandria but he is studying at
the school of Engineering in Cairo. He has been to see us every day
& given our instructions to the servant. Once Uncle J happened to
mention I had enjoyed the honey at Vicha the next morning he sent
me a large pot of honey.

This afternoon he took us to visit the Hanging Church which is
a very ancient Coptic Church built on a Roman fortress, it was most
interesting.

We have moved back to Cecil House for the last four days of our
stay. We would rather have stayed at the Arabic Hotel it is about half
the price but we had left part of our luggage at Cecil House & said we
should stay a few days on our return. Also, I shall be calling to see the
Imp & he would probably have a fit if he knew we were staying in a
native hotel.

I am dreadfully disappointed at the way things have turned out.
We were having a glorious time at Vicha our only trouble was mos-
quitoes. I am afraid it is also a great disappointment to El G. He had
great hopes of getting leave for the rest of our stay, he did everything
he could for our comfort.

We are both very tired tonight, yesterday we did the Tombs
of the Caliphs & Mamlukes, today the Muski & the Bazaars. We
managed every thing without a guide & I find I can remember my
way about from last year very well. Uncle J is very delighted with
everything he has seen & he says it would have been impossible for
him without my previous knowledge & my little Arabic. I am able
to go into a native café & order a simple meal & pay the bill, but I
cannot enter into conversation. El Gerzawy was very surprised at all
I know but he did laugh at my pronunciation. He promised to give

me an examination in Arabic also in riding but unfortunately neither came off – *damn Ramadan.*

I must try to send a short note to Miss Murray now.

Once on board the ship they settled down to ship life, but Myrtle noted in a letter from the boat:

Broome MSS22
Uncle J was quite sorry to leave Egypt. He likes Cairo very much, & I think this time we have done it very thoroughly. It was very unfortunate our visit should have happened in Ramadan, even in Cairo, which is so very cosmopolitan, all museums etc. are closed at 1 o'clock every day & all along the pavements you will see the natives lying with their faces covered, trying to sleep away the hours of fasting, since they may eat only at night.

Most importantly, despite the somewhat sobering second visit to Egypt, Myrtle's interest remained undimmed. She maintained her contacts and continued to search for an overseas position. Her persistence was rewarded when she was named assistant to Amice Calverley, the director of the Archaeological Survey of the Temple of Seti I in Abydos Egypt (see Appendix). She was to assist with the recording of this great temple.

The work would introduce her to a whole new lifestyle, with new friendships, and help her develop a love of this country and its people that would influence her way of looking at the world and the different cultures within it.

Myrtle was offered the post in the summer of 1929 by the Egypt Exploration Society (EES), and Amice made a point of meeting up with her at that time before they left. It was important, due to the isolation of the location, that they were compatible and indeed they proved to be so.

On her way . . .

Her third journey to Egypt was in September of 1929 onboard the P & O ship SS Ranpura. This was an ocean liner that was traveling to Bombay and stopping off in, among other places, Port Said in Egypt. At this stage, she was still referring to Amice Calverley formally as "Miss C" in her letters and this would be the norm for the first year. As was Myrtle's way, she was always interested in the food on the ship and her fellow passengers.

Broome MSS23

Sept 27th 8.30.

Dear Mother & Father.

Had a very easy journey down. The train drew up alongside the new dock where the Ranpura was waiting, we crossed straight from the train up the gangways & on board. A steward directed me to my cabin, where the cabin steward collected my ticket. I had a wash & tidy up. Then went to the salon & had tea & chose my seat & table for the rest of the voyage. I also booked 2 seats at my table to be reserved for Miss C & her brother. After tea I went to my cabin and unpacked. I have two companions so far. One a jolly rather flighty sort of girl going to Bombay & a trained nurse who has a patient in the 1st Class. So, so far I am in clover.

Had a very nice dinner. Soup, fried plaice, lamb cutlets, Neapolitan ice & fruit & coffee.

This boat is exactly like the Ranchi. Lascar crew & everything, I feel quite at home. I am looking forward to turning into my bunk & reading with my nice little electric light just over the head. Dear little stewardess asked what my requirements were in the morning. I told her I only wanted to be left in peace till breakfast time.

Myrtle loved her time at sea; she found it all very exciting. As usual, she describes everything in great detail, and it is fascinating to get a feel for life onboard these ships. She describes the voyages with as much interest as she does her time in Egypt, and we can see how the places she visited have changed over the years. It is hard to recognize some as being the same we know today.

Broome MSS24

S.S. Ranpura

Sept 30th 1929.

Dear Mother & Father,

"A life on the ocean wave is better than going to sea". We are having a wonderful passage, glorious sunshine & sea & sky a perfect blue with just the slightest swell to let you know you are not on land. Our course now is due south. I make quite certain of this by going to the stern & looking at the north star shining directly over our wake. & I wonder how you are getting on & if you are having a look at the night before going to bed.

I am living a life of absolute luxury. The dressing bugle goes at 8 o'clock & I wander down to the bathroom & wallow in hot sea water. Then dress & have breakfast. A varied menu, today I chose kidneys & bacon & coffee of course. The milk here is real milk. They make it from fresh butter, just reverse the process.

After breakfast I walk round the deck, at 10 o'clock I go to the library to change my book & then settle in a deck chair to read till lunch. We have several things to choose from & if I have not forgotten my hanky I usually include a curry in my menu. They are gollyopytious! we have Indian stewards & everything is perfectly served. After lunch, I take my book to the topmost deck & divide my time between reading & watching the various deck games. I give tea a miss so as to enjoy my dinner more. At 7 the dressing bugle goes & dinner is 7.30. So far I have worn my black with my red shawl, but when we get into the Mediterranean I shall sport my new blue, my necklace also appears in public in the evening, it is great fun watching the various people, the things they do & what they wear. My cabin mates are very nice & we have settled down very comfortably. The nurse is a very amusing person. She has never travelled before & asks all sorts of amazing questions, one was, "do we go past Africa?" I tried to explain the course to her, but the places were only names to her she had no idea of their relation to each other. We do not see very much of her as she is on night duty.

Later

We passed C. St Vincent about 4.30 & are due at Gib 7am tomorrow. There are various signs of activity, connected with our arrival I believe. Lascars[4] squat in groups & do things with cables & various portions of ship equipment, but as far as I can see all they achieve is a semblance of being very busy. I watched four cutting a cable, one held the end, one the cable coil, one had a cutting tool & one a hammer. They were very busy about it & though I sat watching quite a time they did not make much impression on the cable. They were still at it when I came down for my bath before dressing for dinner.

4 Lascar is the term adapted by the British from the Portuguese word *Lascarim*, meaning seamen from the east of the Cape of Good Hope, which covered Indian, Malay, Chinese, and Japanese crewmen.

We have a dance band on deck every night I am just off to listen to it.

Broome MSS25
S.S. Ranpura.
Off Gibralta. Oct 1st 1929
Dear Mother & Father,
I have had a glorious day. We arrived at Gib 7 o'clock this morning, I had breakfast & took the 9.30 tender for the shore & wandered through the quaint little town, I had 2 ½ hours before the tender returned, so set off for as long a walk as the time allowed. There were glorious coloured creepers growing over the stone walls & blue plumbago everywhere. After leaving the town I met very few people, one or two peasants with donkeys laden with fruit & vegetables & several soldiers, but the other people from the boat seemed to keep in the town except those who hired cars, or the funny little horse drawn carriages. My walk led me through a quaint little Spanish town, lattice windows, peeps of tiled courtyards & quaint roofs, the roof tiles form such deep ridges & go all shades of red & yellow. Further on I came to part of the garrison & saw the hospital buildings & finally I came out onto Europa Point & could look right across the Mediterranean to the dim shapes of the Atlas Mountains. It was then time for me to retrace my steps. I was very hot & rather puffed, I had a stiff climb to the Point & had walked nearly the whole length of the rock, but it was worth it. On my return I bought a basket of figs from a little Spanish boy. The basket was a shallow one with a high handle made of split cane, it contained 2 huge fig leaves & about 25 green & purple figs. for which I paid the noble sum of 6d. Shades of Bond St. eh!!

I forgot to mention I saw an old friend at Gib you will never guess. It was the "Ranchi" anchored in the bay on her way home from the summer cruises. Ranpura lay alongside her & I could see they were twin sisters; except for the gold letters on the stern I could not tell which was which. We left the bay together & then Ranchi took a western course & we turned our focus to the East.

There are a few new faces on board also some empty places. I believe there will be a great many more passengers come on board at Marseilles.

Broome MSS26
Oct 3rd. 1929
Dear Mother & Father,
We are at Marseilles, arrived soon after one o'clock today. I have been
ashore with the lady who sits next to me at table, she is something to
do with one of the hospitals in Old Cairo. We have had several con-
versations together, she is fairly elderly but very nice & rather retiring,
so finding she was a little uncertain how to spend the time here, I
suggested we made a little expedition together, she was so delighted.
I am sure she was just longing for a companion but didn't like to be
the first to suggest it. We started off at 2.30, we had a map of the
place & made a few enquiries as to trams etc. of course we had to run
the gauntlet of taxi men, guides touts etc. but finally got on our 51
tram which took us to the centre of the town. From there we walked
along looking at shops, our object being to visit the public gardens
at the top of the town, they were worth going to see, very formal of
course but had several very wonderful fountains & some fine statues,
we wandered round one of the museums. In it there was a model of
that wonderful monument to the dead which is in the cemetery of
Pere Lachaise in Paris, do you remember the photo of it in the guide
book? I am so glad to have seen it. There were also some very quaint
little pretty figures of French peasants, & a whole village scene, with
little houses, & people looking out of the windows, windmills, bridges
over streams, herds of goats etc. all pottery. They were very amusing.
We also saw pictures, a few very good modern ones & lots of statues,
some of Rodin's etc.

 We might have seen more, but it was closing time at 4 o'clock,
so we made our way out into the gardens again & visited a small
zoo. Then we had tea & cakes. & after that another tram ride; we
had been told of a circular route that went along by the sea past
a famous bathing place at Courniche, (spelling is guesswork) so
we made our way to a certain side street where they sell flowers
& got on the tram & had a glorious ride right out of the town
along the bay, we could see the lighthouse & the Chateau d'If &
all the little islands, the rocks are white & the sea a most vivid blue,
almost purple not a bit green like the Atlantic. We returned inland
& got down at the point we started from. The ride took an hour &

our two fares came to something less than 5 francs, so it was very extravagant. Our tram back to the docks cost us 60 centimes each & we arrived back on board soon after 7 o'clock just in time to dress for dinner.

Amice Calverley

The following day was again spent in Marseilles, with Myrtle meeting up with Amice Calverley and her brother, Captain Hugh Calverley.

Hugh had been wounded in the First World War and Amice had asked the EES if he could work with them on site as a photographer. She had even offered to pay him herself if it could not be afforded by the EES. They did agree, however, to pay him a salary, and he worked with them for that first season. In Marseilles, they visited the Chateau D'If and visited the cell where Edmund Dantes had been confined.

It was an exciting day for Myrtle, culminating in attending a show with Captain Calverley. Amice had declined to join them as she was tired.

The novelty of the voyage was now starting to wear off a little for Myrtle and she found herself longing for some privacy. She still enjoyed the people, but, as she said, "there was a deadly sameness about a long voyage." She also added:

> P.S. Miss Calverley tells me there is a great speculation in the society as to which of us will marry Beazley. I tell her it won't be me because we are both B's & it's bad luck to change your name & not the letter.

Mr. Beazley was another member of the team they would meet up with in Cairo. He would prove to be a difficult character that, after a time, the women couldn't wait to see the back of.

Eventually the voyage ended, and they arrived in Port Said. All their travel arrangements were handled by Thomas Cook when in Egypt, who were on hand to meet and greet, act as a post office and banker and generally deal with any problems.

Broome MSS29
Cecil House
Cairo
Oct 10th 1929
Dear Mother & Father.

Here I am in Cairo again, we did have a hectic day yesterday, we arrived at Port Said about 11am. Cooks man met us on board & saw to the removal of our luggage.

The Director General of Customs had sent a man to deal with our luggage at the Custom House & it simply went straight through, all our heavy stuff including my trunk was registered straight on to Baliana & our suitcases etc. were put on the Cairo train. We were too late to catch the 12.15 and the next was 6.15 so we left everything in the charge of Mr Cook (who by the way was most impressed by our importance) & went along to the Eastern Telegraph Hotel for lunch. We were a little early so we sat out on the Hotel front (like French Cafe's) & watched the world go by – it was very amusing. Of course we were pestered with natives selling tourist traps, Miss C dealt with them in Arabic most effectively, they soon sheered off when they found we were not just helpless tourists, one man was very persistent, she told him quite politely to go away, we did not require anything, then to clear off, but he still persisted, so she told him to go to the Devil in very forcible Arabic – that did it, he said "all right" & went, we were amused.

Capt C. wandered off on his own after lunch & we had a tidy up & a rest in the lounge. He returned very pleased with himself & told us he had found a perfectly good tea party for us. It seems he had looked up the Padre of the English Church who he knew during the war & the Padre had invited us all to tea at 4.30. The tea party was most restful & the nice kind Padre took us to the station in his car & delivered us into the hands of the waiting Mr Cook who had reserved our compartment & put all our goods on the train. We arrived in Cairo 10.45 & were met by Miss C's aunt & uncle. Capt C went with them & Miss C & I went to Cecil House.

We had a very disturbed early morning, part of the house across the way is being rebuilt & the work men arrived at dawn & it was just babel & pandemonium – we have decided to move to Gresham House

for the rest of our stay in Cairo – Mr Beazley is staying there & he says
it is nice & peaceful.

Prior to starting work, the usual Egypt-specific jobs had to be carried
out: a visit to the consulate, the Antiquities Service to get their permits, and
the bank among them. Myrtle was introduced to Barclays Bank, as, she said,
"Cooks bank is no earthly use to me up country, they don't keep accounts &
I can only cash cheques in person so I drew out as much ready money as I
am likely to need until my first salary is paid into Barclays, when I can draw
what I want by cheque through the post."

The consulate visit was always important as they had to know where
everyone was, should any problems arise. Their passports would always be
left with the English consul.

Pleasurable visits were also made, one being to the Egyptian Museum,
where they met up with the Imp, Rex Englebach, and Battiscombe Gunn,
an Egyptologist, who like Myrtle was also a UCL alumni and had studied
hieroglyphs there under Margaret Murray.

Englebach was to be in most of Myrtle's Cairo letters. He and his wife
Nancy proved to be very good friends and she always managed to see them
at the beginning and end of a season.

Myrtle was particularly excited as they were due to have tea at the
Sporting Club, which she called "the smartest gathering place in Cairo."
Unfortunately for her, during this visit, she was, as she said, "eaten all over
the exposed parts of my legs & feet by the grandfather of mosquitoes."

The Gezira Sporting Club certainly was *the* place to be seen in Cairo
and had originally been set up as a sporting club for the exclusive use
of the British Army. It still operates today but is now open to civilian
members.

Complications arose concerning the hiring of a cook, but they were
given the loan of one for four months, and he was dispatched to the
camp with "Miss C's Nannie to prepare the house for us." Nannie was
the Syrian housekeeper who would be with the women throughout their
time at Abydos.

Meanwhile, Myrtle was caught up in a hectic social whirl and enjoying
every minute of it. She was introduced to the game of '*Pilote*,' which she
described in great detail and found thrilling. Unfortunately, her mosquito
bites continued spoiling her fun somewhat.

We arrived home about 1:30 in the morning. By that time my poor eaten feet had swollen up to a huge size. I was thankful to get my shoes off. I washed them well in very weak carbolic & wrapped them in rags soaked in the solution, it eased the awful burning itching – they are very painful this morning. I am sick about it, because I was to have spent the morning at the museum with the Imp & in the afternoon the head of the Austrian Institute [Herman Junker] was going to take us all out to the pyramids to go over his excavations there & then give us tea at Mena House. I do not think I shall be able to even get my canvas shoes on, but if I do go I shall sit in the car while the others scramble round. I think I could hobble onto the Terrace at Mena. I should hate to have to miss it all.

We had a lovely time out at the Pyramids, the car took us as far as possible then I rode a donkey the rest of the way & the others walked; Dr Junker had had a lovely tea taken out to the camp for us, iced cakes & everything, after tea, I amused myself with a pair of field glasses while the others went round the excavations, then the donkey took me to the car and the car brought me back here.

I have met a very interesting man, I think his name is Lewis [Alfred Lucas],[5] he is a famous analytical chemist. He was employed in the treating & preserving of all Tut's [Tutankhamun] things, he also works for the C.I.D. I think he will also visit us & will advise us as to the best method of restoring the colours on some of the wall decorations.

Oct 14 Today an officer of the RAF is to lunch with us he is to give us instructions & measurements so that we can lookout for a suitable landing base for one of his aeroplanes near our camp. So we may also entertain flying men, it also gives us a third line of retreat should anything happen to the railway or the Nile traffic – we are feeling important & adventurous we almost hope something will happen – it would be so thrilling to be rescued by aeroplanes – but of course nothing like that is in the least likely to happen.

5 Alfred Lucas (1867–1945) was an analytical chemist with an interest and love of Egyptology. He traveled to Egypt in 1898 after contracting tuberculosis, where he was to make a complete recovery. He gained a reputation in forensic science, assisting in many criminal investigations, and he had a fascination with the technical achievements of the ancient Egyptians.
 He was perhaps best known for the work he did assisting Howard Carter in the conservation and preservation of the objects from the tomb of Tutankhamun.

> Tonight we leave by the 9 o'clock train & with luck may be at Baliana by 8.30 in the morning.

Amice Calverley did take flying lessons herself, with the idea of flying to the camp herself; however, it is interesting to note that the EES did not encourage the idea and it was abandoned.

There seems to be a letter missing here as there is no description of the train journey or of the arrival at the camp. Considering the remoteness of the camp and the postal service at the time, we can only be grateful that as many got through as they did, but there are inevitably gaps.

The train journey from Cairo to al-Balyana took twelve hours and the camp at al-Araba al-Madfuna was a further twelve miles from al-Balyana. The "Baliana" that Myrtle refers to is known today as al-Balyana and is a small town located on the West Bank of the Nile in Sohag Governorate, Upper Egypt.

4

SETTLING IN

They soon settled into camp life and Myrtle took great delight in picking out items she knew would amuse and interest her father, such as her description of the carpenter. I will not interrupt the flow of the letters in this chapter except when necessary.

They were living in the old EES dig house. It had been a functional place to work and sleep, but now it was converted into a home. The house had been built by the archaeologist John Garstang in 1908 while he worked at Abydos, and it was later purchased by the EES (then the Egypt Exploration Fund) for £50 with all the contents. It was finally demolished in 1967, to make way for a new house built for the Pennsylvania–Yale Institute of Fine Arts expedition.

Broome MSS32
Dear Father.
I wish you could see our carpenter, he is a most beautiful person in a long white & blue striped nightie. But I am afraid his tools & his methods would make your hair stand on end, he gnaws holes in wood with a chisel that won't cut a bit of string. His pet saw for cutting up planks is like this [drawing] & his method of using it is to squat in the sand & hold the plank with his toes, then he hacks away gaily & all the unoccupied servants stand round & say Ya Allah!! & hand him the wrong things at the wrong time. He had a lovely time cutting an extra window in the mud brick wall of the tower room which I am to inhabit. The dust & dirt fell through the cracks in the floor onto the belongings of the person who lives underneath, but no one minds. If one points out such a trifle he smiles sweetly & says "What matter! the boy will clear it up".

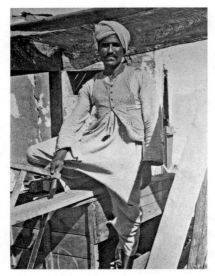

The carpenter

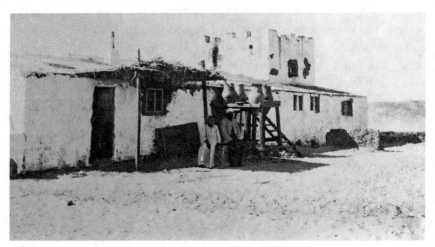

The camp house

On my return yesterday from the Temple this joyous carpenter pointed to the tower with great pride & said "See Oh Lady I have made for you two windows & praise be to God they will *both* open." To-day this carpenter is fixing corner shelves in my room, he has erected posts & cross pieces for the shelves thus. But when it came to cutting up odd bits of [drawing] plank with the correct angle to form shelves he got in a hopeless mess. Miss Calverley & I had to

go & measure up the wood & mark it out for him, he is now getting on with it.

My tower windows have two of the most perfect views one could ever wish for, one across the desert to the pink hills, the other across the Nile valley.

My leather trunk is due to arrive today, it started to come here by goods train with various other things direct from the ship ten days ago. Yesterday news came that certain boxes had arrived at Baliana station so camels were sent. Later news came to say that by the will of Allah the train had come too late for the things to be despatched that day. So today the camels set out before dawn, in the hopes that the will of Allah will be more favourable for us.

We have a small boy, the nephew of the head man who is being trained as a house servant, he is a good little boy but oh so puzzled by all the things the excellencies require to eat with. Yesterday he came running in clutching a cucumber in each little brown fist, & was promptly sent back to bring them in on a plate. His name is Abdullah.

We have lots of fresh dates; when they are first picked they are a beautiful golden colour & are as crisp as an apple, the flavour is lovely. Later on they will ferment & be like the dates we have in England. Yesterday Captain Calverley & I gave our donkeys some dates, much to the amused amazement of their owners who held up their hands & said "Ya Allah but the donkeys are indeed honoured."

Our importance is simply terrific, our servants are as the sands of the desert, of these about 5 are paid by the society. But all their friends & relations come in swarms so that they can swank in the village as having had the honour to serve their excellencies.

Yesterday in the temple a small boy came to Miss Calverley & said "Oh Lady, the noble Prince wishes to drink." She dispatched him to the engine room with a tin mug of cold tea for her brother, but he was as proud as if he were carrying the crown jewels at least.

You will wonder if I ever do any work myself. So far I have made two scale drawings of the great sandstone doors of the Temple. Later, when the photography is completed the details will be filled in by tracing direct from the negatives. [See Appendix.]

Amice at work

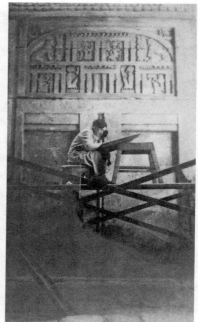

Myrtle at work

Broome MSS33
Oct 21st 1929.
Dear Mother.

We are now settling down to work. I have started near the roof &
have to climb up a huge erection which feels very wobbly but has a
good work platform, room enough for a trestle, a chair & wooden
box. Sardic our head man carries my drawing board & materials aloft
for me, & sharpens all my pencils. This is our daily programme. We
get up 5.30, breakfast 6 o'clock, we are at the temple by 7 & work
till 12, then our donkeys are brought round, & we mount & scamper
back to the house for lunch, after lunch we have an hour's rest. At
present it is still too hot to do much work in the afternoons, the heat
makes our pencils smudge.

Yesterday was Sunday, when we came in for lunch our carpen-
ter was making some new measurements so I complimented him in
my best Arabic on the way he had fitted up my room, he beamed all
over his face, & fumbled in the innermost recesses of his garments &

produced a very small loaf of bread which I had to accept & eat. He is a Copt, & this was the sacramental bread that he had brought from the church specially for me, it was quite a nice little loaf, about the size of a bun & had a lot of little crosses stamped on it.

Today we went to tea with the police officer at al-Araba al-Madfuna. He is a very young officer, rather shy & self conscious but most polite and anxious to be friendly, he gave us a very nice tea with bread, butter, jam, cheese, biscuits, melon, & grapes, & entertained us with Arabic records on his gramophone. It was quite dark when we left, our servants were waiting for us with a lantern to light us across the sand hills. It was glorious to see the stars, we learnt some of the Arabic names for them from our guards.

My mosquito boots are a source of great admiration, all the others are very envious of them, my clothes seem very suitable & comfortable.

Today all the new things for the house that we had purchased in Cairo arrived on two camels. Oh the fuss & excitement, I took a snap of the camels with their loads & attendants & then came the fun of unpacking.

All the servants & friends rushed to help & they all got in each others way. They just hauled something out dumped it down anywhere & rushed back again to see what the others had discovered – imagine the confusion. Plates & pots & pans jugs & slop pails – china for the table (& for the floor also) all over the place mixed up with mattresses & pillows & mosquito curtains & bits of packing cases, everyone talked at once, the dogs barked, the donkeys brayed, the camels grunted & poor old Nannie waved her arms & screamed directions & abuse in fluent Arabic & everyone did their various jobs according to their own ideas on the subject. We just stood aloof & watched & wondered how it was that nothing was broken except one lemon squeezer. Eventually things found their way to the proper places.

My room is now complete & I am to sleep in it for the first time tonight, it is so cosy & pretty. I will draw you a little plan of the arrangement, my table cover & curtain over the shelves are in blue & white check & I have grass mats on the floor. [drawings]

I hear there is a native rug weaver here who will be very thrilled to make me a mat out of goat's hair. I can select the wool for it, don't

you think it would be rather nice to have one specially made out here. I might see a nice hanging for the door between the studio & the library, the Bedouin tent makers weave glorious striped camel cloths, it would be a pity to miss the chance of getting things we want direct from the native craftsmen here.

The house was presided over by Sardic, who Myrtle refers to as the head man. He seemed to have been an adviser, bodyguard, and general factotum; he was always there to deal with any problems that might arise. He would accompany them on all their excursions and would also guard the house during their summer absence.

Nannie, the Syrian housekeeper, was, as is often the case, the real power in the house. She was always referred to as Nannie, and earlier Myrtle had described her as the old Nannie of Amice, but it is not really clear how she came into being. However, these two would remain while others would come and go.

Nannie in the garden

Broome MSS34
Arabah – el – Madfunah.
Oct 25th 1929.
Dear Mother.
I have had the thrill of thrills today. I rode
on a real desert camel. It happened thus
wise. When our beds and other things came
up a few days ago on camels I got my camera
out & took a snap to the great delight of the
camel man. Today some more stores came
& the camels were unloaded just when we
were ready to start for the Temple, so the
camel man asked me if I would like to ride
his camel, you may be sure I did not say no,
so the gaudiest blankets in the house were
fetched and draped over the saddles & then
I mounted one camel & Miss C the other.
The man made a hissing noise & the camel
heaved up his behind, nearly shot me over his
head, then up went his front legs & I thought
I should slide over his tail, then he set off with
his long swinging stride, it was perfectly won-
derful the easy swinging motion going up &

Sardic

down the sandhills without a sound. It was fine being able to view
the desert from such a height, when the camel broke into a trot
I really thought my spine would be jarred through my head but I
think I could soon adapt myself to the motion. The folding up of
the camel for me to dismount was also rather charming, but I am
glad to say I managed everything without loss of dignity, of course
this adventure caused huge delight among the servants, they rode
our despised donkeys & there were hoots of joy from everybody, the
final incident was almost the most delightful when the camel man
thanked us most profusely for honouring his camels by condescend-
ing to ride them.

I have received two Observers since I have been here we all
appreciate them very much, when finished for reading they do to line
shelves & keep dust off things.

Today Sheikh Abdu Wahid presented us with a charm to protect us from evil spirits, it is composed of certain chapters from the Koran beautifully written out on strips of paper & folded in a special way, this Sheikh is a very holy man & it is a great compliment, for it is very rare for a Mohamedan to give such a thing to a Christian.

Yesterday our poor little house boy Abdullah came running in screaming & crying with fright, he had been sent on an errand to the village & had delayed his return till dusk, he told us that he had seen a ghost rise out of the desert & it came towards him, he was in a great state of terror, we think he must have seen the wind lifting up a little column of sand as it does sometimes & it probably looked very weird in the half light these people are very imaginative & superstitious. They believe this place is haunted & hate to be out alone after dark.

We are having a very hot spell just now, they call it the second summer, it is not possible to work after 12, so Miss C & I get up at 5.15 & are starting work in the temple by 6.15. We rest in our rooms after lunch till 3.30 & then manage to get in an hour & a half's work before sunset. But even then it is very hot because the sand absorbs so much heat, when we get back in the evening my clothes are all wet

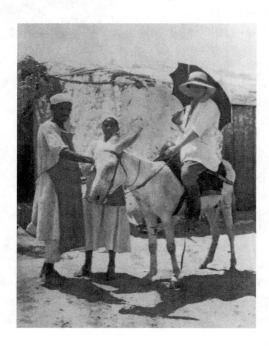

Myrtle riding a donkey

through but I don't feel in the least distressed, as soon as we get in we all have hot baths. That means that a large copper bowl big enough to sit or kneel in is placed in our room, also a large can of hot water & ditto of cold, so we are able to get a really good sponge down.

I wash my vest & stockings at the same time & put all clean things on for dinner, the things I wash are dry before bed time.

We have had a present of a live turkey from one of the guards at the Temple, this gift has caused quite a lot of discussion, because it is against camp rules to accept presents, one has to make very definite rules because the natives will bring such extraordinary things & we should get all sorts of horrid insects & unpleasantnesses about the place, also we would be bound to give a gift back & the situation would become impossible. We tried to explain this to the owner of the turkey, he is a splendid old fellow & he was dreadfully upset, it seems Miss Calverley had been very good to his family when his children were ill & as he is a very poor man he had nothing he dared offer, so he reared this turkey from the egg so that he could bring it to the camp when she returned, under those circumstances it was impossible to refuse, but it was an enormous gift for one of these people to make, it was like an English farm labourer rearing a horse to give away. Miss C is writing to the Army & Navy stores to have a blanket sent out from England for him.

We are planning to make a festival of Abu [Father] Christmas for the native children & to have a decorated tree for them. I want to make some paper toys for it, so could you enclose scraps of bright coloured stiff paper in some of your letters. I have a roll of gum paper here with me, so could make all sorts of paper toys if I had suitable paper.

Oct 26th We had the police officer to dinner, he does not go about with such an army at his heels as El Gerzawy did, but his outpost is not so important, he has not long left the military school, he speaks English very well but has to think his sentences out carefully & we have to speak slowly & distinctly. I think he enjoyed his dinner party, we had soup, roast turkey, potatoes & beans, caramel custard with watermelon & pomegranates & coffee.

Oct 27th Two gentlemen from the village called this evening & drank coffee & made polite remarks, several times, in fact in each lull in the conversation they enquired after my health & I assured

them that I was very well thanks to Allah. Miss C & I are asked to attend a ceremony which is to be held for the benefit of one of the wives. This is called a Zar & is really a ceremony for propitiating a possessing spirit.

It seems one of these ladies has got into a highly nervous & hysterical condition, so a witch doctor is called in, the women sit in a circle beating drums & swaying their bodies about, & the possessed woman gets into a sort of trance & the spirit speaks through her mouth & demands certain things to be given it, the curious thing is that the spirits are male & the voice is the gruff deep voice of a man, after the demand has been made the things are got. Then another big ceremony is arranged, the women work themselves up into this hypnotic state & the offerings are made to the spirit. This is part of the ceremony we are to witness. This splendid spirit has demanded 3 gold rings, a fish talisman, white robes & a sheep, I shall be able to tell you all about it later on, of course the men cannot go to this, we are very lucky to get the opportunity.

Oct 28th We have been keeping a doctor's shop today, at dawn this morning just as we were starting off two women arrived, a pathetic little wife of 15 with her mother & baby. This girl had a dreadful gathering on her breast, it looked as if it ought to be lanced. She said it had been bad for 10 days, probably the baby bit her & nothing was done at the time. The only thing to do was to send her to the doctor at Baliana 11 miles away, Miss Calverley wrote a note for her to take saying we were willing to do any necessary dressings according to his instructions since it would be impossible for the poor child to make the journey every day. We are rather hoping she will be sent to hospital but of course they are terrified at the idea, she nearly cried when we said she must go to the doctor for treatment.

This evening a man came with a great gash in his shin, he'd done it 5 days ago, it was a nasty cut but not inflamed or septic so we removed dust & dirt with Lysol water, put hot Borasic lint on & bound it up, he is coming again tomorrow to have fresh lint put on. These people are so pathetic they have no idea how to look after themselves, they just go on suffering & have no idea how to save themselves so much pain by a little care & common sense, it is all as Allah wills. They think English people have some special power, they can get all the Epsom

Salts they require in the village but they always come here for a dose, they say what we give them has greater power – so we dole out Epsom & get much credit there by. This sort of life is full of interest there is no chance to be dull here.

Oct 29th Our man patient arrived very early, the Lysol compress had done its work during the night & we were able to get the cut properly clean, it was a dreadful gash. The bone was exposed & the poor man had been going about with it uncovered among dust & flies for 5 days. We painted it with iodine, Miss C explained that it would burn like fire, he said it did not matter & he never turned a hair during the operation, he went off neatly bandaged with much more faith than we have that all will be well.

This is market day & our day of rest, we had breakfast at 8 instead of 5.45. Miss C & I have been washing our more delicate garments that we do not like to trust to the native washerwoman, we had tubs outside in the shade of the house & Abdullah fetched hot water for us & carried the bowls of wrung out clothes for us to hang on the line, it was a wash de lux.

I am enclosing the first lot of snaps. I am opening an account with Kodak's in Cairo & post all my films off for them to deal with.

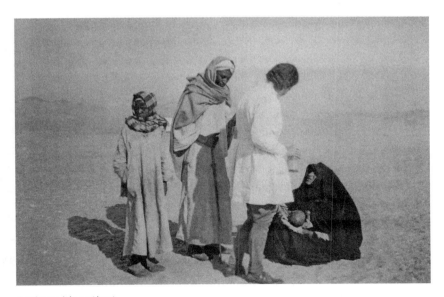

Amice with patient

This is proving the Father of all letters. There are so many exciting happenings & I want to tell you all about them, later on, when the weather is cooler we shall work longer hours & my letters will have to be shorter in consequence.

Broome MSS35
Arabah el Madfunah.
Oct 27th 1929
Dear Father,
You ought to see our desert gardens. There are two, the earth for them has had to be carried in baskets about a mile & it takes a man several hours a day to bring the water for them.

They are laid out with a perfect irrigation system like this [drawing] & are enclosed in mud walls about 14" high to keep out the sand, at the end of each little channel is a bit of pottery, the water is poured on this & flows all along the edges of the little beds. These gardens are the joy of Nannie's heart. (N. is the funny old Syrian woman who looks after us)

We are having beans & water melons & a sort of salad, some of your mustard & cress is coming up & she intends to sow some more seeds when the present crop is finished, just now we have no flowers & she was in a dreadful state of sorrow about it yesterday as we were giving a dinner party to the police officer, however she was equal to the occasion, when we sat down there was a centre piece of one of our fruit bowls filled with dried moss & stuck in the moss were *pressed* pansies & rose leaves & fern!!! We managed to contain our mirth & complemented her upon the arrangement.

My clock wakes me up every morning at 10 past 5. We have to start as early as possible as we cannot draw after 12 o'clock, the heat makes the pencils go all greasy & the paper gets smudged. Tomorrow we shall have the engine going & shall do some work in the temple at night by the electric light.

Occasionally Myrtle would write to others besides her parents, but her letters were usually passed around relatives and friends at home. One such exception was to a family friend called Eric, where she gave a synopsis of her adventures to date with this description of the views:

Broome MSS35A

The beauty of this place passes description, a great sweep of pale gold desert, rolling sand hills & distant limestone cliffs in one direction, in the other more desert fringed by a line of palm trees marking the cultivated area of the valley. Every hour of the day the colours change & morning & evening the shadows take fantastic shapes, & sunrise & sunset flood everything with rosy light.

I have seen a jackal flit by at night & have seen the footprints of wolves & hyenas. We have an armed guard stationed outside every night.

Broome MSS36

Dear Mother.

I am glad to have the photos to show the others here, they were very interested in them Nannie loved our Mulberry tree, there are lots in Syria where she comes from. Mr Beazley always steals the crossword puzzle out of my Observer & returns to his room with it, then at intervals we hear shouts, "I say, what can so & so be?" he most eagerly awaits the arrival of the next paper with the solution.

When we returned from our morning's work in the temple our patient with the gash in his leg was waiting, he is progressing most favourably, we sent him off with a dry Boracic dressing, he takes the keenest interest in all the proceedings.

In the temple we have a little tent fixed up with a sand closet & wash bowl, of course all the servants and guards watch our comings & goings, the other day Miss C. asked where I was & was informed that I was in the "house of good behaviour", I think it is the most poetic description of an unromantic necessity that I have ever heard.

*Oct 31*st We went to the temple as usual in the morning & rested all the afternoon, it is so hot that one perspires all over just lying on one's bed. When it got dusk we set off to the Temple again. Capt C got the engine working & the wires connected up & we did a couple of hours tracing by electric light, we have a projector which throws the image from the negative onto a drawing board, we trace the outline & so get the whole picture correctly spaced out very quickly.

Abdullah brought our supper down to the temple & we sat among the mighty columns & ate omelettes, bread & butter & chocolate

mould. Our white robed servants waiting on us like attendant priests, it was a weird scene. We saw a big spider scuttling out of the light so we asked Sardic what it was called in Arabic, he told us it was the "dog of the ceiling" nice name don't you think?

We have not yet heard when the Zar ceremony is to be, we hope they have not forgotten to ask us.

I had another letter from you today, it is jolly getting so many letters, all the others here have no home ties, & are surprised at my correspondence, they just hear occasionally from friends.

I am enclosing the prints that Capt C made of our camel ride. I think you will be able to recognise me on the tallest camel, Miss C is on the other, & Nannie was heaved up on a donkey so as to be in the picture, you can see Sardic holding her on, the others are some of our servants, camel men, etc., it was a great occasion.

Nov 1 Today being Mosque day Miss C gave all the men an hour off to go to the service, when they returned they said "Blessings on you Oh Lady for permitting us to go to pray". Imagine what the British workman would say if he were told to go & say his prayers.

5

ALL CREATURES
GREAT AND SMALL

Broome MSS36 contd.

Nov 3rd

Yesterday Miss C & I visited Sardic's house in the village, his buffalo has presented him with a calf so of course we had to go to see this new arrival. It is just 3 days old, very black & glossy & generally adorable, they live in the inner courtyard of the house. I wanted to take a photo, but there was rather a lot of shadow, so Sardic said he would take them outside into the sunshine; to reach the outside they had to pass through one small room & the front door. Mrs Buffalo thought we were playing a trick to deprive her of her infant, & promptly stuck in the front door, the entire Sardic family reinforced by his cousins & his sisters & his aunts all came & pushed & pulled till finally Mrs B & child were got outside. Then I took the picture, after that I had to take a picture of all the little boys & girls, squeals of delight from the crowd. I hope to send you prints soon.

After bidding a polite farewell to Mrs Sardic & relations friends & offspring we were escorted by Sardic & his small son to see the weaver at work.

I wish Father or Miss Collins could have been with me.

I have never seen a more ramshackle affair, also, I have never seen finer results, their work is really wonderful, I have already given two orders, one for a table runner & one for a curtain, but before the weaver is employed much has to be done. I have to go to the market examine all the sheep, choose one black sheep, one red sheep & one white sheep, then the owners of these fortunate animals wash the fleece *before* it is cut, then shear it & weigh it, &

you pay according to weight, then armed with your three fleeces you employ the most skilled spinners from numerous applicants, these, chiefly tiny girls, spin on wheels while tending the flocks. When all your wool is returned & you have paid the spinners, you take your yarn to the weaver & he weaves it for you for a certain price. This is the only way this special cloth can be got, they do not understand selling by the yard or metric. Consequently it has not got spoilt by tourist trade which is ruining so many of the native crafts. But to continue my description, I was unable to take a photo as the loom was in a dark corner of a tiny courtyard, so I have made a memory sketch. All the woodwork was just sticks as they are cut from the tree & all tied together with string. The reed only showed signs of more scientific construction, the warp is about 1 ft off the earth & it is tied to a post, a hole is dug to admit the pedals, & the weaver sits on a plank across the hole. I forgot to mention that one has to give the weaver a certain amount of flour with the spun wool. This he makes into a thin paste & dips the warp into it, the flour stiffens the wool & prevents it breaking, making it possible to beat it up tighter & keep the selvedge more even. When the cloth is taken off it is washed & comes out very soft & nice.

The skein winder & warping mill are of equal simple construction & look as if they were made out of odd packing cases.

I would very much like to have any photos of the Eastcote Weavery that Miss Collins can spare, also will Father collect for me samples of carded wool in bright colours, a little bit of natural fleece uncarded, also any odd length of spun wool & bits of weaving that can be spared. I would very much like to show them to the natives here.

I am going to try to send Miss Collins a hank of white spun wool some time.

You will be glad to hear all our patients are progressing favourably.

Myrtle was extremely interested in the native crafts and in future seasons would make special trips to places like Akhmim, which is noted for the quality of the weaving to this day. Myrtle took several photos of the weavers in Akhmim and I have taken similar ones in modern Akhmim. As far as the actual weaving premises and machinery are concerned, very little has changed.

Broome MSS37
Arabah el Madfunah
Nov 5th 1929
Dear Mother,

Yesterday we stayed late in the temple to work by electric light so our supper was sent to us, we choose to partake of it on the roof as there was a cool breeze & a glorious slender new moon, pale green in colour, floating in an opal sky. We clambered up ladders & over enormous blocks of limestone to the highest part, & there our attendants spread a cloth & set out cold chicken pie, fruit salad, rice & melon, you see we do ourselves really well out here.

Today we went to market. I purchased the little cap I am sending you, they are worn by the small boys, the stitching is all done by hand & it cost the enormous sum of 7 ½d,[6] they are rather quaint so I thought you might like one, if you think of anyone who might like such things let me know & I will get some more.

We visited the wool market, but shall make the actual purchases through the servants, because if it were known we wished to buy a quantity the price would go up, Miss C is having a large native blanket woven also, we shall keep the weaver fairly busy. The poor man has 9 people to feed on his earnings.

I was very pleased with the picture of the St Bernard dogs, we had great fun with it, our old water carrier Simman is called Abu Kelb (ie. Father of dogs) so we showed him the picture & asked him if he knew what they were, he said they were monkeys, another servant guessed a kind of pig. Then our little house boy got very excited & said they were elephants. They were all amazed when we said they were English dogs. Simman then said "Surely such an animal must be the king of dogs." He was delighted when I gave him the picture to keep.

We had told the people here that Nov 5th was one of the English festivals which was celebrated by lighting big bonfires. So they all got busy during the afternoon & collected all the rubbish from the packing cases. & all the old straw & shavings that were lying around, & after supper we had the father of all bonfires. & the men all danced round & threw stones in it to make the sparks fly up, it was fun.

6 Previous formatting of cents without decimalization.

Nov 6th Ahmud washed his white sheep today, he told us it took a whole cake of soap. Then he clipped it, & brought the fleece into the Temple & laid it out on the limestone floor in the sun to dry. I selected a little bit to enclose in this letter, he was very proud when I told him it was to be sent to England.

Nov 7th Old Ahmud brought his shorn sheep to the temple for us to see this morning, he had made her a jacket out of an old sack, she had the sweetest little lamb with her it was jet black with a tiny white tuft to its tail. There was also a red sheep with all its wool on, it will not be sheared until its lamb is born in a month's time. These sheep are quite tame & all sleep together in the house.

I am busy drawing in the Isis chapel of the Temple, it is about the size of our house & there are 5 of these chapels to be done as well as a courtyard & many pillars & various passages with small rooms leading off them. So we have enough to keep us busy.

The weather is delightful now, the hot spell with the horrid S wind is over, it is quite cool in the early morning, we now rise at 5.30 instead of 5.15.

Nov 10th Ahmed Ibrahim, a village elder called this evening, he came to tell us that the Zar to which we were invited cannot be held, because the lady for whose benefit the ceremony was arranged is in a worse condition, it is not a possessing spirit that has entered into her, but a wicked Jinn, in other words she is quite mad, when she gets excited she throws things about & when told of her brother's death she burst out laughing; holy men are now reading the Koran over her.

Nov 10th

Ahmud brought me a sample of the white wool spun on a spindle. I am sending a sample of it to Father, I am also enclosing the little bit of the newly cut fleece as in his letter. I think your letter is going to be rather bulky as it is.

Will you send me two calendars for 1930 size to go in envelope, I want one for my room & one for the living room.

Broome MSS38
Dear Father.
I am sending two little samples of Arabic wool, a scrap from the fleece the same morning as it was cut, & two days later a tiny skein

of the same wool spun. This was done on a spindle whorl like this. [drawing]

Miss Calverley & I are sharing this fleece between us & the weaver is going to make us each a very wide scarf, the natives wear them round their heads. I thought it would make a nice table runner at home, (I may perhaps wear it as a wrap here when the N wind blows in January.) The weavers here have a delightful way of finishing off their fringes, the idea might be useful to Miss Collins. I do not know how large this scarf will be, the weaver does not work to measurements at all, you just give him a certain weight of wool & he uses it all up – & there you are! I wanted to get a tiny scrap of the woven stuff to send to you, but it was not possible.

I am enjoying the work here very much & am getting into the way of it. I have never seen so much delicate detail in any place before, it needs most accurate & careful copying, each tiny hieroglyph is in itself a perfect picture, the wee ducks all have their wing feathers marked & the owls have their faces most carefully carved & the men & gods are wonderfully represented & their bead necklaces & pleated linen robes drive one to distraction. & as for the wigs & head-dresses!!

Broome MSS40
Nov 11th 1929. Arabah.el Madfunah.
Dear Mother.
I have been wrestling hard with Arabic today, to start with Mr Beazley wanted me to tell Sardic to buy him 2 boxes of cigarettes, 20 stamps & put correct stamps on two letters for England & take the necessary money out of 20 PT. I did my best & thanks to Sardic's intelligence it came out all correctly. Then as I was collecting my things together to return home Sheikh Abdu Wahid came to pay me a call, I managed to get through the polite greetings & reply to enquiries after my health & then I was stumped. I find I almost have to start learning all over again as the language is quite different to Cairo Arabic all q's are g's & lots of the words are very different or have different shades of meaning.

Mr Beazley has had several lessons in Arabic, but he will not attempt to speak it, Capt Calverley knows about as much as I do, he gets on very well, when Arabic fails he shouts directions in English &

waves his arms about & makes an awful commotion, but they seem to understand what he wants somehow.

To-day on our return to the temple after lunch the Capt & I had a wild donkey race, with all our escort running yelling at our heels, it was fun. These little donks gallop full tilt down the sand hills & we have to balance on their backs somehow. Of course they take their time climbing up the next rise, then away they go again when they are over the top.

After a while one accepts this wonderful climate as a matter of course, every day the skys are deep blue, sometimes flecked with little fleecy clouds, always the sun is shining, & now the fresh north wind blowing over the hot sand makes the atmosphere wonderfully invigorating.

Everyday is perfect yet everyday is different. Sometimes the outlines are clear cut & sparkling, another time the distance is veiled in an opal haze, the pink limestone cliffs change their colours every hour, & the desert sand varies in hue from the palest suggestion to mauve to deep orange.

On our way home midday, we passed a gentleman taking a hot sand bath. all one could see was a mound of sand with a brown head sticking out at one end & two brown feet the other end, it seems to be the native cure for all aches & pains, our old Nannie believes in it firmly, when she gets a twinge of rheumatics off she goes with a sunshade to protect her head & wearing an ancient dressing gown & gets the old water carrier to dig her in. We are all thinking of donning bathing dresses one hot day & all having sand baths there is something very wonderful about the feel of hot sand on ones flesh. If we do it I shall try to get a snapshot.

Nov 17th More struggles with Arabic, I had to have my high scaffold taken down, part rebuilt in the same place & the other part set up in another chapel, there was half an hours pandemonium but finally all was done as I wanted & I settled down to work again. Then Sardic came with a telegram & form to be filled in by the addressee it was addressed to Calverley, I enquired where the Capt was, the man said he was at the house, so I instructed the messenger to deliver it to him. I hoped that would be the end of it, but oh dear no, in about an hours time the answer was brought to me by the small house boy. I told Sardic to have the messenger take it to the Telegraph office (11 miles

away). Sardic said it was not possible because the writing was not on the proper paper. I asked where the proper forms were, & he told me they were in the cupboard of the store room that I had the key of, can you imagine the difficulty I had to make this all out, with Sardic, the house boy & the messenger all talking at me at once. When I did understand I had the donkey brought round at once, galloped to the house, got the forms, wrote the answer & sent the man off with it. This telegram was from friends of Miss Calverley's she had asked them to visit us on their way from Luxor. The wire was to ask if Tuesday would be convenient, she will be here Monday morning so we sent the answer to say we would be delighted to see them.

Nov 18th Miss Calverley has returned & I am very glad to hand the directorship back [to] her, its no joke keeping a crowd of natives busy with such a limited vocabulary. Our two men were not a bit of help they took an unholy joy in my difficulties,

The new batch of photos have come from Kodak, I am enclosing them with this, some of them are really beautiful, I may use them sometime for sketches so keep them carefully as the negatives may deteoriate (can't spell it) in this climate. I may not have much time for writing the next few days as there will be two guests to help entertain in my spare time, so I will seal this up now & put it in our post box. The mail comes in tomorrow & Sardic goes to meet the postman with our out going post & collects the incoming one.

Broome MSS39
Arabah.el Madfunah.
Nov 14th 1929.
Dear Mother.
Your letter of the 7th arrived to-day, it must have just caught an overland mail.

Just at present I am in charge of the camp. Miss C. has gone to Sohag to pay a state call on the Mudir, the head official of this province, it is diplomatic to be on friendly terms with the Powers that be, after the call, she is going on to Cairo, there are several things that need seeing to personally, she will be away 3 or 4 days. Before leaving she gave me the key of the store room & medicine cupboard also James, the automatic revolver was handed over into my keeping, she

will not trust the men with either. I have to give all directions to the men, (Nannie helps me with the Arabic) & boss round generally.

Of course the first day of my directorship a letter in badly written French & Arabic was delivered with our mail, we could none of us make the address out so I sent it round to the police station, they may read the Arabic & find the right owner. I am hoping it won't turn up here again.

Nothing very exciting has happened the last few days. We have been working steadily and our patients are off our hands now. The gash in the man's leg is healing over, we have given him a supply of ointment & bandages & dismissed him. We found out by enquiry that the poor little wife did not go to the doctor at all, so we had her round again, the ulcer had broken so we got it properly cleaned out with Lysol solution & sent her off with a bottle for future cleansing & a supply of dressings, we hear that all is going well. If these people succeed in growing to maturity they are pretty healthy, (only the fit survive) all one has to do is to insist on constant cleansings, & keeping the places covered so the flies cannot infect, or lay eggs & then nature does the rest very quickly.

Nov 15ᵗʰ This is Mosque day. so at 11.15 I sent Sardic off to say his prayers. he seemed delighted that I should remember to give him permission at the correct time.

We are having local oranges & mandarins now as well as melons & dates & grapes. I have a glass of freshly squeezed orange every morning to start my breakfast, then a huge slice of melon & a cup of coffee.

The paper you sent will do very nicely. I shall start making toys in the evenings now.

In the list of fruits I forgot to mention that we are having sweet potatoes, these are lovely, the flavour is rather like chestnuts they are long like a carrot but the skin & consistency is like an ordinary potato.

Arabah el Madfunah.

This is an ant blowing his trumpet (a flower) and below, this is the trumpet blowing the ant. This is the trumpet (the wind took it and bowled the ant right over).

6

MAD DOGS AND ENGLISHMEN

Broome MSS41

Nov 20th 1929

Dear Father,

It was jolly getting such a long letter from you, I loved hearing all about the caravan in red picked out with blue, or vice versa & the lady (colour not mentioned). All the exciting things seem to happen when I am away, still I mustn't grumble, I'm finding life full of excitements just now.

The big bundle of paper arrived safely also the envelope, the contents will help towards decorating the Xmas tree splendidly. Nannie was so delighted with the forget me not seeds, she went straight away & pulled something up to make room to plant them, we have had the cress & mustard, & the lettuces will soon be ready. When I first described the gardens to you I am afraid I very much underestimated the size, the immensity of the desert makes everything else appear very tiny, now that my eyes have got used to the proportions I realize they are much larger than I first thought.

I am so glad the lavender water was a nice surprise I was very much torn in two about it, I did so want to have the fun of giving you your birthday present before I left home, & at the same time I didn't like to think of there being a blank when the day really came so I compromised by giving you the jade first and leaving Yardley's with Mother.

It was lucky the letter arrived in time also, so far the mail seems very good. The natives simply love my letters with the big address they always recognise them & bring them straight to me, they feel they can really understand English writing.

Today Ahmud brought about 1/3 of the white fleece all beautifully spun, it is all as fine & even as the sample I posted to you a week or so ago the texture seems harsher than English wool but when woven it makes a beautiful supple cloth which does not pull or ravel. If I could procure a pound or so of this spun wool would it be any use to Miss Collins, the red brown sheep here is a lovely colour, (like a bay horse in shade) the wool is slightly coarse in texture & I believe less expensive The black is the coarsest & cheapest. I do not yet know the cost of the spun wool, but in time I shall find out all the details.

The rugs they make in the village are not heavy enough for what we want. They are woven rugs not pile rugs, I will see what I can do in Cairo I believe old Hammadans & Bokhara's are very scarce now. I am having a hanging made for the door between the studio & library, the weaver is to do the usual native pattern in the 3 natural shades of wool, it will be nice & heavy & I believe draught proof. The method of weaving is like this [drawing] wasp threads [arrow] it is rather like basket work pattern but is beaten up very tightly.

Nov 22nd We had a glorious day yesterday. Miss C's friends Mrs & Miss Firth came, so we took the afternoon off & had a picnic up one of the wady's. We told the men that we should require two to carry the tea & the gun, (we never go far in the desert without a weapon because of wolves & wild cats) but they all came, five men & three donkeys, we preferred to walk, so the donks trotted along with us just as dogs would.

We walked about 1 ½ miles along slightly undulating sand & then we came to the glorious pink cliffs, the wady is a natural break in these cliffs forming a long winding trail that finally leads to the top. Imagine blue sky, pink cliffs shading to mauve in the distance & golden sand sprinkled with silver dust.

The tops of these cliffs are white alabaster & the wind blows the white dust onto the sand drifts. We wound our way up & up until we came to a part where a great bank of sand led up to the very top. The servants donks & Mrs Firth, & Mr Beazley remained there while the four of us attempted the climb.

It was like a sand glacier, we had to go on all fours & kept slipping back, but after a violent struggle we got to the top. It was worth it, the

view was simply immense, range after range of hills with great sand drifts between, these hills are crowned with rocks of alabaster & on top are all silver & gold.

We did not take so long coming down, we chose a still steeper slope it was simply terrifying to approach the edge it seemed to fall away the angle was the angle of rest for sand, we sort of flopped & slid down all yelling with the joy of it. When we reached the level we found tea ready, our men had made a camp fire & boiled the kettle. Dusk came on before we had quite finished & the camp fire with the shadowy forms of our Arabs & the donkeys all grouped together among the sand drifts made an unforgettable picture (like the one of Mrs Bruntons only a little more light from the afterglow of the sunset.)

We came home by starlight, & weren't we just glad of hot baths & clean undies when we got in.

Today we had another excitement, Miss C & I were returning to lunch on our donks with Sardic Ahmud, & Ahmed Abdu Sellam, we heard our dog barking violently, (he was chained), & when we came in sight of the house we saw a wolf like creature running round in a strange sort of way, it didn't seem like a dog & yet the colour was too light for a wolf, our three men were off like a shot, galabias tucked up all shouting at once, the animal made off, still running in circles or to & fro. They all got out of sight over the next sand hills, then we heard two bangs, we left our donks at the house & scrambled after the hunt, we found Sardic had shot the creature it proved to be a mad dog, it was very gaunt & its mouth was all dribbling & foaming.

It was a beautifully clean shot through the head, & a very lucky thing too, these half wild dogs often do go rabid & cause a lot of trouble, (another reason for carrying a gun).

When we got back to the house we looked our own dog over well to make sure he had not been bitten but he was all right, we have to keep him chained as they are poisoning a lot of dogs in the village on account of rabies. (It is a cruel country in spite of all its beauty.)

Same day later Just heard some exciting news. Because the mad dog had been round our dwelling & because one of us caused its soul to be torn from its body all who saw it are in danger of being entered in by the evil spirit (in such a case our servants are one of us, we

provide them with the means of living therefore they are like blood relations). In order to avert this dreadful thing the priest is coming tomorrow to read prayers over us, & we are all to eat bread that he has blessed, even our own dog will be included in this ceremony, also the donkeys we were riding.

This evening the Omdah called, Miss C was staying on later in the temple so I had to receive him, I am afraid my conversation was limited but Nannie filled in the gaps.

I have heard that Turkish delight is pure grape juice sweetened with honey & boiled & boiled until it becomes a thick glutinous mass.

Nov 24

We had the ceremony to protect us from the evil spirit that possessed the mad dog. I will try to remember the ritual. First the priest was provided with a mat & a stool, on the stool he placed 7 loaves of bread (like pancakes) & 7 dates & a tiny cup of oil, beside the stool was a water jar, then, when we had all gathered round & our own dog was brought into the circle, he began to read from a book.

There was a certain holy man who had been bitten by a mad dog, & he was seized by a great fear, but he prayed to God for deliverance & the evil was averted, it was this prayer the priest read out. Then he took a stick & struck each of us lightly on the head saying, "Depart oh fear." Then three small boys who came with him walked round us 7 times one way & 7 times the other chanting some ritual. They stopped before the priest & he said to the first boy, What do you want my son & the boy replied "Oh Master I crave deliverance from evil," Then the priest took the 7 loaves consecrated them with the holy oil, & he offered the bread to the boy, who barked & bit savagely at it, & then spat out the mouthful. Then he did the same with all the dates. The evil spirit was supposed to pass into the food which, being blessed had the power to destroy it. Each of the three boys repeated the ceremony. Then the priest poured oil into the water jar & sprinkled everyone in turn while the 3 boys ran round barking & snapping at each of us in turn, This was to entice the evil spirits to come out of us so that the holy water might destroy them.

It was a most impressive ceremony & it was really delightful to see how anxious our servants were that our dog should get the full benefit of it. Sardic sat hugging him, & implored the priest to hit him

well with the stick, & half drench him with holy water. They have great faith in its effectiveness.

We gave the priest coffee & his 3 boys sweet biscuits, we also (Miss C & I) gave him PT10 (2/-) each for charity, & a fine red silk handkerchief to wrap the holy book in. Miss C has made notes, & we are going to write it up carefully because as far as we know such a thing has never been published in any works on Modern Egyptian magic. We should never have heard of it if it hadn't been for the mad dog being killed outside our house by one of our servants.

Will you keep this account handy in case I want to refer to it when I come home.

Broome MSS42
Arabah el Madfunah. Nov 25th 1929
Dear Mother.
I posted Father's letter this morning. so now I'm going to answer yours, I was so pleased with all the enclosures, & have started to make little purses out of the scraps of silk & ribbon.

We saw a most interesting sight this evening. One of the great camel droves have made their encampment quite close to our house. There are 200 camels resting on their long trek from the South to Cairo, we walked out to see them after dinner, it was a picturesque sight, the men were gathered round their camp fire cooking their food & the camels were lying all around them, the head man came & talked to us & showed us the fine white riding camels that one reads about in novels, they are very fine looking beasts & their coats are short & beautifully smooth like a white pony. The camel men invited us to take coffee but we excused ourselves & thanked them for their courtesy, we did not dare think of the probable state of their cooking pots.

I am just off to bed, tomorrow is market day, our day of rest, we have planned a picnic I hope to describe it to you later on.

Nov 26th Today we packed our lunch & our tea in two big baskets, loaded the donkeys & set off for the day, there were Miss C & myself & Mr Beazley, Sardic, Ahmed Abdu Sellam, Mahmud & Abdullah & three donkeys, named "The Black", "The Steam Engine" & the "Father of Tiredness". Their names are of course in Arabic & are very descriptive.

We walked across the level desert to the cliffs, & clambered up one of the big passes. we had our lunch before the steep ascent & left two of the men to look after the donkeys & started the stiff climb up the cliff. near the top we found an ancient stone quarry, when we went in, we disturbed hundreds of bats, we were able to go quite a way back into the limestone cliff & could see how the great blocks were hacked out. After leaving the quarry we continued our upward climb till we reached the top & could see the high desert with its outcrops of rock & great sand drifts stretching away as far as the eye could see.

We came down from the heights by one of the great sand drifts, it's a gorgeous feeling taking great strides & then sitting & sliding in an avalanche of yellow sand. We had tea [at] the foot of the cliffs, then being weary we mounted the donks & rode home, our journey covered about 8 miles, part of it very stiff climbing so am feeling nicely exercised.

We would very much like some Crossword Puzzles from the DT [Daily Telegraph]. (also solutions of same.)

I have enjoyed looking at the L.H.J. [Ladies Home Journal] but have no time for reading the stories, I seem to be letter writing all the time I have to myself. My evenings are rather full as I am teaching Mr Beazley hieroglyphs, he does not know them at all & consequently is very hampered in his work as a lot of the ceiling designs that he has to copy have bands of inscriptions on them.

I posted a very fat letter to Father two days ago, Sardic nearly had a fit when he saw me stick on 4 stamps. I hope the letter arrives safely as it contains an account of a very curious ceremony.

Our men killed a lovely little snake outside the house to-day, we have put it in a bottle of spirits & hope to get it identified some day.

Broome MSS43
Nov 29th 1929.
Arabah-el Madfunah.
Dear Mother.
Fancy the customs fussing about the enclosure in your letter, I expect you will be surprised to see it is only a little childs cap. I was advised not to send the skein of wool unless specially required, as the postage would be more than the cost of the wool & might never reach you, so

shall save all such things to pack in my trunk. I couldn't resist sending the little cap I thought it would amuse you. (The cap cost 7½.d the postage 1/-).

All your enclosures have arrived safely & I have had no trouble with them, we are using the pencil protectors. I showed Ahmud the samples of wool, & did my best to explain how it was spun, I said the cloth was used for English clothes for cold weather. He examined them all carefully then went off & fetched a hank of wool spun to a similar thickness of thread, & told me that the Arabs only used such wool for blankets, I think the colours pleased him very much.

Today we had tea with our little police officer it was laid out in the garden among the banana trees, we had Cairo bread, jam & cream, biscuits & apples, it was all very nice, we talked village gossip about the Omdah's & their various familys & the gaffirs etc.

I wrote my first Egyptian cheque yesterday for Dr Brown, the mosquito bites cost me 50 piastres (10/6).

I am wearing your kasha coat early morning & evening, it looks so nice & is just the right warmth.

We had the first batch of Cook's Tourists in the Temple this morning, they were a mixed lot I expect we shall have them once a week now.

I am sending you some more snaps, we developed & printed them here. I had taken some in the evening & didn't expect very good results, so it seemed hardly worth paying the high cost of postage to send them up to Cairo.

I shall soon have to start my Xmas letters.

We are expecting Mr Lucas to visit us next week, he is the chemical expert who preserved all Tut's things, we met him at Gresham House. I think he will be a very jolly guest, we want his advice about cleaning some of the painted reliefs in the Temple.

Will you ask Father to get me a sheet of Flour Sand Paper & cut it into sizes convenient to enclose in letters, we use little scraps of it to keep a very sharp point to our pencils, I still have some to go on with so there is no hurry.

I hope to hear better news of Mr Childs, please thank Mrs Childs for her little note, I am glad you read them all my news, I expect they think I am living a funny life among very strange people.

Broome MSS44
Dec 4th 1929.
Arabah el Madfunah.
Dear Mother.
Another nice long letter from you, we get the English mail Tuesdays
& Thursdays & I do look forward to those days.

I will first answer your questions. Yes I have had the silver tissue
& the packet of seeds, the envelope was open at one end, but whether
by chance or by post office inspection I do not know, the contents
were safe anyhow. I think I sent you a message in one of Father's let-
ters to say I had received the packet, also pencil protectors, but the
letter may not have reached you yet, I have also had two other lots of
ribbons & scraps which I have made up into little gay bags.

The silk stockings sound very tempting & everything else has
come safely so far & I would love to have them of course. We do try to
make ourselves look nice for our evening meal, I always put on one of
my pretty frocks (not my two evening ones of course). As to camp litera-
ture we are really over supplied. We have about 50 cheap edition novels,
presented by various visitors & contributed to by ourselves, we have
Illustrated London News, Overseas Daily Mail, Punch, Spectator & my
Observer & barely time to do more than skim through any of them, life
here is too full of live interest to leave any time for reading, also our eyes
are a little weary after a day's steady drawing, so we thank you for the
kind thought, but will be content with the weekly paper & the L.H.J.

Mr Lucas is here for 5 days, he is a nice man it is an awful feather
in our cap to get him out here as he is quite a famous analytical chem-
ist, he has worked a lot for the C.I.D & has helped detect a number
of criminals, he is now finishing his work on preserving all Tuts stuff.

Today after our mornings work when we had had lunch in the
Temple we went across the desert to some old remains of excavations
& he told us all sorts of things about the various chips of stones, pots
etc. that we picked up. By the way, my Observer came at lunch &
when I opened it the bundle of D.T Crosswords fell out & there were
hoots of joy from both Beazley & Mr Lucas, they are both enthusiastic
about them, they have been busy with them ever since dinner.

Tomorrow Mr Lucas is going to experiment in cleaning the
painted surfaces of the Temple we have found him bowls for different

solutions, various old brushes, sponges rags etc., he is going to have a glorious time.

We have been having an awful bother with Ahmud Abdu Sellam, he's the one whose sheep provided the wool that is being spun for us. We want to pay him, & he says no, he is happy, & his sheep is happy for us to have the wool & that is enough. We know the dear old boy cannot afford it, he needs all the money he can get to keep himself & his family through the summer when there is no regular employment so we were in an awful fix, at last Miss C hit on a splendid plan. She told him that we would be delighted to accept the gift with our right hands, but our left hands must offer the correct price, but since the right hand knows not what the left does this will not matter nor will it make it any less a gift. Ahmud agreed to this, the subtle reasoning appealed to his oriental mind, & his pride is not hurt. We have the wool, he has a sum of money & we all agree that there is no connection between the two & everyone is satisfied.

My Arabic progresses very slowly. I can give the necessary directions about ladders, pencils & all requirements for my work, fetchings & carryings etc. But I get stumped in ordinary conversation & I hate to keep asking, what did he say? all the time. I pick up bits here & there, & am learning names of things but I am not at all quick at it.

I am glad to have the photos of the weaving & will take great care of them.

Thurs Dec 5 I am so glad to hear you enjoy my letters & photos & that they arrive fairly regularly. I have tried to write every day, but of course can only post when the man is going in to meet the incoming mail. Just now I have very little time, as we have lunch sent to us in the Temple, we leave here about 6.45 AM & return about 5.45 PM. Then we have hot baths, change for dinner at 7. & go to bed at 9 o'clock. between dinner & bed I am giving Mr Beazley lessons in hieroglyphs, so I have to scribble my letters while I am waiting for my bath as now, or write in my room by candle light before turning in as I did last night. I shall have to write to Miss Murray & several others for Xmas, (I have already written to Uncle Jim & to Buffles) so for the next week or so my letters may be rather snappy compared to the former volumes but I will do my best to send regularly, as I know how much pleasure your regular letters give me.

I expect by now you know that I have had all your enclosures, it really takes quite a long time to get a reply back, (it is about a month since I sent your little cap).

Broome MSS45
Arabah el Madfunah, Baliana, Upper Egypt
Dec 8th 1929.
Dear Father.
I think it is your turn for a letter, though Mother is such a splendid correspondent that I find I cannot keep pace with her.

We all enjoyed Mr Lucas' visit so much & were quite sad to say good-bye to him today. He seemed to enjoy himself trying all sorts of methods of getting the layer of dirt off the walls without removing the paint underneath, some of my fine sand paper came in useful in parts.

We had the spinner round here the other day so I made a careful drawing of his whorl for you to see this is the top [drawing] the thread goes in one of the notches & through the hook when it is spinning.

This is the side view. The little piece of pulled wool is twisted onto a cleft stick which is held in one hand while they play out the thread. This is done very quickly, the finest work is done by men.

I am going to try to get the wool you sent me spun by one of the natives I do not think they like our wool very much, they say it is too soft to wear well & would not keep out the wind or the sand.

The white wool for my scarf is all spun & I have paid 26 piastres for it (5/6).

Now it has to go to the weaver & I shall have to pay him for his share of the work separately.

Sardic's donkey caused a lot of fun this morning, he brought it round the house for its drink of water as usual, he just leads it by putting his arm round its neck, no halter or neck rope. But today the donk didn't want to return to his stable, he broke away from Sardic & galloped round & round kicking up his heels & baying at the top of his voice. Sardic tried to coax him with melon peel, but donk wasn't having any, he jumped about like a young goat & finally all our domestic staff had to turn out to catch him.

We have hospital parade most mornings, the people here get horrid boils, we usually give them a good dose of Epsom, Lysol water

to wash in, & hot Borasic fomentations, & trust in Allah. This morning a man brought a small boy with his poor little nose swollen twice its size & bright red. It was rather a problem, it might be a sting, but more probably a boil, so we gave the usual prescription with modifications & a little zinc ointment.

We have had several old ladies come & ask us to make them young again, we are sorry to have to shake their faith in our skill. We can only recommend them to Allah.

Two nights ago one of our men got bitten by a scorpion, of course he was terrified & thought he was going to die, but it was more shock than anything, he only stayed away from work half a day.

7

MERRY CHRISTMAS

Broome MSS46

Dear Mother & Father,

A Happy Xmas to you both. I am sending you each one of my Xmas Cards, you will probably recognise the subject. I have made a number with great success, I spent nearly all last market day (our rest day) doing them so as to have them ready for the English mail.

I have purchased four more of those jolly little caps, I shall keep them & bring them with me, I have also bought 4 little bead bracelets that the brides here wear, they make jolly serviette rings, we each use one for that purpose here, our house boy recognises each by its different pattern & never makes a mistake over them.

Such a sad thing happened today, one of the temple guards dog was poisoned & died before we could do anything for it. The poor old man nearly wept, he said he would not have been more distressed if it had been one of his children, he said his only consolation, Praise be To Allah was that the dog died very quickly. We do not know how it got the poison, it might possibly have been given it out of spite such things are done here, or the police may have put out poisoned meat for a rabid dog, & this dog got hold of a bit, anyway we are very sad for Mahomed, it was a well trained watch dog, no one but its master or any of his family dared to touch it. It guarded the engine room every night, now since the dog is dead & a trained dog is not easy to get, the old man will have to sleep near the engine room, & we have to provide him with shelter, it is rather a problem. He must be near enough to be roused if anyone attempted to enter, but not too near for his little fire to be a danger on account of the petrol. All this is causing great discussion.

Miss Calverley has been making Xmas cards too, she sends you one of hers with best wishes for Xmas. She makes stamps out of rubber they really are very effective, I love the string of camels, one can hardly believe they are all made with one stamp.

Broome MSS47
Dec 15th 1929.
Dear Mother,
Another letter with silk scraps arrived this week, also the L.H.J. & Observer as usual. Mr Beazley is very pleased with the extra Crossword Puzzles, though he always blames me when he cannot solve them.

On Friday we had some people from Nag Hammadi to visit us they came to lunch, unfortunately Nannie was in bed with a bad cold, so Miss C & I had to leave our work early & see to the laying of the table, making salad etc. we are having the lettuces & the cress from my seed, they are very good.

Yesterday we went with Sardic & Ahmud to visit the weaver again to talk about the wool he is to weave for us. Our way from the Temple led through the cultivation & as we went we saw them filling the little channels with water with the shadoof, we saw a young lady camel tethered in one of the fields, when she saw us she made wonderful burbling noises like a big cauldron bubbling over, Sardic said it was because she was happy, so he made burbling noises too, & went & kissed her on the nose, it looked so jolly that I took a snapshot of him in the act, I hope it comes out well, I find most Arabs are fond of animals.

The weaver was very pleased to see us, we showed him all the Eastcote snaps & the samples of wool he examined everything very carefully, he says their wool is not like ours, the colours pleased him very much, he worked his own skein winder so that I could take a photo of it, I also photoed the loom, but the light was so dim under the shelter that I do not know if it will be a success.

Today we had a sand storm, the hills & the sun were completely blocked out, yet we did not feel the sand blowing against us with any great force. The wind seemed to lift it up high above our heads but it was very cold in the Temple, I was glad to have my tweed coat over my knees.

We have our lunch brought down to the temple now & afterwards go for a short walk, or find a convenient sand hill & take a sun

bath, when we came home to lunch I always occupied the rest time in scribbling an account of my doings day by day up in my tower room, now I have to do my letter writing in our general room after the evening meal & I find it very difficult to give you a good account of things when the others are talking & occasionally drawing me into the conversation.

Our Xmas turkey was brought into the Temple today, he was a fine fellow & strutted round proudly, he cost 55 PT. (11/-) I think we shall have a great time, we are ordering a whole sheep to be killed to make a feast for our servants, they are already talking about the great day.

I have finished writing my Xmas letters for England, & must now think of my friends in Egypt. I wrote to El Gerzawy for his birthday Dec 8th but have not heard from him.

Broome MSS48
Arabah-el Madfunah. Dec 16th 1929.
Dear Mother.
We are having a real sandstorm to-day, we have to stay in the house & keep the doors & windows shut as tight as they will shut. Outside nothing is visible but driving sand, all the scenery is blotted out like in a sea mist. We are settling down to do various odd jobs, Miss C is making a case to carry one of the cameras, I am writing letters & afterwards shall do some mending, & probably make some more fancy boxes etc. for the Xmas tree.

Yesterday we walked along the outskirts of the village past the place where the potter makes his pots. there were rows of new clay pots laid out to dry before baking, we had a look at his oven it is just made of earth bricks build in a circle with a hole to put the fire in, over the fire is a clay plate with holes in it, the pots are piled on top of this, & the oven roofed over when ready for baking. The wheel he makes his pots on is a very simple affair he works it with his feet sitting on a plank over a hole in the ground

Dec 17th
My efforts at letter writing yesterday were cut short in their prime, first Miss C asked me to make a little case out of an old kid glove for a special lens, & then Capt C asked to mount a big map on linen, both jobs in my line, I am quite the general handyman here.

To-day the storm had blown itself out, so the Temple was swept & we continued our work. In our rest hour after lunch Miss C & I went for a walk across the desert looking for an extra nice patch of fine sand to lie on & take a sun bath, our investigations led us to a strange looking hole, & instantly our body snatching instincts were roused & we set to work like a couple of terriers, our excavations laid bare a portion of mud wall, but as further haphazard digging was impossible we built a big cairn of stones to mark the place & retraced our steps. When we had finished work for the day we took old Ahmud with us & showed him our hole, he has been employed on all the excavations round here ever since he was big enough to carry a basket of sand. He got very excited & said there was a man down there, & his head was in a certain direction etc. etc. From his description he evidently recognised a Roman burial, of course such burials are too common to be worth opening up, but old Ahmud warmed up to his pet subject & told us tales of strange painted figures to be found here, buried with pots of date stones & grains of corn. These are probably figures of Osiris buried with the chief produce of the country in order to increase the productive powers of the earth. The old boy says he knows where more are to be found after two days digging, so we are thinking of writing to the antiquities dept to apply for a permit.

Dec 18th I had a letter from you & one from Father today, with sandpaper, pencil protectors, calendars, etc. I think I have enough calendars, one for my room, one for the dining room, one for my pocket, one I have given to Miss C & an extra one.

Dr Gardiner[7] has written to say he is sending us a hamper from Fortnum & Masons, we shall have a feed at Xmas, we are having lots of good things sent up from Cairo as well.

Poor Sardic has the flu, he is reduced to a miserable bundle in a blanket, he is also in great distress because his "Excellent Lady" insists on his keeping a recumbent position when she condescends to visit him, this is a very terrible breach of good manners for a dignified Arab. He is being dosed with cinnamon, aspirin etc. & fed on meat broth. As it is quite impossible to prevent all his friends visiting him

7 Sir Alan Gardiner (1879–1963) was the editor of the first three volumes of *The Temple of King Sethos I at Abydos*. He was very prolific in his writings, with the most famous work being his *Egyptian Grammar* published in 1927 and still referred to today.

to condole with him in his affliction, we have given all the servants a strong dose of cinnamon, there were great rejoicings, our little house boy Abdullah attracted by the smell & the big lump of sugar that was in his cup, swallowed the dose in one gulp! He just gasped Ya Allah! & fled hand on mouth amid hoots of joy from all the others.

Dec 19th Today we went with Sheikh Abdu Wahid to visit his farm, the people who can afford it rent a portion of the fertile part of the valley where they grow clover to feed cattle, also wheat, barley, beans, lentils etc., they build shelters of the thick straw stalks & live out there with their families when the inundation has gone down. We saw Mrs Abdu Wahid, Mahomed & Fatima the son & daughter, they showed us the clay oven where the bread was baked, the cheeses made in tiny baskets & put in a big bowl to drain, the butter, & the dried goat skin in which they make the butter, also the buffalo milk in the pans with the thick blanket of cream on top, the cream was over an inch thick & ever so slightly sour, the Sheikh sat on the ground & held a bowl & we were given spoons & invited to help ourselves, the spoons were like soup spoons. I thought of Father & wished he could have had such an opportunity I am afraid our abilities in that direction fall rather short of the Sheikh's expectations.

Sardic is better, but now Semman our water carrier has the flu, I expect they will all have it one after another if one is ill, all the others herd in with him in order to keep out the angel of death, a kindly custom but rather unhygienic.

Dec 20th Today we had the Director General of Customs his wife & son & daughter to lunch, they were on their way to Luxor in their private motor launch they tied up at Baliana & came on here to spend the day, they are such nice jolly people, we all enjoyed their visit very much.

I had intended to send this letter off by tomorrow's mail, but we hear that as tomorrow is election day there will be no post at all, as there is no post the following day either I am afraid there will be rather a gap between this & the previous letter, I had a lovely home mail to-day your letter, with the fine red bell, silver tinsel & pink shoulder strap ribbon came, all contents very acceptable, the envelope had been opened & not sealed again it was fortunate the contents arrived intact. They did not change any duty.

Sardic is better & back to work again, he has appeared in a glorious daffodil yellow satin galabia with maroon stripes, we think this must be to celebrate his recovery, he said the medicine was very good & potent.

Dec 21ˢᵗ This is election day, round here everything is very quiet, but we hear rumours of riots in other places.

Christmas presents continue to pour in I have had a dear little diary for 1930 from Miss C's aunt in Cairo, she sent something for everyone, Professor & Mrs Newbury have sent Turkish Delight, Nougat, Sugar Almonds & stuffed dates, about 7 lbs in all.

We hear Dr Gardiner's hamper has got as far as Baliana & its declared value, (customs pre paid) is £3. We are wondering what it can contain, we shall have a good time in the eats line.

I hope you will have had a splendid Xmas & that the parcels appeared on the breakfast table as a surprise.

Broome MSS49
Arabah. El Madfunah.
Dec 25ᵗʰ 1929.
Dear Mother & Father.
Yesterday I spent the strangest Xmas eve you can ever imagine. We were just putting the finishing touches to our decorations after the evening meal when Ahmed Ibrahim called to offer compliments, & enquire if we would like to attend a wedding festival. As you can imagine we were delighted. We collected a suitable following of servants with lanterns & set out. I took a little satin bag I had made, as a present & Miss C took a Woolworth necklace. Upon making further enquiries we learnt that we should not see the bride as she will not arrive until tomorrow at the conclusion. It seems the two families provide entertainment for their various friends for several days before the real event. As soon as we reached the village we heard the music of the pipes & drums & after several turns through the narrow village streets we came upon a truly picturesque sight. The gathering was held outside a large house, the company sitting in a wide circle on the ground. Our host received us most courteously & invited us to seat ourselves on the divan reserved for guests of honour. After we were settled & the various compliments had been exchanged, the music began again. The performers squatted on the ground among the guests.

The flute player had a zummara with the peculiar drone, it is a delightful instrument heard in the proper surroundings. The huddled figures in their multicoloured draperies, the brown faces with keen eyes glittering in the lamp light, the rapt attention, & an occasional murmur of Ya Allah! after a favourite melody, in such a setting one can appreciate the beauty of the soft clean notes of the zummara with the hum of the drone forming a sort of undertone & the rhythm of the drum. There was a slight pause in the proceedings & the musicians quickened their time & a tiny dancing girl was lifted over the heads of the spectators & set down in the centre. She was the little sister of the young bridegroom & was only six years old. She was the best dancer in the village, her mother, a famous dancer had trained her as soon as she could walk. This tiny thing danced the old Arabian dances, twisting her little figure in perfect time to the music. She wore a white dress with silver ornaments at the waist, her hair hung in long plaits & each plait had an ornament & tassel tied on to it & she had a coloured handkerchief tied on her head. Her little feet were bare, she danced so long that we were afraid she would be overtired but her father assured us she was not tired because she was so happy to dance before honoured guests at her brother's wedding.

Afterwards two men got up & danced balancing long sticks across their shoulders & after them came the star turn, a well known piper & singer. The piper was a Soudanese, he had the Father of zummaras. it was over 5 ft long & had a deep bass hum, it was wonderful to see him blow out his cheeks, never have I seen cheeks extend to such a size, greater even than those of cherubs on tombstones. The singer sang the old Arabian love songs. He held one hand as a shield to his mouth as if to make his voice carry, with the other he pleaded, entreated or emphasised & he directed his songs to us. I have no doubt we should have been covered with confusion & blushes if we could have followed all the words, fortunately we didn't, but we guessed a lot. The man was a perfect actor & had a deep rich voice. No wild yells, but beautifully modulated & flexible to a degree; he certainly made the most of his unique opportunity of singing his passionate love songs to two visible & unveiled females who so obviously appreciated his performance. We noticed a very worried look on Sardic's face, he was evidently wondering how much we understood, he is very proper in

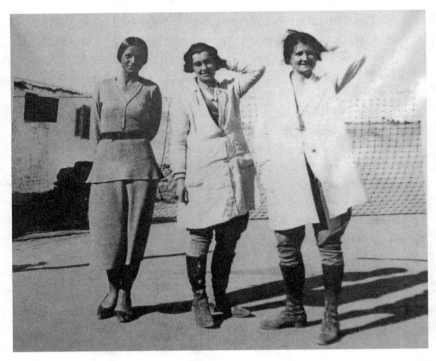

Miss Jonas, Myrtle, and Amice

quite a European way where we are concerned & of course one can't expect a real Arabian love song out in the desert to be modified to suit European ears. It was all very thrilling & we were very sorry when midnight came & we felt bound to depart. We left our gifts to the bride with the bridegroom's father.

Mr Beazley has gone to Luxor for the Xmas holidays, he wanted to escape from us for the time being, he doesn't take the slightest interest in the natives & their customs. He refuses to even try to learn Arabic, & is altogether rather a bore. So we were not sorry when he decided to take himself off for 5 or 6 days of his leave. We now have Miss Jonas, the secretary of the E.E.Soc staying for four days, she is a dear & is enjoying everything thoroughly, it is her first visit to Egypt.

There was great excitement today at breakfast we exchanged gifts. I gave Miss C four of the nicest of the stock of hankies you passed over to me. I sort of felt she was going to give me something & I didn't want to come to the table empty handed. I was right too, she

gave me the daintiest pale pink cambric nightie, handmade & embroidered in Italy; she is the most generous person in every way, & most delightful to work with. For Nannie I had made a magnificent pair of garters out of some shoulder strap ribbon (this is why I had to write for more) all puckered on elastic, this was a huge joke, as her stockings are always coming down. I gave Capt C. a purse I had made out of cuttings from the White gloves. He has ordered a present for me, but it hasn't arrived yet. We are quite like a happy family party now. After breakfast we prepared the things for the tree, we had about 10 lbs of mixed sweets a huge bag of nuts & 70 oranges. & 70 handkerchiefs we expected about 60 odd children & provided for some extra in case we had miscalculated, as it happened over 80 came, we had to hastily supplement from our own stores & make a few adjustments, but fortunately no child went away empty handed.

Dec 26th Last night was simply gorgeous. I hardly know how to start to describe it. We provided our servants with whatever they wanted for a proper Arabic feast & left the other arrangements entirely in their hands. We purchased a live sheep in the market, which was slaughtered (out of our sight) in the approved Mahomedan way, it is very quick, & they pray to Allah to forgive them for taking life, we also provided bread, tea, sugar & sweetmeats & cigarettes & we engaged the piper & the drummer. Also, the Soudanese piper with the Father of zumaras & the singer. During our own dinner Sardic brought a portion of the sheep which had been made into one huge stew so that we might taste it, (it was rather too tough for our liking but we said it was delicious of course). After dinner we were informed that the fantasia was ready so we went outside & took our seats on the deck chairs specially set out for us. Sardic was host & master of ceremonies & his manner in both capacity was perfect. His other guests, about 70 in number, were squatting round in a wide circle on the sand. The night was very cold & we were glad of the heavy travelling rugs over our knees, so we told Sardic he might use some of the wood that we have for heating our bath water. With this wood 3 small fires were started & the company arranged itself into three circles.

The singer & piper walked backward & forwards among them singing a verse to each in turn, can you imagine it! The squatting figures round the fires, stretching out their hands to the flames, the tall

figure of the singer bending over them singing his songs & the portly
Soudanese strutting round with his 5 ft zumara, waving it right & left
as he played, sometimes raising it as if he was addressing the stars.
When a favourite song was being sung all the company clapped their
hands softly in rhythm, & repeated the refrain after each verse.

One of the guests showed us a very good trick, he spread a rug
on the sand & laid a small cushion on the rug. Then he put a tall glass
bottle full of water (without a cork) on his head & without holding
it in any way he walked round the rug, then knelt on it & gradu-
ally worked himself round until he was stretched out full length like
this [drawing] then he got the cushion in his teeth & raised himself
erect again. All without touching the bottle or spilling a drop of water.
He then repeated the performance replacing the cushion on the rug
again. The show turn of the evening was the little play our men had
made up themselves. I don't know when I have laughed so much in my
life, old Ahmud, who is called the Father of Moustaches had got him-
self up as a fat, self important Pasha, & he held a court of justice sitting
on a large packing case turned upside down. A woman (man disguised
of course) came to plead her case, & in a shrill wailing voice she told
how her goat had been stolen, a goat that gave 3 pails of milk a day.
The accused pleaded that he 'had a right to the goat as the woman had
been one of his wives but he preferred to keep the goat.' The Pasha
said he must be put in prison until he loved his wife properly, so they
shoved him under the packing case, & he began to wail about the
discomfort & the bugs & how much he loved his wife & there was a
most touching love scene between the man in the packing case & the
wife outside.

But the Pasha wouldn't listen, then the man began to heave the
case up & down & finally tipped the Pasha off & escaped & there was
a general scuffle & everyone began to bang each other with lighted
palm branches & sparks flew all over the place. The prisoner escaped
in the confusion, so the Pasha condemned everyone to be executed &
soon there was a nice pile of corpses heaped up in front of him.

Then an awful *afreet* (ghost) came & scared the Pasha into a fit &
all the corpses got up & danced round him. There were lots of other
incidents but the plot was a little complicated & my Arabic very lim-
ited, so I can hardly attempt to describe them. The men had contrived

their costumes out of the rubbish out of the packing cases & some were remarkably ingenious. The party broke up about midnight.

I will have to continue my Xmas adventures in a later letter as I want this to catch the mail tomorrow.

Much love to you both.

Your affectionate daughter

Myrtle.

p.s. The people here call the butterfly the "bride of the herbs" isn't it a nice name?

Broome MSS50

Arabah.el.Madfunah

Dec 29 1929

Dear Mother,

The flour paper has arrived & is splendid for putting the fine point on pencils.

I had to write my account of the Xmas festivities by fits & starts, I hope it was fairly coherent. It is very nice of you to think of sending New Year cards to the men, but I do not think it would be easy to explain them to them. A written document is to them rather what a telegram is to you, rather alarming! They always send greetings by word of mouth personally or by messenger, also their New Year is different to ours. I think it would please them if I were to give them a message of greeting from you at the great feast at the end of Ramadan.

I will try to continue the account of our festivities. Boxing Day was devoted to another picnic in honour of Miss Jonas, we went to the wady with the best sand slide, had our lunch there, cold turkey & salad, mince pies, sweets, mandarins etc.

While we were resting our men had great sport on the sand slope, racing each other up & coming down in the most spectacular manner they entertained us immensely. Then we made our attempt, choosing a longer, but less steep way up, of course they all came with us, including Abdullah, we started down in great style, the men were down first & of course turned to watch our descent. To our consternation they were consumed with unseemly mirth, & we wondered what on earth could be the matter with us to make our respectful servants lose their respectful attitude towards us, but as we came lower they signalled to

us to look back, we did so, & there was poor little Abdullah spread-eagled on the slope too terrified to come down except on his tummy of course we couldn't help laughing too, Sardic indulged in a fine flow of Arabic sarcasm which was quite beyond our linguistic powers. Abdullah came down safely, doing the less steep part in the more approved manner. We had tea & biscuits before starting our trek home.

The next day we did our usual round of work; the following day was another state occasion, we had invited the Mudir to lunch, this gentleman is a very high official in charge of all the military & police in this province. We had a very fine turkey, stuffed with chestnuts one end & rice, nuts & raisins the other. Then – Christmas pudding, fruit & sweets & coffee. They all did justice to this fare, the Mudir had two of his officers with him, of course they all spoke English & we really had a very nice time, during dessert Sheikh Abdu Wahid came & sang the Koran to us, this sumptuous meal was served in the temple since the Mudir is too fat to walk the necessary distance to our house & his car cannot go over desert, so a primus was sent & the cook carried the cooked turkey over & kept it hot until ready to be served at table. Of course we had to conduct our guests over the Temple & the Osirion. This took up the greater part of the afternoon so when they had departed it was too late to start work again, so we collected our things & saw everything packed up & set off home, intending to get some letters written before dinner. To our great surprise as we reached the top of the last sand hill we saw 3 desert cars arriving, of course we hurried to meet them, they proved to be Princess Fouad & her sister, cousins to King Fouad, who had been travelling from the Red Sea in company with Mrs Phillips (a Cairo Society Lady) & her daughter & a gentleman whose name I do not remember, of course we had to offer hospitality to these people & their servants, fortunately they had camp beds etc. with them as they had had to put up in rest houses part of the way, they also had odds & ends of provisions which we handed over to our cook, & we managed somehow to feed & sleep them all, it certainly was rather a strain on our little community without a moments warning. Sardic remarked "it was like a house full of worms". Mrs P. is well known in Egypt as the "world's worst cadger" – & I think she well deserves the title. The two Princesses (of uncertain age) were very pleasant, but rather mouldy examples of royalty, they

are of course Mohamedans, but they like to demonstrate their free mindedness by eating huge quantities of bacon, of which they had brought a good supply, to the great disgust of our own servants. They stayed two nights & started their journey to Cairo the morning of the second day.

8

ANCIENT ZAR CEREMONIES
AND MODERN DAMS

The two women were often invited to native ceremonies as honored guests, and Myrtle was always meticulous in recording these events. The *zar* ceremony is performed to drive out a demon and was once highly prevalent throughout the villages of Egypt and still continues today throughout the country, mostly in cities and provincial towns.

Broome MSS51
Jan 2nd 1930
Dear Mother.
Your letter with the second piece of fine sand paper arrived today. I think we will have enough to last the rest of the time now.

Yesterday we went to a "Zar" it was the weirdest thing I have ever seen. I do not understand exactly what it was all about but I will do my best to describe all I saw. The Zar was held in the house of our water carrier, we were invited to attend by his wife. Miss C & I went directly after dinner, Sardic & two others escorting us as far as the door. The ceremony was held in a sort of courtyard, in the centre was a little low table piled with bread & other sorts of food. The women were all grouped round squatting on the ground. The old witch doctor was in the centre, she was an aged crone of about 90, toothless, scrawny arms & claw like hands. She had a large drum like a tambourine without bells on which she beat a sort of rhythmic accompaniment to the chants they were singing; beside her sat a man with another sort of drum shaped like this [drawing]. We were very puzzled at seeing a man sitting among a lot of unveiled women who were not relations. We got Nannie to question Sardic about this afterwards, & learnt that he was one of those

unfortunate sexless creatures (or rather bi-sexual) they are often asso-
ciated with these ceremonies & this one was a professional Zar master.

We were shown to a divan which had been prepared for us. &
after we had greeted the various women we knew, the ritual continued.
It simply consisted of the rhythmic drumming & singing of chants
which seemed to be a constant repetition of certain phrases. Then one
of the women began to sway & twist herself about, tossing from side
to side till she fell exhausted. Then another joined in & several others
kept up the swaying motions clapping their hands in time with the
drums. After a while the Zar Master stepped into the circle & began
to sway & twist, he went through extraordinary contortions, uttering
short sharp cries he flung himself on the ground, twisting his body &
rolling from side to side. He then called for water & when a bowl was
brought he buried his face in it & drank like an animal making rapid
shuddering motions all the time. Then, when the drumming & chant-
ing stopped he suddenly became quite normal again, rearranged his
headdress & cloak which he had torn off & took his place in the circle
again. Several of the women did the same sort of thing. One woman
in her frenzy tore off all her clothes except a long white undergarment
like a nightie. We stayed watching this until past 10 o'clock & then in
a lull in the proceedings we made our adieus, dropping a few piastres
into the witch's bowl as we passed. Sardic & co were waiting to escort
us back, & we walked home across the desert feeling that we must be
creatures belonging to quite a different world.

As far as we can gather from the explanations given us, there are
certain underground spirits called Sheikha's who enter into people &
possess them until certain demands are satisfied. The curious thing
is that women are possessed by male spirits & men by female. These
Zar's are held to find out what the spirits want & the frenzy & con-
tortions of the women is the spirits way of manifesting itself. It is very
akin to spiritualism & mediumistic practices. It is very primitive & in
a way rather beastly, but all the same intensely interesting.

We have had lots of tourists at the temple usually on Fridays, we
are beginning to look on them as one of the plagues of Egypt, perhaps
they have the same opinion of us.

Sheikh Abdu Wahid's daughter has had bronchitis rather badly,
she is such a sweet girl about 19 or 20. The old man came to us in

great distress, he said she had a bad cough. Miss C. sent one of the men back to the house for cinnamon & aspirins & a dose of Eppy & we both went round to see her. She was on her bed, which was simply a mat of dried grass on the packed earth floor & a very hard pillow. She looked very ill & could hardly speak, we got one of the women to heat water & gave her hot cinnamon & sugar straight away & instead of the dose of Epsom Salts we gave her Syrup of Figs, gave instructions that she was to be kept warm & not to go out of the room for any purpose what ever & only one woman was to be with her at a time. When we got home we sent her over a hankie well sprinkled with Vapex & a great bundle of eucalyptus leaves to be put in boiling water for her to inhale, explicit instructions *not* to drink it. All these ministrations had a wonderful effect, in two days she was ever so much better, since then Sheikh Abdu etc. has been going round singing our praises with the result that several members of his family have been coming round expecting to be cured of the most extraordinary diseases.

Sardic's wife has now got the flu, we sent him off with the usual remedies & instructions to dose the whole family with cinnamon. I am afraid Sardic is not too attentive to his husbandly duties, his house is in the village about ¾ of a mile from here, but he prefers to sleep with our cook. All the same he is very fond & proud of his wife & family & sees that they have everything they require.

Broome MSS51A
Jan 2nd 1930
Dear Father.
Thank you so much for looking after my banking affairs, my accounts both East & West seem to be flourishing, also thank you very much for the pocket money! I didn't really expect that while I am earning such a princely salary out here.

I am glad you are pleased with the information about native weaving etc. that I have been able to gather here, just wait until you see the work they can produce with these primitive tools! I am enclosing the pictures I took in the weaver's house. The photo of the loom is very successful considering it was such a dark corner & I had to make a time exposure. The weaver's son is working at the loom you will see the old man himself sitting beside the skein winder, doesn't he make a beautiful

picture. (Kodak have made me an enlargement of it.) The picture of the little boy actually working the winder is slightly blurred owing to the movement I should have made it 1/50 of a second instead of 1/25.

I hope you like the picture of Sardic flirting with the lady camel. Isn't she sweet, just look at the love light in her eyes. (she was dribbling but this doesn't show in the photo).

Broome MSS52
Arabah el. Madfunah,
Jan 8th 1930
Dear Mother,
We had a very exciting day yesterday we have been invited to visit the chief engineer at Nag Hammardi where they are building a new dam across the Nile. Miss C & I decided it would be good fun to go on camels. This was before we actually knew the distance (we thought it was about 11 miles) our suggestion was received with some amazement & a lot of doubt as to our riding capabilities, but Sardic quite cheerfully said it was possible, & he could get us good camels. We made further enquiries & consulted the map & found the distance from here to Nag Hammardi was 22 miles, we still said we would go & gave Sardic orders to have four camels ready for us at 6 o'clock Tuesday morning, this was one for Miss C. one for Capt C. (who decided to join us at the last moment after teasing us considerably for our mad idea) & one to be shared between Sardic & the camel man.

We had breakfast 5.30 just before sunrise, our lunch was packed & we were ready by 6. Our camels arrived & were induced to fold themselves up, we had our blankets spread over the saddles, (pack saddles not proper riding ones) & we mounted, Capt C was a few minutes late so of course we hooted at him, he came out with a rush gave a wild yell & charged his kneeling camel intending to leap onto the saddle, the poor camel wasn't used to this behaviour & shot straight up in terror, the Capt managed to clutch the poles of the saddle & was lifted off his feet clinging to them, for a moment the men were too helpless with laughter to render any assistance but he was finally hoisted up on top. I think it was the funniest thing I have ever seen, I can hardly describe it for laughing even now.

The first part of the journey was across desert, it is a gorgeous feeling to be mounted on a great tall beast going along with swinging strides. after a few miles we turned down into the cultivation & went along narrow tracks between fields of clover, beans, lentils etc. sometimes our way was along canal banks & under the mimosa trees, we often had to bend very low to avoid the branches, the scent was glorious, often we stopped to talk to the people & ask them about their crops, & we were given handfuls of flowering beans & clover, we did not have to carry these far, for soon an enquiring nose came round & the camel begged for a mouthful. I quickly discovered it was quite easy to feed ones camel while riding & very soon my bouquet was all gone.

Sometimes another party of camels would be going our way for a short distance, & we would all jog along merrily, enquiring after each other's health & where from & where going. It is very pleasant to be riding along the country ways of Egypt in the proper native style, far better than hooting along the dusty dirt roads in cars, being cursed by all the people as infidel dogs. We were merely pleasant & interested, & we received courteous greetings & blessings & handfuls of flowers.

About 12.30 we came in sight of our destination, so we called a halt at a suitable spot on the banks of the Nile, had our lunch unpacked & fell too. We had bully beef, tomatoes, baked potatoes & bread, a tin of peaches, cake, biscuits & oranges. The men had brought their own food & they were given a portion of ours as well as we couldn't possibly eat all of it. By that time we were getting very stiff & saddle sore, we had done nearly 20 miles in one stretch, part walking, part trotting, a camel's trot is the most ghastly motion one can imagine at first, one feels as if ones spine is being jarred through one's head, after a while one finds the best way is to lets one's body go limp & sway to the motion. After lunch we lay flat on our backs for a short rest, then mounted again & completed our journey. Arrived at Nag Hammardi we found the Ellisons house, induced our camels to kneel dismounted & collected our rugs etc. & sent the camels off in charge of the camel man to be fed & watered. Mr & Mrs Ellison were delighted to see us but held up their hands in horror when they heard we had come all the way by camel in 6 ½ hours, they said such a ride was considered very good going for the camel corps (spelling uncertain) & they could not believe we had only been on a camel once before for a quarter of

an hour. We had to own to being very stiff & sore. Mrs Ellison was a
dear she insisted on ordering hot baths for us. We were very grateful
but suggested we would like to have them after we had been over the
dam. So we just had coffee & some lovely sandwiches & adored a
glorious bulldog Peter & a terrier Tommy, both very friendly & then
went out to see the barrage.

It is a marvellous engineering feat, but in its present state hardly
a thing of beauty, but it is going to give Egypt many more areas of
cultivated land. We had a special thrill, Mr Ellison took us over in
the bucket. This is an iron cage which is lifted up to a great height
& passes along a wire right across the Nile it is said to be the biggest
thing of its kind in the world. It certainly was great fun seeing every-
thing from so far above, we saw the pile driving etc. & returned via
a steam launch. Then Miss C & I each had a glorious hot bath with
vinegar in it & doctored each other's sore patches with cold cream,
Mrs Ellison insisted on lending us each a frock & shoes so that we
might shed our breeches & boots for a time. We had a very cheery
dinner with them. Sardic was entertained in the kitchen (the camel
man having started back as soon as the camels were fed & rested).

6

Then we once again put on our serviceable garments & were
driven back as far as Arabah el Madfunah in our host's car (a very
bumpy journey), the last part of the journey we had to finish on foot.
We got home by 10-30, & oh dear we were so tired but so very pleased
with ourselves. Nearly everyone here had said we would never get as
far as Nag Hammardi on pack camels.

We were up this morning by 6.30 & at work as usual, none the
worse for our adventure (though still a little stiff & sore as to seat
& back).

We had the Marmur of Baliana, (he is similar in rank to our
Major) to tea today we heard tales of the village fight that has been
on in this neighbourhood, it seems one man's gamoose [buffalo] got
into another mans field & there was a rumpus & some serious fights
began & several were killed & wounded, the police came in force but
could do nothing until they fired at the people, (I don't suppose they
fired to do any damage) this eventually scared the people so that they
ran & hid in the houses, where possible hiding their wounded so that

they cannot be proved to have had a hand in the affair. Now there is an awful to do because two men killed are Bedouins who have strict tribal laws & have sworn on their beards to take 10 lives in revenge for one.

The police say they can do nothing in a case like this, these Bedouins will wait a year even, to pay back a blood feud & no one knows when they will strike, the people in this village (some miles from here) are watching day & night, & the police are also alert but the Marmur says it may go on for an indefinite time. Of course this does not affect us at all. We do not know any of the people in this special village & I expect the tales that reach us lose nothing in the telling all the same it is very exciting to be living in a country where such things can happen. It shows the other side of these peoples characters.

I really must stop now & go to bed. I hope you have a really nice birthday & that the Turkish Delight arrives safely.

Lots of love

Your affectionate daughter

Myrtle.

I hope you can read this I have so much to say in a short time that my pen falls over itself.

I am enclosing some of the snaps Miss Jonas took at Xmas.

Broome MSS53

Arabah el Madfunah. Jan 10th 1930.

Dear Mother

I really have a good opportunity to write today as I am having a day off, I have got a sneezy cold in the head & it is no use trying to do fine pencil drawings & blow ones nose every five minutes, so I am just staying in bed for a day to get rid of it quickly. I think I must have caught it from Mr Beazley who came back from Luxor with a bad cold.

Yesterday I got your letter with the rest of the sandpaper. I am glad to hear you received my first letter about new boots, as now the canvas ones are quite useless; the sole has come right away from the upper. I expect an English boot maker could mend them, as both sole & upper are in good condition it's only the actual stitching that has gone, but the Egyptian cobbler is hopeless. He does not understand how our boots are constructed, so at present I am wearing rubber shoes & stockings, I do not want to ruin my nice riding boots I am

keeping them for "swell occasions." It is quite safe to wear shoes now as all the snakes have gone to sleep in their holes for the winter. (I have only seen one since I have been here).

I seem to be getting through my scribbling paper very quickly so will economize by using both sides in the future. I enjoyed hearing about all your Xmas festivities, you seem to have had a very good time, rather different to my Xmas however.

We are now settling down to steady work after our many Xmas excitements. We have had a little bother with Mr Beazley's work, unfortunately he has had no archaeological training, but considers his work above criticism because he has studied at the Slade – both Miss C. & I have done our best to help him, but he seems unable to acquire the technique or the accuracy needed for this work & takes all criticism as a personal insult. This makes the situation very difficult as Dr Gardiner is trusting to Miss C's judgment in this matter. She is the most painstaking & skillfull draughtswoman I have ever seen, though she does not claim to be an artist in the matter of original work. It will probably mean she & I will have to do everything except the quick mechanical part such as rubbings & measurements.

Capt C's job is the photography & charge of the electric light engine, which by the way has had something go wrong with its innards & has been sent to Nag Hammardi to be repaired, it went by mule cart to the river & then by boat.

I took a snap of it being loaded onto the cart, there was a fuss & a hulla ba loo about it. Everyone yells instructions to everyone else, & each one does exactly what he thinks most suitable until Capt C. comes on the scene & yells louder than all the others, a good British bawl makes itself heard like a big dogs bark among a pack of yapping little dogs.

So far Mr Beazley is the only one who has taken any leave, he had a week at Xmas. Miss C & I are trying to plan a gorgeous trip for our leave about the beginning of Feb. we want to visit the oasis of Khaga. To do this one has to go by camel along the ancient camel track across the desert. They tell us it takes a good camel rider 3 days & two nights, it is over 100 miles, & desert all the way, (we had this in our mind when we did our camel ride to Nag Hammardi). There are several Bedouin in our village who have done the journey many

times & we would have two as guides as well as two of our servants. We should need 10 camels as one has to carry all the water required for the journey & a good allowance over in case of any delay. We have one tiny tent that we use for a sand closet for our private use in the Temple, we should take this for dressing & undressing in, but we would have to sleep in the open with the camels wouldn't it be fun. I am not counting too much on doing it, as something very likely will occur to prevent it, but we are both very eager to do some real desert travel in Bedouin style. Sardic is very thrilled at the idea, he is a real Bedawi, he belongs to a tribe of camel men & tent makers, & though he has settled in the cultivation & married a woman of the fellahin (people of the fields) the desert is in his blood & I believe he loves camels more than his own children.

(don't you love the picture I took of him kissing the lady camel.)

We still have a "hospital parade" several times a week, they are usually quickly dealt with, a bottle of Lysol water & a handful of Epsom Salts. Miss C is known among the women as "Mother of Purges."

Sheikh Abdu Wahid has been up to Cairo to look after one of his sons, he told us that he was "behaving badly in the ways of young men & bringing shame upon the head of his family." I was walking through the service rooms in the Temple when I met the Sheikh & stopped to say the usual polite things, I thought I had got through them very

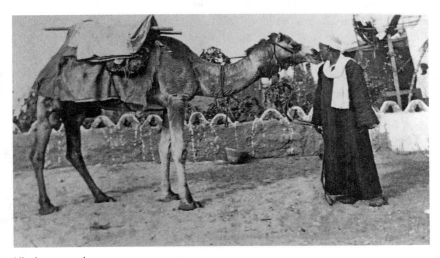

Kissing camel

well when he sprung an entirely new lot of salutations on me & took me firmly by the hand & led me to the Temple courtyard. Here a very handsome young man was presented to me who proved to be the erring son. He certainly didn't look the sort who could easily resist the temptations of a gay town like Cairo, I am rather doubtful whether such a dashing youth will be content to stay on a quiet country farm, but the Sheikh seems quite capable of ruling his family with a firm hand.

The last few nights we have been rather disturbed by jackals, they are getting very hungry & bold, they can smell our chickens & prowl round the house: of course our dog barks frantically. We have to keep him tied up at night otherwise he will go off to the village to visit his lady friends. Sometimes our night guard fires his gun at them, but they are rather superstitious about killing them.

We have not yet eaten all the good things sent us for Xmas, we have a wonderful dessert every night. Turkish delight, stuffed dates, chocolates, almonds & raisins nougat, candied fruits as well as our local grown oranges, mandarins & bananas. The fresh oranges are simply delicious & they come in big baskets with lots of leaves on them, our meals are very varied & we make use of all the local vegetables, just now we are having black carrots, a cross between ordinary carrots & beetroots, they are very good.

One of our favourite puddings is date rice, it is rice pudding & chopped up dates, baked until the milk is all absorbed & the rice is very tender. The flavour of the dates goes all through it, I think you & Father would like it for a change.

When we have chickens we usually have them stuffed with rice & raisins, you have no idea how good this is, sometimes the liver is boiled & chopped up with the rice (or it may be giblets) we don't have bread sauce alas, because the native bread is not suitable for it.

The meat is usually rather tough, it has to be eaten so soon, but we do have good soup & splendid egg dishes & lots of tomatoes all of which I do full justice to. We are most polite over our dessert. We always have finger bowls, & such dear little cups for our black coffee, in fact we are really in the lap of luxury. Nannie is such a dear old soul & looks after us splendidly.

I read her your remarks about her photo, she was so delighted, I heard her repeating them in Arabic for Sardic's benefit.

Jan 11ᵗʰ Cold is better this morning, so shall get up to lunch & sit in the sun. We are planning a little expedition for next week. There is to be a great Mohamedan Festival held at Kena which is held every year & it would be an excellent opportunity for us to see it, as we can probably get the loan of the antiquities rest house at Dendera & see the Temple at the same time. We should have to travel by train Wed morning, stay Wed night & return Thurs night. There is a very curious custom connected with this Festival, the King sends £100 in million pieces. (less than ¼) These are scattered & when the mob rushes to pick them up they are lashed & beaten with long whips, the man who secures a coin will be lucky all the year & the more he is beaten in getting it the more merit he will acquire. I expect it will be a very brutal sight, but one has to remember that these people are fanatical & it is absolutely true that when the religious frenzy is on them they have no physical feeling whatever. One gets quite a different outlook on things out here, western ideas & standards simply won't work in the east. There will be many other sights besides the coin scramble, there will be the great procession of camels in all their best trappings, the dancing horses & native music, trials of skill, & single stick contests, conjuring etc.

Mon 13ᵗʰ Have decided not to go to Dendera after all as this wretched cold will hang about & I don't want to risk making it worse. I am very disappointed, we find the festival is a day sooner than we thought & will mean a long tiring journey. I wanted Miss C to go with Capt C & leave me at home with Nannie, but she says she doesn't care about going without me, so we are leaving Capt C. to do as he likes he is over at Nag Hammardi seeing about the engine.

Mr Beazley is leaving for good tomorrow, there is really nothing that he is capable of doing now that the ceiling rubbings & measurements are done, it means Miss C & I will have a lot extra to get through, but possibly a lot could be finished in England. I am glad my work has proved up to standard. I shall probably have the offer of several more seasons work out here.

I went down to the Temple to lunch today & the walk absolutely fagged me out, it's a touch of this beastly flu that I've had, there has been one consolation however & that's the welcome I got from the men on my reappearance, the Temple rang with their "Praise be to God the

Lady has returned". Old Ahmed took me by the hand & enquired most earnestly after my health & each time he saw me afterwards he told me he was happy because I was better. I overheard Sardic telling Nannie that he hoped I would be back in the Temple soon, as the work did not go at all well in my absence, so evidently I am popular, even when one has taken off a percentage for Oriental manners.

9

THE FESTIVAL AT QENA

Broome MSS54
Arabah.el.Madfunah.
Jan 16th 1930
Dear Mother.

I went to the Festival at Kena after all, my cold was so much better Tuesday evening that at the last moment we decided to go just for the Muled, & leave visiting the Temple nearby for some other Time.

We were off by 6.45, caught the train at Baliana 7.30 & arrived at Kena a little before 12. We took Sardic with us, & enough provisions for the day and had lunch in the train to save time. When we arrived we had a good look around, it was a wonderful sight, a real Eastern crowd. We found it so dusty & difficult to push through the throng that we hired a carriage, we could only go along at a footpace, the driver shouting "h'oa ya ragil". (Take a care oh man) all the time.

Once, when we got quite blocked, a nice police officer came to our rescue & gave us two policemen to clear a way for our carriage, we drove all round the fair & saw all the stalls, fruit, sweets, fancy pots etc.

This Festival is held in honour of a certain very holy sheikh whose tomb is at Kena, we saw this tomb, it is like a fairly large mosque, the roadway going all round it, (like some of our Town halls in market places), there were wonderful young men in striped satin robes & flowing head-dresses in vivid colours on tall camels with gorgeous trappings glittering with embroidery & sequins, their bridles decorated with masses of artificial roses, they were all riding like mad round & round the mosque, we joined the throng our horses urged to a gallop to keep up & round we went twice camels to the

right of us, camels behind us & camels in front, it was a thrill, they all seemed drunk with excitement, we left them to continue going round the prescribed number of times, (7 I believe) while we went to see more sights. We watched nabout men giving an exhibition of single stick, & we saw a most extraordinary sword dance. There were two rows of men lying flat on the ground with drawn swords laid blade downwards across their tummies, the drums & pipes played weird exciting music, & a man supported on either side by two other men leapt from man to man alighting on the swords each time, the men seemed to be almost hypnotized, they were breathing very quickly but made no sound, it was a very curious sight & evidently had some significance that we did not understand, we did not inquire of the on lookers as the people are very fanatical at this time & it is not advisable to be inquisitive about these matters. We did not see any other Europeans except a party of English men who are instructors at a large local school.

We spoke to them to ask when the big procession started, & curiously enough I recognised two of them, they were spending Xmas at the Thebes Hotel, Luxor the year I was there, wasn't it funny. They invited us to have tea with them after the show. The procession of camels is the climax of the festival, I have never seen such an extraordinary sight, each camel carried the embroidered cover from some famous sheikhs tomb these covers are called "holy carpets", they are stretched on large frames and are all sorts of colours. These go in procession round the town, & the people stretch up & touch them as they go by in order to get special blessing, all the camel riders follow also, some of them were very beautiful in their festival robes & some of the saddles had priceless Bokhara rugs over them, it was impossible to see everything at once. We were very fortunate, we were advised to drive to the square to see the procession, when we stopped there, a very polite Egyptian came & asked if we would like to watch from the balcony of his harem, of course we were delighted, so we left Sardic in the carriage & were escorted up. The husband was not permitted to enter his own harem, as his wife was entertaining visitors, but he turned us over to an ancient dame. The lady of the house received us very kindly, she could speak a little English, she took us out onto the balcony where the other ladies were assembled to watch the show.

Some of them were very lovely & some very fat & uninteresting, they seemed very pleased to see us, & we could see everything perfectly.

After the camels had all passed by, the representative of the king rode through with an escort of mounted police & a detachment of the famous Soudanese camel regiment; he threw handfuls of coins right & left among the crowd, there was a mad scramble, the police were armed with long whips & they beat the people as they scrambled for the money. We could only see the surging throng & the whole affair was soon over. We bade our hostess farewell, & drove to our school master friend's house where we had a very nice tea, then we had another walk round the fair ground, saw it all lit up, went to a conjurers entertainment, made several small purchases & got to the station about 8, arrived here a little before midnight, very weary, but very pleased with ourselves. There was another curious thing I forgot to mention, in the centre of the marketplace there is a large tree with a boat hanging from it. The people say it is a very very ancient custom & we think it is probably the survival of one of the boat festivals of the ancient Egyptians.

Fri 17th I was so anxious to describe the Muled that I forgot to describe the events of the previous day. On the Tuesday we paid a visit to the Coptic Priest, there is a little Coptic community living near here. They have built their little village of mud houses inside the ruined walls of a very ancient fortress (probably 4000 years old). I expect they chose this situation in the days when they were so persecuted, we went into the little church, part of it is very old, supposed to be sixth century AD, most Coptic Churches claim to belong to this period, it probably was a time when they flourished & did a lot of building (& a lot of wanton destruction to temples etc.). The Priest showed us some old pictures with great pride, one was a very exciting one of St George slaying the Dragon. (I wonder if you know that our patron saint originally came from the East), I trust our gasps of amazement were taken for admiration, but really Coptic painting is the climax of the truly awful. The old Coptic Bible was really beautiful. After viewing the church the Priest took us to his house & regaled us on cinnamon tea & insisted on presenting us with a cock on our departure.

Miss C. had given him a very fine cover for his reading desk, it was made out of the remains of a cream satin evening dress (the joins

disguised with feather stitching) with a large Coptic Cross in apricot silk
sewn on To it. It looked very handsome & pleased him tremendously.

Tuesday night was a special time for Mohamedans, it was the
night on which the Heavens open & if any one offers a prayer at the
exact moment, their desire is granted. Also if any one dies at that very
time they go straight to Heaven without any preliminary judgement
or punishment for their sins. On that night also the Angel of Death
shakes the Tree of Life and the people whose names are written on
the leaves that fall will die within the year. The people make a special
kind of bread for the occasion with wheat & some milk, each one gives
away his own loaves, & of course receives from his friends, there is a
special blessing in the bread which only acts when it is a gift. All our
men brought us loaves, & we had to eat some of each. It is so nice to
be included in all their little feasts & they are so delighted because we
are interested. I must say some of the bread is rather nasty especially
the loaves brought by the very poor ones, but we were very careful to
eat equal quantities of all of them.

Our cook celebrated our absence from home on Wednesday by
calling in the local barber to pull out a double tooth that had been
aching, the result was the tooth was broken off short & the poor man
was nearly crazy with pain. Miss C sent him off to Assiut first thing in
the morning to the Anglo American hospital with Sardic to look after
him. They got back this morning, the cook proudly displaying three
awful fangs, he said the dentist got them out without hurting him.
They both seemed to have quite enjoyed the experience.

Now that Mr Beazley has left we shall not need any more cross
word puzzles, our time being fully occupied with far more exciting &
interesting things.

I must be off to bed now, I am so glad to hear you get so much
enjoyment out of my letters I expect quite a lot of people imagine I
have a very dull monotonous time living out in the desert – perhaps it
is dull for some people. Mr Beazley got rather bored – but for Miss C
& I it simply teems with interest.

An unfinished self-portrait of Myrtle, date unknown

Self-portrait of Myrtle as a young girl with her cat, c. 1914

Some of the wonderful wood-carvings done by Washington and Myrtle at Avalon, still there today

The back gates at Avalon, put in by Washington Broome to enable access to the newly built garage to house Myrtle's car named "Lady Godiva"

William Matthew Flinders Petrie, the Edwards
Professor of Egyptian Archaeology at UCL,
where Myrtle obtained her Certificate of
Egyptology

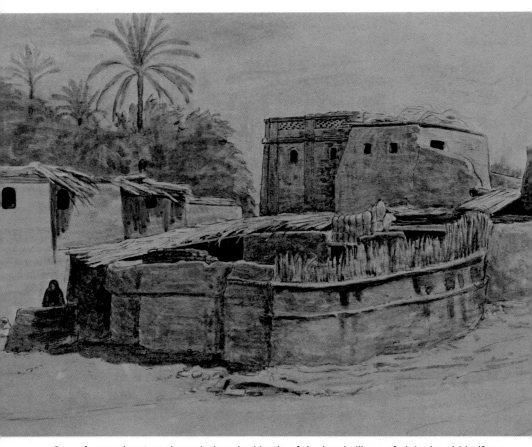

One of several watercolor paintings by Myrtle of the local village of al-Araba al-Madfuna

The camp dig house painted by Myrtle during the time she and Amice called it home

Myrtle painted many desert landscapes during her time in Egypt; she loved nothing better than spending time in the desert, preferably on a camel

On her one day off a week, Myrtle would often head to the local village to paint for pleasure after the intense concentration needed for her work

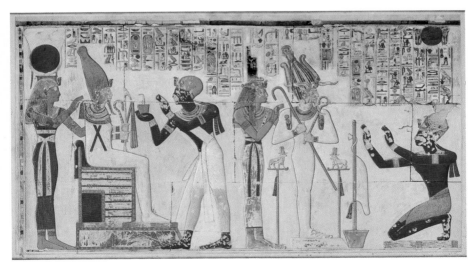

One of the paintings from Volume I by Myrtle showing the king worshipping and gazing upon the god Osiris

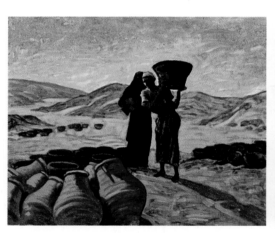

This painting by Myrtle was done from a photo
taken on one of her many desert excursions

Another of her paintings of the local
village she loved while in Egypt

Christmas Greetings

Both Amice and Myrtle would always make their own Christmas cards to send home to friends and family

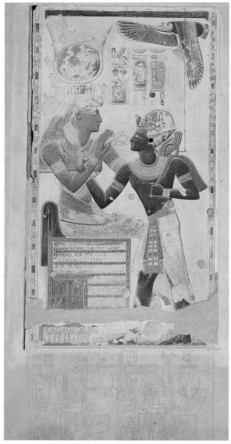

Myrtle writes of the skill needed to pro-
duce these paintings with others sent out
to help who were just not up to the job

Girga was a favorite town with
the women, with several visits
made over the years. Myrtle
painted several oils from
photos taken on these visits

There is a wonderful description of these stones seen in the desert on the epic excursion to Kharga on camels

Once they reached Kharga, not too much time was spent there, but enough for several photos from which paintings like this were made. The joy for Myrtle was the desert travel

One of the many sights captured by Myrtle on film and then painted later in oils

Painting from a photo taken in Girga and later painted in oils

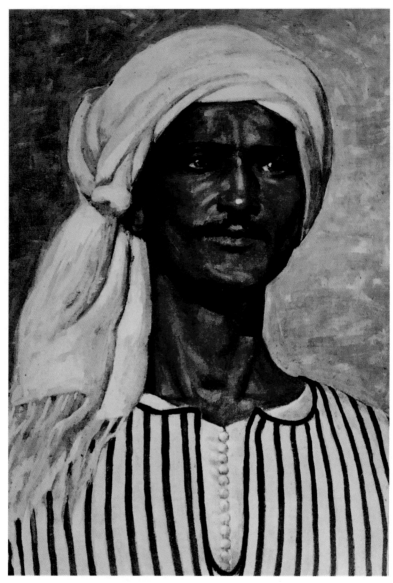

Mahomed "with eyelashes positively sinful on a man." Myrtle was always appreciative of a handsome face

These dovecots can still be seen in Egyptian villages today

A retouched photo showing
the system of drawing on the
photos developed by Amice

Amice and Myrtle were very well matched as
archaeological artists and these paintings are a
superb testament to their outstanding work

A lovely little watercolor from inside the temple for Myrtle's own pleasure

Light and shade in the temple in this watercolor

10

ALONE AGAIN!

Broome MSS55A
Jan 20th 1930
Dear Mother.

Once more I am in charge here, very much on my own this time. Mr Beazley has gone altogether as I told you in my last letter. Capt C is in Luxor & yesterday Miss C went to Alex for a week of her leave, she had to go sooner than she intended as a stopping [filling] had come out of [a] double tooth, so she arranged time for a week & also get the dental job done, so I saw her off by the night train & am now reigning supreme.

We had a very jolly time yesterday evening, a Major Anderson & General Gordon invited us to dinner on one of the big Nile steamers which was staying at Baliana for the night, of course we accepted with great joy, poshed up in pretty frocks & powdered our noses & set off, we had a lovely dinner with red wine & all trimmings & sat & talked in the lounge until it was time to start to catch the train to Cairo. Sardic & Ahmud were at the station with the suitcases etc. Sardic complete with rifle as usual, he handed this over to me while he handed in the luggage & saw that Miss C was comfortably installed. Some Egyptians seeing me with this huge weapon inquired if I was Sheikha el Guffia. We saw the train out & then returned here, as far as possible by car & trudging across the desert the last part of the journey.

This morning our two hosts came to the temple & saw some of our work, they think it is wonderful that we are able to work in so exactly the same technique. They had seen the work that is

being done at Chicago House Luxor & they say ours is much better, they are anxious to come & spend a few days here later on I said I was sure Miss C would be delighted. They are both so jolly that I am sure we should enjoy having them. Tonight, I had to take the Cook's account (with Nannie's help) & give him the money for the market tomorrow.

In the morning I have to pay the men.

Tuesday afternoon. I washed your old Kasha coat this morning it was dry in an hour, it is now ironed & ready for wear & looks very nice. I have also changed my room, I am now in the one Mr Beazley had, it is divided into two, so I have a bed room & a sitting room as well, it is better for Nannie as the steps up to the tower were a great trial to her. It will be more convenient in many ways although I am quite sorry to leave my Tower.

I got through the ordeal of paying the men very well, can you imagine me dealing with these affairs in a foreign language & foreign money!!! Of course Nannie assisted as interpreter, so far my accounts agree with the sum I have in hand.

You will see in Father's letter the news of Sardic & the wool, he is simply crazy about English wool since he tried to spin it, I must say his fingers are like magic. I must take a photo of him spinning. I am trying to get a photographic record of all stages of native weaving. The other day I took old Ahmud with his sheep & 2 two day old lambs, one black and one red, such darlings.

We picked them up & cuddled them while mama sheep nuzzled us to see what we were doing with her babies. They were soft & silky & adorable with funny long drooping ears.

I think it would make an interesting series if I could get good snaps of all the processes.

I am going to try to get a series of pot making & bread making also –

Lots of love to you all

Myrtle.

P.S. The princesses did *not* wear veils they belong to the New Egyptian party & try to be ultra European. The result is not very pleasing – They are partly Turkish by birth.

Broome MSS55B
Jan 20th 1930

Dear Father.

Sardic has bought me a spindle, I looked out all the bits of wool that Mother has sent at various times. & he pulled it out & started spinning straight away. He is delighted with the English wool, it runs through his fingers like lightening in such a fine thread, he began to enquire the cost per kilo & price of postage from England. I got Nannie to talk to him & she found out that he would like some to make himself a long sort of vest that they wear under their galabias. He also would like to make me a shawl in coloured wool according to his own ideas. So I think it would be very nice if I could get him the material for both. Will you please talk to Miss Collins nicely about this for me & tell her that I should like about 4 lbs of fine white wool, washed ready for carding (for vest).

Some red, (two shades) green, yellow, & white in about equal quantities about 3 lbs altogether, I enclose the sample of colours, also ready for carding (for shawl.)

If this makes a big bundle, it would be best to pack it in calico, as paper only would get torn, but I am sure you will make an excellent job of this. Address it to me care of Thos Cook & Son, Cairo, & let me know when it is despatched so I can give Cooks instructions to clear it through the customs.

Would you please pay Miss Collins for it, & I will settle up with you on my return, unless either of you prefer a cheque on my Egyptian Bank, (swank) if so, please make out the bill in piastres. 1=2 ½. I have many thousand of them & feel very rich & longing to spend. Also let me know the price per lb & cost of postage to Egypt in case Sardic wants more another time.

It will be rather fun to see how he will use the coloured wool, most of the Bedouin tent patterns are stripes with curious triangle designs. In any case it will be an interesting exhibit for one of the Eastcote shows, & I shall probably use it as a cover for the chest or table in the studio.

I have not told him that I am writing for it, he thinks I am bringing it out with me next winter, but I cannot wait such a long time, it will be such fun to see him spin it & I am anxious to compare the

same workmanship in the two sorts of wool. Also possibly it would be worthwhile to bring some more with me if I come again, getting the natives to spin it all & bring back with me for Miss Collins to use in her weaving. Anyway, all these are just ideas, & may be very foolish when more thought out. The first thing is to get the wool out here & let Sardic get busy –

I hope Miss Collins won't mind sending some of her wool for the Arabs to spin. I expect she will agree with me that it is an exciting experiment. Sardic's tribe has worked with wool for many generations he spins as naturally as a fish swims.

Broome MSS56
Jan 25th 1930
Dear Mother,
Your Turkish Delight is on its way at last, I had a letter from Hadji Bekir (The Constantinople confectioners) to say it was duly despatched, the letter was in French but I was able to make most of it out, it was chiefly about "honoured commands – & distinguished salutations" & such like frills, so I wrote out a cheque in my best style & hope you will receive the goods some-time – I am sorry it will be rather late for your birthday, I sent the order Jan 3rd evidently it got delayed or mislaid.

I am still reigning in solitary glory, it is awful having so many servants with nothing to do. If I make the slightest movement on my scaffold both Sardic & Old Ahmud come running in to see if I wanted anything picked up or held or moved. When I get back to the house I set them to work in Nannie's garden, then she comes out & scolds because they touch something they ought not to touch, or put their feet in the wrong place. Ahmud nearly drowned her new cress today & out she flew & turned him out watering pot & all. Old A went off in disgust remarking "if a man mayn't work he might as well sit down & die".

It has been very cold here the last few days, there is a strong N wind blowing, I am glad to wear my brown coat & stocking cap in the temple in the morning. Nannie sends Abdullah with hot Bovril about 10 o'clock to warm me up, after midday it gets quite hot & then cold again at night. They say it is abnormally cold even for January – the poor natives look more blue than brown.

Abdullah now has a nickname. "Little Demon" Nannie says. "What's that little demon doing now." off she goes to see & you hear shrill Arabic cursing. "Oh you son of a dog – may you be the last of your house" etc. I am afraid we rather spoil the little demon, he's an engaging little monkey, & Nannie has to take some of the swank out of him.

My photos of the Festival at Kena came today they are simply splendid, I will send them on to you as soon as Miss C has seen them.

Broome MSS57
Jan 26th
Dear Mother,
I am still alone in my glory, I do not expect Miss C. back before Wednesday so I shall have the cook's accounts to wrestle with again tomorrow, & pay the men the following day.

Yesterday I sent Sardic over to Nag Hammadi to see about getting the engine back, he left before six yesterday morning & he arrived this evening about 5 o'clock with the engine on a mule cart, he must have had some difficulty with transport & had to stay overnight, I shall have to take his account tonight, as I gave him a pound for expenses, so with Nannie's help I hope to hear the whole history. Ramadan starts the end of this week, I expect our servants will be very tired & sleepy during the day, as they have to eat during the night, we shall try to arrange the work to let them have either the morning or the afternoon off in turn.

Nannie has asked me if you would be kind enough to get her some hair nets, she says she will pay you for them, but I shall not let her do that, I will give them to her, & pay you back on my return. She wants half a dozen small cap shape hair nets, black or very dark brown. You can get them from any hairdresser's & they can all go together in one envelope it does not matter if you fold them, if you are in at Woolworth's would you get 6 of those silk hair nets, they are 2 for 5d. They would be useful for wear in the morning when she is making bed's etc. as they don't tear as easily as the real hair.

Later.

Sardic had quite an adventure with the engine at Nag Hammadi, he got it on board a boat to come to Baliana, & part way here they

got stuck on a sand bank. It was getting too dark to get the boat off
again, so he went to the Omdah of the village & asked for two gaffirs
to guard the engine during the night the Omdah sent them & also
offered Sardic hospitality for the night. Then in the morning they
got the boat afloat again after considerable difficulty, arrived at Bali-
ana, transferred the engine to the mule cart, which brought it to the
Temple, so now I hope all will be well. I had quite a little conversation
with Sardic this evening & he complimented me on my Arabic. I really
am having a hard struggle with it, such a slight change of pronunci-
ation alters the meaning for instance germal is camel, but germāl is
beautiful some of the kh sounds are hopeless & the gh sound is pro-
nounced more like an r. I get frightfully tangled & find myself making
the most extraordinary noises – quite different to what I intended.

The day before yesterday I paid a visit to Mrs Sardic after lunch
it was great fun, I was shown two baby goats, six days old, of course
I had to cuddle them both, then two baby pigeons were brought
for my inspection. They were not fledged so I didn't cuddle them.
Then I had to see the three sheep, they came up to be petted just
like dogs, Sardic said "Their wool is not so nice as the wool of the
English sheep." & I said, "The Arabic wool is very strong, it is like
wire," which remark caused much amusement. Mrs Sardic makes all
our bread, she showed me the oven where it is baked, it is made out
of Nile mud shaped like this [drawing].

One day I am going to see the corn ground, I hear they use a
simple stone mill, I shall try to take a photograph.

Nannie makes such a fuss of me, since I had the bad cold, she
makes a drink of hot lemon & black currant as I still sometimes get a
tickly cough in my throat at night & she insists on bringing me a hot
water bottle & tucking me up. She is such a nice kind old thing, I am
sure you'd love her.

11

STILL ALONE—BUT NOT FOR MUCH LONGER

Broome MSS58
Arabah el Madfunah
Jan 29th 1930
Dear Mother,
This is my last day of solitary glory & it has proved a very nice one. Professor Newberry came to the temple today, he is one of the leading lights in Egyptology and is a most charming man. He came up on my scaffold (which is called "gunterer" in Arabic) & looked at my drawing & said lots of nice things about it. He has the reputation of being a severe critic so I was very bucked, he said I must have a remarkably steady hand as my line work was perfect. He had a lot of Egyptian students with him & he asked if they might see some of the work as he is training them to be archaeologists. So I climbed down & went to where we keep the drawings in a large tin lined box. I had to send one of the guards to fetch Sardic from the engine room as he had the keys. I was quite surprised to find myself giving instructions in Arabic without any hesitation. I usually say the sentences over to myself a dozen times before I dare attempt them aloud. Sardic handed me the finished drawings as I wanted them & I explained the work & methods to the students. The Chief of Police & the Inspector & all the guards were there too so I had a good audience. The explanations were in English of course. Miss Calverley will be very sorry to have missed Prof Newberry's visit, but I know she will be delighted to hear what he said about both our drawings.

She will arrive tomorrow morning by the night train from Cairo. I shall be awfully glad to see her, it is a little bit lonely working all

alone, but I have really managed very well on my own. Nannie is such a dear & all the servants are simply splendid. Fancy that friend of Agnes Broome's saying she could not endure the natives. I expect she was remarkably prim & narrow minded: these people do not show their best side to everyone, but once you gain their liking & their respect there is nothing they will not do for you. Unfortunately tourists only see the very worst type of native, those who have been spoilt by too much contact with all sorts of Europeans & have learnt all their vices & none of their virtues.

To know the people you must live with them, take an interest in all their affairs, be sympathetic & friendly but not familiar. They are very proud themselves & they respect pride in others, it is a great mistake to be too free & easy. In the village near the temple two English women were stoned some years ago because the people considered their behaviour improper. Our servants have a great contempt for tourists, one day I was leaving my drawing things loose on my scaffold as usual to go & have lunch, & Mahmud came up & began to collect them all & put them away. I told him I should need them after lunch, he said "They shall be here when the Excellent Lady requires them, but it is not good to leave them now because Cook's people are coming & they are not nice". I was very amused, & certainly I agree with him some of Cook's people are not nice, their manners & their clothes pass description, but one does see a number of very nice people also but they usually come in small parties.

We have not applied for a permit to dig yet. Somehow there does not seem any time & now Mr Beazley has left we have more work than we reckoned for. I don't expect I shall be home before May unless the hot weather sets in very early.

I had a woman with a bitten arm to attend to yesterday, a savage dog had seized her just below the elbow and fortunately she had the sense to come here at once. Nannie heated some water & we bathed it well with hot Lysol & I painted all the tooth marks with iodine & bandaged it up. I hope it will be all right.

A day or two ago there was a great fuss in the temple & one of the men came to tell me Ahmed Abu Bekku one of the guards had cut his hand on some glass. As luck would have it I had my tin of homocea in my pocket as I had a little sore on my lip from my cold.

So I got some rags that I keep handy & hurried off expecting to see something very nasty & gooey. I found the unfortunate guard half drowned, as I had said "put his hand in clean water until I come" they had poured about 2 jugs full over his hand, arm & galabia & were preparing to empty a third over him. The cut proved to be nothing more serious than a rather deep gash on the second finger, (it had bled rather a lot) so I put a generous dab of homocea on a clean bit of rag & tied it up for him. You should have heard the blessings that were called down on me, they extended to my whole family so you & Father ought to benefit.

Broome MSS59
Arabah el Madfunah.
Jan 31st .
1st Ramadan -
Dear Father.
The Essence of Peace arrived today thanks very much for getting it for me. I haven't seen a ghost of a mosquito since the inundation went down, but I expect they will be buzzing around when I go down to Cairo in the spring.

Miss Calverley arrived yesterday morning. Today after lunch she had another rather important stopping come out of a tooth, so will have to go down to Cairo to the dentist again, isn't it rough luck, it might have come out two days ago when she was on the spot.

3 hours later

Just returned from seeing Miss C off, we walked to the nearest road where the car was waiting to take her to the station. Sardic and Ahmud Abdu Sellam went with her in the car & I returned here with Ahmed Ibrahim our night guard. it is only about a quarter of an hour's walk across the desert, but at night one feels it must be miles & miles as one plods across the sand, the guard walking in front with the lantern. Tonight is the new moon of Ramadan, just a thin sickle in the evening sky.

I am enclosing the photos I took at Kena, isn't the one of the Arab horseman a splendid picture? Kodak thought it so good that they made a special enlargement from it, the ones of the procession that I took from the balcony are very good considering I had to lean

over & tip the camera downwards. I think as photographs they are rather unique. I have made a little plan of one so that Mother can find the things I have described in my letters, if she uses a magnifying glass she ought to make out everything very clearly.

You can see how completely Eastern it all is, not a single European to be seen among the crowd.

Broome MSS60
Arabah el Madfunah
Ramadan 3rd
February 2nd 1930
Dear Mother.

We are having such a job to arrange the work now, with the men sleepy & muddle headed with fasting. I shall be glad when Miss C takes charge again I can manage my work & my men easily enough, but I have to see that Capt. C's men get their proper time off, he thinks Ramadan awful rot, & it's the men's own silly fault if they are exhausted & he doesn't bother a bit to keep to the regular time for changing them, & of course that sort of attitude is what leads to trouble out here. Miss C is most particular to see the men have suitable time for all religious observances & of course I take the same care when I am in charge. Consequently we are "Friends of the Faithful" & not Christian dogs or dirty Infidels.

We are having guests again tomorrow, a General Wilson & his wife are coming from Cairo by the train that gets here in the evening, Miss C will be here by the morning train. Another friend of hers is also coming from Luxor & will arrive midday on one of the American Express Boats. Nannie is busy making preparations – she loves having guests when they are nice people. (but doesn't she hate some.) Nannie doesn't do anything by half.

I am sending a photo that was taken during a luncheon party in the Temple our guests were Herr Lanard, (a photographer from Cairo) & his wife. Herr Lanard fixed the camera & showed Abdullah what to do, & when he had taken his seat at the table again he told the boy to press the bulb. I think you will recognise me on the left, behind me is Mr Beazley & Herr Lanard, on the right in front is Frau Lanard, Capt. C. & Miss C. I hope you admire our table cloth.

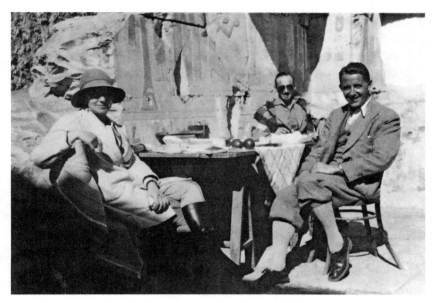
Luncheon party

Two days ago. Dr Capart came to the temple he's head of the Belgian Museum, (do you remember I made him a cast of Akhenaten's daughter) I had to show him all our drawings etc. He tells me we may expect a visit from the Queen of the Belgians in March, won't it be fun. Miss C & I are practicing our curtseys, it's not easy in breeches, we think a manly bow would be more dignified.

Ramadan 4ᵗʰ (Feb 3ʳᵈ)

The expected guests arrived last night. & today being souk day we all went for a picnic in our favourite wady & introduced them to sand slope sport, we are getting experts & enjoy it more & more.

We are now enquiring into the possibilities of making the trip to the oases, 120 miles across desert. Our chief problem is of course water & we have to find out if we can hire camels who are trained to drink once in three days or so. Ordinary village camels who are used to being watered every day are no use for this trip. Sardic is bring-ing the men who make the journey to carry the green dates to see us tomorrow & from them we shall find out what can be done. The inspector of police has offered to lend us the proper riding saddles, the ones we used on the Nag Hammadi trip were only pack saddles

& not suitable for a long trek. We are getting so thrilled at the idea. I do hope nothing will occur to prevent us, but of course we shall not attempt it unless we are quite sure we can obtain everything suitable. Won't it be an experience if we do pull it off. I don't think Capt C will come, he doesn't enjoy camel riding it makes him feel sea sick & he thinks we are perfectly mad to think of such a trip, he teases us about it tremendously.

I was glad to see Miss C back and hand over the accounts etc. The part I didn't like was arranging the men's work in Ramadan. I'd tell them to go for their 4 hours rest as arranged & then find Capt C had told them to look after his belongings while he went off goodness knows where. He's no idea of time, & one simply cannot leave valuable lenses & other Society property about without someone to see it isn't pinched.

It's nearly dinner time & I must go in & be polite.

12

KHARGA

Broome MSS61
Arabah el Madfunah
February 6th 1930
Dear Mother

We are in the midst of our preparations for our visit to Kharga. Last night the camel men came, they can provide us with 7 desert going camels & require 3 days to condition them for the journey.

They do look a band of glorious ruffians fit for some of the 40 thieves, but they are really perfectly respectable & well intentioned individuals. They are wild with delight at the prospect of being engaged for such a trip. Today Ahmed Ibrahim our nice guard & our very good friend, brought the date merchant (who goes into Kharga every date season) to the temple for us to talk to him. His name is Hassan & he has agreed to act as guide. The Inspector of Police has promised to lend us proper saddles belonging to the police force, also special skins for carrying our water supply. Needless to say we do not intend to wash on the journey. We are taking a tiny tent to retire into to change our clothes, as for sleeping arrangements we have blankets & shall crawl into flea bags & sleep on the sand like the camels & the men. We shall not be able to retire any distance for fear of wolves & hyenas. Miss C will have James (the revolver) & of course Sardic & the other men will carry rifles. I can't believe it is really true it sounds like some of the tales we read. Of course something may turn up at the last moment to stop us, the police may get the wind up & prevent our starting. The Marmur is very troubled about us he says, we shall die of tiredness, our backs will be broken

Band of glorious ruffians

in two & there is nothing to see but sand & rocks, (needless to say he has never been). Why don't we have a nice comfortable motor car & go to a place where there is pretty scenery, educated people & good shops for our holiday. We laugh & tell him it is because we are English and all the English are mad & he shrugs his shoulders & says "Inshaalla" (as God wills).

Feb 7th In haste before going to bed. Heard today that we cannot have police saddles because the village where there was the big fight recently is giving trouble again & the police may have to go out in force, so we are having Mahomed & his camel with pack saddle up to-morrow to see if we can adapt it for comfortable riding. I am stuffing my few requirements into a hold-all to carry behind me. my flea bag & blankets will of course festoon the camel.

I am afraid I may have to miss two mails after this as the first chance of posting will be Monday week, so don't be alarmed if you don't get your usual letters. No P.O. in the Libyan Desert that I know of.

I don't think I have ever been so thrilled in my life.

Broome MSS62
Arabah. el Madfunah. Feb 8th 1930
Dear Mother.

Our preparations are now nearly complete & we hope to be off tomorrow morning early, we have had a great fixing up of saddles this evening. The ordinary pack saddles are like this.

Two poles covered with grass matting with padding underneath to fit the hump, the loads are slung on the poles. You can imagine it is not exactly easy or comfortable to sit on for long. We had the carpenter up, & he has fixed poles up in front like the proper riding saddles, like this [drawing]. We are strapping thick pillows on the seat part & with the pole to steady us when the camel sits down & gets up we ought to be quite comfortable. We have food for six days, three roast chickens, 6 tins of beef, 1 salmon, 40 loaves, jam, biscuits, Bovril, tons of fruit etc. the men will bring their own food & we have bought a new goat skin for their water. Our own water we are taking in petrol tins. We shall start about six in the morning & expect to go 30 to 35 miles a day. We are taking a small stock of drugs & a little brandy in case of any accidents, I expect we shall create quite a stir on our arrival. Our local Marmur has advised the Governor of Kharga of our intended visit, as one is not allowed to go without doing so. I suppose otherwise they might think we were a party of bandits.

I expect my next letter will contain more news, this is just dashed off between final packing etc. & will leave here after we have departed as there is no mail tomorrow.

Broome MSS63
Arabah el Madfunah
Baliana, Upper Egypt.
Dear Mother.

Just a frantic note to tell you our Kharga trip was a great success. I have never had so many thrills in my life I will describe my adventures more fully in a longer letter or letters, but I want to catch this mail in case you are a little anxious, the people here, including the local police were scared stiff at our undertaking, but we have carried it through in spite of many warnings & now find ourselves quite celebrities. We

have trekked 130 miles across waterless desert in 4 days, average speed with camels 2 ¾ to 3 miles per hour.

Just think what that meant, we had to push on no matter how tired & stiff we were because everything depended on our water supply lasting out. I have been through a nightmare land, endless plains of stony desert & sandy desert with the wicked mirage shimmering on the horizon, across a land of fantastic rocks like prehistoric monsters. True monsters frozen to stone across a land so cruel & pitiless that one felt even the gods were dead & buried there under strange rocks of tomb like shapes.

Across vast wastes of sand strewn with black round stones, going on & on westward all the time, until we came to a place where we stood on the roof of the world & looked down on a country of sand dunes, tossed up rocks dotted here & there with specks of green where the springs bubbled up, & ringed round with a chasm of limestone mountains.

I never imagined such wild fantastic beauty, we stood & gazed & gazed & could not speak a word until we had to pull ourselves together to face the descent; how we got down I do not know. It was simply marvellous, our camels slid over rocks wallowed down sand slopes & we floundered after them until we reached to level plain in which the Oasis of Kharga lies, many feet *below* sea level. We still had 20 miles to go across this plain but half way, there was a well at a ruin

Final descent

of a Coptic Monastery where we watered our poor thirsty camels & rested for an hour & a half. Then on again, arriving at the Oasis itself something after 10 at night under the full moon of Ramadan.

I must close this scrawl for the post & will write a more sane & readable letter for next mail.

Some of the rocky formations on the high desert remind one of pictures of lunar landscapes.

Broome MSS64
Arabah. El Madfunah.
Feb 16th 1930
Dear Mother and Father.
I am going to try to give you some little account of our exciting journey. I expect you will be able to find the Oasis of Kharga on the map, it is a place very seldom visited by tourists because of the difficulty of getting there. It is possible to reach it in one day by a single trolley line which was laid across the desert at the easiest approach, some long way down the line from Baliana about 20 years ago. They run a little train part way & a trolley the rest of the journey once a week, the only other way to get there, is as we went by camel. Our old guide told us that as far as he knows we are the first Europeans to take the old camel trail for 25 years & never has he known or heard of solitary women attempting it as we did. Lots of people tried to discourage us. When Miss C was in Cairo she mentioned it to Dr Junker the head of the German Institute, & M. Benaise the French Inspector of Monuments both did their best to dissuade her. They said it was a most dangerous undertaking to travel across a waterless country with only a native guide & servants. They told her all the awful things that might happen & she came back from her visit feeling very depressed about it, especially as she had suggested that a great friend of hers should join us & she had jumped at the opportunity.

However we talked it over & then had Sardic in & told him of all the dangers that had been pointed out to us. He said Oh yes certainly such things might easily happen if suitable camels were not taken or if certain precautions were not arranged properly but he would see we had proper camels & everything required. So we cogitated on one side, a Frenchman & a German, both excellent men, knowing the

country for many years, but also having decided ideas about a woman's limitations. On the other side, a Bedouin Arab, a trusted servant & willing & eager to take all the risks with us, & with a firm belief that the English ladies could do anything they attempted. We finally decided to take an Arab's word & go; then preparations began; Miss Alexander arrived a few days before our proposed departure, she is charming, a young forty, very jolly, a writer, making a leisurely journey round the world to visit all sorts of places. She proposes going to India via Persia, after leaving Egypt & expects to take 3 or 4 years over her travels. So you can see she was an ideal companion & delighted to have such an unusual opportunity. She had taken several camel rides in Cairo so as to get hardened for the longer journey.

I told you in a former letter how the Marmur let us down over the police saddles & water carriers he had promised to lend us, & how we got the village carpenter to convert 3 pack saddles into riding saddles, we have good reason to believe this failure on the Marmur's part was a ruse to stop us. He thought we would not go without the proper saddles & he knew there were no others to be had, the excuse about the turbulent village was mostly bunkum as camels wouldn't be used in a local rising.

With converted saddles, petrol tins for our water + two water skins for the men we thought all was prepared, but oh dear no. The afternoon before we started our guide sent word to say he had a belly ache & could not come (probably the belly ache was also provided by the Marmur). But Sardic knew of another guide from a further village so we sent to him, & the sporting old boy said he would come, & promised to meet us at the entrance to the wady soon after dawn the next day.

By six o'clock on Sunday morning our cavalcade had assembled, there were 7 camels & 7 men, we carried our own personal effects – rugs etc. & a sack of camel food on our camels & the four others took water & provisions, our little tent & the rest of the camel food & the men took turns to ride. By 7 o'clock we were on the road (figuratively speaking).

We had a tremendous escort for the first 4 miles, all the rest of our servants, guards, friends of the camel men etc. came with us. At the entrance to the wady our guide was waiting for us with his camel, a

supercilious lady who proved an amusing, though rather troublesome member of this expedition, as she was a dreadful flirt & two of our gentlemen camels fell in love with her. It was a great business getting the camels up the wady, you have seen the photos so you can imagine what it was like getting up to the top. Here we bade good bye to our escort with many blessings & good wishes for our safety & set out on the great adventure. Our caravan consisted of we three females, Sardic, our guide, 7 men & 8 camels. We arranged our going thus, during the morning trek we walked for about two hours & made the men ride our camels. We had rather a job to make them ride while we walked at first but we insisted, at 11 o'clock we stopped for a drink & biscuits, then on till 1 o'clock when we had lunch. Started again 2.30 or 3 & kept on till 8.30, right through sunset & on by brilliant moon light; we had timed our trek for the full moon of Ramadan, (our men got exemption from fasting during the journey.) The first part of the journey was across stony desert, in parts there was quite a definite track but there were vast areas where there was no sign of any path except here & there a few stones were piled on each other to guide others. Thus we also made little cairns as we went.

The afternoon trek was the most trying, we were going due west & the sun shone right in our faces, we wore sun glasses, & soon found we had to cover our noses & mouths with a handkerchief as our lips & nostrils got so dry & cracky. It was during the hot afternoon spell that we first saw the mirage, we could see the sparkling water rippling over the desert sand a few miles ahead of us, the Arabs call it "Bahr Shaitan", i.e. Sea of Satan. It made one realize the mocking cruelty of the desert & I think we all felt our expedition had a grim side to it. Then came the glory of the sun set, the desert flooded with golden light, then pinkish mauve & as the sun dipped below the horizon our shadows came from behind us & walked in front & we were going by moon light & what a change in the landscape. The golden sand gleamed palely & the big patches of limestone were like snow drifts.

The first night we camped near the Trolley rail, you will see I have marked it on the little sketch map I have made. We had a meal of roast chicken, bread, tomatoes, & a slab of rice & date pudding. & Sardic made us hot tea (no milk), never have I appreciated tea so much before. Then we removed our boots & jumpers, crawled into our flea

bags, our little tent was just sufficient to shelter our heads from the moon light & give us a semblance of privacy & we slept & slept & slept. No complaints about hard beds or anything. At five thirty we were up, the camels packed & on the way soon after six.

The second day's journey took us across an immense plain fringed with low sand hills, it seemed as if we spent an eternity crossing it but at last we got into more broken up country & it was here we made a discovery. We had noticed lots of broken pots as we went along, but this place was covered with them, we examined the area carefully & came to the conclusion it had been a Roman Camp & that this camel track was really the remains of an ancient Roman road from the Oases to the Nile valley & that they probably had water dumps at regular intervals & always near some outstanding rock or mound. The country grew more strange it was like thousands of tombs in outline like this.

The guide said it was called Zigga Gat & from of old the people said immense treasure was buried beneath the mounds but the place was dangerous, no man could live in it long enough to steal the treasure. It was a terrible country, here not only cairns marked our way but skeletons of camels, our guide pointed to one & said it had been his 22 years ago, it had gone mad in the desert & had died there but praise be to Allah he had another. It was sunset before we got through the Zigga Gat & the effect of the long shadows cast by the mounds was weird, it gave one a horrid feeling that something inhuman & malevolent was lying in wait watching. We called it the land of the gods who were dead, we had a very strong feeling that we had no business there whatever. The next part we came to we called the land of the Brontosauri, here the mounds were crowned with extraordinary cracked rocks exactly like giant prehistoric monsters that had gone to sleep there & got turned to stone. This is the sort of outline as far as I can remember.

We camped among these rocks, they were weird & alarming but one did not feel they were malevolent like the Zigga Gat. That night we had bully beef for supper & the rest of the rice pudding. Our breakfast consisted of hot tea, 2 hard boiled eggs each & an orange & bread. The outstanding feature of the 3rd day's trek was the petrified sea. (our name for it) it was exactly like a rough foamy sea turned to

8

tree & got turned to stone. this is the sort of outline as far as I can remember.

We camped among these rocks. they were weird & alarming. but one did not feel they were malevolent like the Zigga Zat. That night we had bully beef for supper & the rest of the rice pudding. Our breakfast consisted of hot Tea, 2 hard boiled eggs each & an orange & bread. The outstanding feature of the 3rd day's trek was the petrified sea. (our name for it) It was exactly like a rough foamy sea Turned to limestone & stretched as far as the eye could see. It was rather rough going for the camels as the surface was all cut into ridges by the sand. It was something like this.

Beyond the petrified sea we came to the land of Water Melons. This was a vast sandy plain

limestone & stretched as far as the eye could see. It was rather rough going for the camels as the surface was all cut into ridges by the sand it was something like this. [See above letter.]

Beyond the petrified sea we came to the land of the watermelons. This was a vast sandy plain covered by huge round black stones, just like giant water melons, where they came from or what they were we have no idea. All the surrounding rocks were white limestone we

thought of meteorites, but we examined a chip from one & it was not heavy enough.

Towards evening the 3rd day we sighted an extra large mound or Tell with a very high post sticking up, the guide did not know its history but said it had been up there to point the way to the gateway of the descent. That night we camped on a rocky plain like a sea shore that the tide had left & forgotten to return, the moon was so bright that I attempted to take a photo by its light. I haven't much hope of any result, but thought it would be fun to try.

The 4th & last day was the most thrilling, our guide had said we should see the gateway (i.e. way down to the oasis) by noon so all eyes were strained on the horizon, at 10.30 we reached a slope like this.

(Oh the songs that were sung & tales that were told on the journey).

We made a short stop for our mid morning refreshments & sitting on the ground I noticed the little flat pebbles were of uniform size & shape. I picked one up & found it a perfect little flat shell like an ammonite, we had a good hunt & found some fossilized bones that look like fish bones, we have brought some back to show to experts.

After descending the slope we had another long plain to cross & then quite suddenly topping a slight rise came upon the most marvellous view. We were standing on the edge of a great chain of mountains, below us great clefts & tossed up rocks & beyond a great sandy plain with wonderful dunes & two beautiful isolated mountains standing like sentinels guarding it. Miles away in the centre of the plain were wee green dots which were Oasis's. Then came the descent, at first it was like a mountain pass winding in zig zags. The three of us were positively drunk with the beauty & wonder of it, we jumped from rock to rock like mad things, the men too were impressed.

Down we went the men leading the camels, down & down until we thought we had reached the end, then the guide said he knew a short way a little rough at first but it would save an hour & a half. So we said very good we will go, well we did go!! the very ground seemed to fall away from our feet, it was a sheer sand slope dotted about with rock & boulders; this sketch is *not* an exaggeration. Our guide led the way & he & his camel went down like mountain cats. It was simply amazing, we were struggling down & there we saw him, like a little

ant far below & the old devil stopped his camel at the foot & calmly reclined, at his ease in its shadow & laughed at all of us, for sheer impudence I think it beat everything.

He was a grand old boy about 60 & absolutely tireless, he could do more than any of the younger men. They were furious with him for taking such a dangerous way & he just laughed at them, there was very nearly a scrap up but fortunately there had been no mishaps & it blew over.

We had really got the level of the plain at last & there was the promise of water at our next stopping place. Before we came to it we passed through very wild country as if it had been mangled & rent by earthquakes. Then plain again & then before us a track leading to a ruined Coptic Monastery & a WELL, it was nearly 2 o'clock & we had been going with only ¼ hours break since 6.30. What a joy it was to flop down in the shade of the great wall & see our poor thirsty camels led off to be watered & how glad we were to drink our own water & feel we need not treasure every drop.

We had not nearly reached our journeys end, the guide said we had 15 to go & should reach Kharga by 8 o'clock. After 1 ½ hours rest we set off again through wonderful sand dunes like giant puff balls, everywhere was sheer beauty the plain, the dunes, the sentinel mountains & the great range that made a chain round us. As the sun set so the colours changed & the shadows made new forms & outlines. It was a trek, at 7 o'clock we said "where is Kharga?" & the guide said it is still a little further on. It was – the 15 miles from the Monastery stretched out to 20 & the hour of arrival was 10.30 instead of 8.

We had got a permit to use the Government Rest House at Kharga & we were looking forward to getting out of all our clothes & having a real wet wash, the thought of that wash spurred us on – but alas, the guide missed the rear entrance as it was at night & had to take us all round the Oasis to the main entrance on the further side, it is like a fortified town. One has to go in by special entrances. Here we made enquiries & learnt the rest house was 5 kilos off this was the limit. We camped then & there, we had reached Kharga which we felt was in itself a great triumph & were content to postpone the joys of washing till the next day.

I am going to leave the story of our day in Kharga till another letter, there are lots of things I have forgotten to mention in this account, for instance on one part of the trail was a mound that the guide pointed out, & said it was the grave of a man who had died on the way & all our men each took a stone & cast it on the mound, the idea being that if each man who passes, adds one stone, in time it will grow to a great monument.

We also noticed that our camels wore neat little cotton bags tied on to their bridles, these contained little texts from the Koran that Sheikh Abdu Wahid had written specially to protect us all on this journey, they were most effective.

Now for general news. My boots & shoes have arrived, & are most satisfactory, the hair nets also are to hand & Nannie is delighted. I am also glad to hear the wool will soon be ready, I had a letter from Miss Collins a day or two ago but the one about the Exhibition must have gone astray. I am enclosing a few local snaps. I hope to have the photos I took on the way to Kharga in about a weeks time. I used 5 rolls of films I do hope they will be good ones.

I do hope you do not very much mind my staying later than I at first anticipated, we do so want to get the material for the first volume ready & Beazley's failure has thrown a lot of extra work on our hands. I am afraid my letters may give you an idea that we have more play than work but I assure you it is not so, we have lots of fun but we do work very hard. Oh the tales I shall have to tell on my return.

Broome MSS65
Feb 20th 1930
Dear Mother & Father.
I am going to try to describe our day in the oasis. I told you how we got as far as Kharga but were too tired to attempt the extra 5 kilos to the rest house.

In the morning we did not rise as early as we did on the trail, it was past seven when we crawled out of our rugs. We made a hasty toilet, had breakfast, saw the camels loaded & set off. The Government Rest House is built on a little hill close to an old Coptic burial place; the guards were looking out for us & they showed us all the accommodation, a living room, table & chairs, 2 bedrooms each with two beds,

chairs & washstand & pegs to hang clothes on. Table appointments of a solid nature were also provided. Our camels all sat down outside & our goods were carried in. Our first demand was for hot water, we had a glorious wash all over, & got into real clean clothes & felt like giants refreshed. Our first expedition was to a Coptic Monastery, it was built of mud bricks, & inside was a mass of tiny cells, each with a vaulted roof; it was on a high hill & the view from it was superb. When we looked across the plain & sand dunes to the distant mountains it was difficult to believe we had made such a journey in one day.

After the monastery we visited the Coptic tombs, they were like tiny chapels, square with a dome. The inside was painted with conventional designs & some biblical subjects, there was Eve sitting next to St Peter & a few other biblical subjects & there were very strange pictures of the Ark & the flood etc. We explored several of these tombs & then came down the hill & walked a short distance to a fine temple built by Darius the Persian. It was in the usual Egyptian

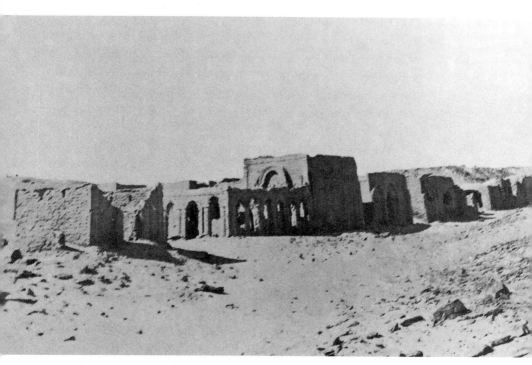

Early Christian tombs (al-Bagawat)

style of architecture, but the walls were decorated with several strange gods besides the usual groups of Osiris, Isis, & Horus, etc. We decided to pay a polite call on the Governor of Kharga next so donkeys were procured. & off we trotted, back over the 5 kilos we had come in the morning. The Governor received us most politely & regaled us with coffee, enquired about our journey & expressed regret at the short-ness of our stay in his domain. He said we must be sure to visit the ancient part of Kharga, & he kindly gave one of the guards instruc-tions to show us everything of interest.

So, after a decent interval we made our adieus & set off sight-seeing once more. The guard took us down lots of quaint old streets & along curious dark tunnels that twisted & turned with other dark tunnels leading off from them, only here & there a shaft cut in the roof to admit a faint gleam of light. The whole place is like a rabbit warren, the walls built of mud & roofed over with the trunks of palm trees & houses built above them. The place was built in this curious way as a protection against invading bands of Dervishes, Senusi etc. The people would take refuge in these underground places & block them against their enemies, the last raid took place in 1914. Since then it had been fairly peaceable & the underground streets are used more for protection from the heat than anything else. Our guard took us to see a mat weaver, a most primitive affair of ropes & sticks. I bought a jolly rush praying mat for 11PT, it looks so fine hanging on the wall of my room here.

We reached the outskirts of the old village. & here the guard showed us one of the springs, it was a large pool with the water bub-bling up in the centre, they call it the Eye of the Sheikh.

The guard who was showing us round invited us into his house we went up stairs (outside) to a room where his wife & another woman were sitting, there were just rush mats on the floor & we were invited to occupy the finest of these. So down we squatted, & had a very pleasant conversation, we admired their dresses & ornaments & they politely replied that ours were much nicer. They offered us dates & oranges, & what we did not eat then we were obliged to take away with us.

We made inquiries about the weekly train which was due to leave Kharga the following morning. We had timed our visit so as to be able to return that way, as we could not spare the time from our work

to make the journey by camel both ways. The station was over three miles from our Rest House but the rail passed close by it & our guide said perhaps they would stop the train specially for us. So on our return ride we stopped to see the station master, we asked if it could be arranged for us to get on the train near the rest house, he said at first that it was quite impossible to stop the train. He inquired when we came to Kharga as he had not seen us the previous week when the train came in, we explained that we had arrived the previous night by camels from Baliana. He held up his hands in amazement & said. "Oh then certainly the train shall be stopped for you" so we bought our tickets then & there & arranged to be waiting by the rail a little before 7 o'clock the following morning.

We had a very nice supper of scrambled eggs. biscuits. oranges & dates. & went to bed early, it was strange to be in a real bed again but I didn't sleep half as well as out on the desert. (I forgot to tell you in my last letter how my nice old camel man used to sing Arabic songs to me by moonlight & judging by the twinkle in his eye I fancy they were love songs, but he was so very nice & respectful that I am sure they were quite proper & all they ought to be, he had a beautiful deep voice & sang very softly as he walked along. Some of the men made up songs as they went along like this. Oh the way is long, the desert is hot & thirsty & we are far from our homes. They use the same words over & over again but vary the ways of singing – but to continue my story –

We were up & packed in time to catch our train which stopped with many snorts & puffs, it was a funny little affair more like a tram than a train & had 3 engines to get it up to the high desert. The pass we went up by was a more gradual ascent & had been blasted out of the rocks in places to make way for the rail. The scenery was lovely, but did not compare in any way with the gorgeous pass we came in by. The rest of the journey was dull & uneventful, at 3.30 we left the train & continued by trolley car. The line ended a little way from Nag Hammadi & our friends the Ellisons had sent a car to meet us, so we paid them a visit for a belated tea, & continued on by car to Baliana arriving about 10 o'clock at night.

At breakfast the next day we had a visit from Ahmed Ibrahim to congratulate us on our safe return. & in the evening the Omdah &

several others called, the village had evidently been in a great state of anxiety during our absence. The following Tuesday our camels came back & the men all came for their money. We gave them 21PT a day for 10 days & 50PT as backsheesh, the old guide had 25PT a day & 100PT (£1) as his backsheesh. He made long calculations & looked his extra 100PT note over carefully & remarked. "This will not go very far, as I have to entertain the Omdah & all my village to celebrate my return." We were amused at this, but didn't stump up any more. He was really very pleased with his pay, it's not very often he gets the chance of earning more than 20PT a day & his tip was equal to 5 days pay, but of course it is very seldom an Arab will admit he is satisfied. My old camel man was the exception, he was delighted with his pay & said so with many "May god increase your goods" & "Allah preserve your excellencies" etc.

The old guide was a wonderful character, he knows all the ancient names & folk lore of the desert. We got him to tell us all the different names for the places we went through & Sardic wrote them down in Arabic. & then we got Nannie to translate into English. As we went along this old guide used to relate thrilling fairy tales to the men. Miss C got a sort of idea of what he was telling, but the Arabic the old tales are told in is rather different to that used in ordinary discourse & not easy for a European to follow. One day he was remarkably busy, we saw him squat down & begin scratching about in the sand & then come running with a bundle of something in his scarf. He did this several times & we finally discovered he was collecting ancient dried camel dung. He used this to make a fire when we camped at night, it made a splendid blaze, & the red embers lasted a long time afterwards. It was a wonderful picture, the group round the fire & the flames lighting up the circle of sitting camels & the strange background of tumbled rocks, it didn't seem like real life at all. we seemed to be living some wonderful romance in another planet.

Thank you so much for the nice little slumber cap & birthday wishes. I think I would like to wait until I get home for the real celebration.

I am not in need of note paper or envelopes really, as there is always a good supply of this paper for everybody. I found my block handy as it was ruled, & I could write with it on my knee in any old place.

My new boots are very comfortable & look nice & strong. I hope they have nailed right through into the uppers as I asked.

We are to entertain royalty next week, the Queen of Romania is visiting Abydos & we shall have to assist in entertaining her, showing the drawings etc. We have been practising our curtseys, not easy in high boots.

The Queen of the Belgians is to come in March, date not yet fixed.

13

GUESTS AGAIN

Broome MSS66
Feb 25th
Dear Mother.
Here are the snaps I took on our journey to the Oasis they may help you to see a few of the things I have tried to describe but of course they fall very short of the reality. The lens flattens things in the distance so you get no idea of the splendour of the mountain called The Plunderer nor the ruggedness & grandeur of the descent. But the camels, with their many strange bundles are really very good & the one of me I am sure will amuse you very much. & perhaps you will be able to see how strange some of the desert formations are – not at all one's idea of flat sandy plains.

The Plunderer

We are settling down to work in earnest now. I still have three days of my leave which I shall probably spend with the Bruntons next month. There is more work here than we can possibly get through this season without help so we are having a new man on a week's trial, to see if he can carry on with Beazley's job. His name is Charles Little & he was recommended by Mr Gunn (friend of the Imps) so we hope he may prove useful, he is coming today. He didn't waste any time accepting Miss C's offer to pay his expenses for a week if he liked to come & try his hand at copying ceilings he simply wired, arriving [at] Baliana 6 o'clock tonight, he evidently took the first train after receiving the letter. I hope such enthusiasm bodes well. In some ways we are loath to have a stranger since we are so very happy as we are, but he may prove very nice & anyway nothing definite is settled, we needn't keep him on after the week if we don't like him.

Ramadan ends either Saturday or Sunday, it all depends on the moon. The first day after Ramadan is a great feast & we shall go to visit the houses of all our native friends to offer our salutations & good wishes. We shall have to drink coffee & taste food everywhere & shall probably need a good dose of our own physic afterwards, but it will be fun & I hope to describe it to you next Tuesday.

Last Sunday we had great fun, a party of Bedouin with real hajin trotting camels passed the temple & one of the guards told them there were two English ladies who were very interested in camels, so the men waited & of course when we heard they were there we left our work & went out to see them. They (the camels) were beauties with real riding saddles, we got up & had a little ride on two of them & then the chief Sheikh gave us a display of real camel riding. He just spoke to his camel, & as it rose he leapt to the saddle, & off it trotted, circling & turning, then broke into a gallop, then as he came towards us at the trot he just leapt from the saddle & ran beside it. I have never seen anything more elegant & graceful, his saddle had a lovely cover red & black & white & blue woven wool with great fringes & tassels. Miss C. admired it & asked if she could buy one like it & he offered to sell her that very one. She gave him PT230 for it, he accepted it & handed over the saddle cover saying "This is a gift the money is a mere nothing", we now have this gorgeous thing spread over our lounge chair in the dining room.

There are great preparations being made for the Queen's visit next Thursday, a special road has been made to the Osirion, & a new flight of stairs fixed for her to go down by instead of the plank that ordinary tourists use. M. Banaise the Chief Inspector of Monuments arrives tomorrow to see all is in order for her, he will probably be here for lunch & dinner. There will probably be a lot of fuss & palaver as he is a Frenchman.

I am afraid this letter is rather tame after the two previous ones, still one can't have adventures *all* the time & I certainly don't think I have missed much.

Broome MSS67
Feb 27ᵗʰ 1930.
Dear Mother.
I made my curtsey to royalty today, Queen Marie of Rumania was charming, she talked to Miss Calverley & me for quite a long time & was delighted with our drawings. She is very beautiful & was dressed in a dove colour, I think it was a very heavy dull crepe de chenin, but enough of Queens we find them rather dull & boring & much prefer our nice people here.

In the following seasons the women entertained more visitors including many more royals. Apart from the Queen of Romania who visited in the first season, they also had visits from the King and Queen of Italy, the Crown Prince and Princess of Italy, the Queen of the Belgians, the ex-King of Bulgaria and, amongst others, the many relatives and hangers-on of the Egyptian Royal family and the King himself.

Usually a little something would arrive with these visitors.

Broome MSS166
We have great excitement to-day Lady Lorraine[8] paid a visit to the temple she had her father & mother with her & several other people from the Legation. There were great preparations, The road from Baliana was mended, all the military & police from miles around were in attendance, also a young regiment of camel corps & of course all

8 Lady Lorraine was the wife of Sir Percy Lorraine, the British high commissioner to Egypt from 1929 to 1933.

Arabah & Bene Monsur came to see the arrival, We, being the only British representatives in the place received them, & showed them round & generally did the polite. They were most awfully nice & insisted on us having lunch with them. A magnificent spread had been specially sent down from Cairo, we provided the table. (the two large drawing boards on trestles that we play ping pong on). We had sardines, tunny fish, pate de fois gras, ham, turkey & trimmings chocolate cake, chocolates, marrons glaces all sorts of fruits & coffee & various wines. It was some picnic & everyone enjoyed it I am afraid very little work was done.

Of course we showed our paintings & they were very much admired.

The amusing thing is that Nannie & the native servants are basking in reflected glory. They are so puffed up with pride at our intimacy with such important people that there is no holding them.

The most important visitor in January 1937 was the king of Egypt himself—King Farouk.

Broome MSS391
The King is coming to see the temple on the 14th of this month & there are great preparations being made, the Queen will be with him & the two Princesses, so we will have to be in attendance, All the road from Baliana is being decorated with pylons & obelisks & flags & all sorts of things. he will have lunch in the Temple & depart about 4 o'clock so it will be an all day affair.

Myrtle's description of the visit is really interesting, and she gives us an insight into the royal family at that time. The queen she mentions is Queen Nazli, the Queen Mother. King Farouk was only sixteen years old during the visit, and his tour of Upper Egypt was groundbreaking. They traveled on the royal yacht Kassed el-Kheir and received a great welcome from the Egyptian people wherever they stopped.

Broome MSS393
There was great excitement here last Thursday when the King came to visit the temple, Amice & I were presented by the Head of the

Service des Antiquities, & we made our curtseys as advised by one of the Residency ladies, it had to be quite a low dip with the knee not quite touching the ground, Amice & I had practiced it the day before & did not in the least need the very helpful uplifting handshake that the King gave us, he is a nice looking lad, a little too plump & floppy perhaps for English standards, he has quite a fair skin & grey eyes, the Queen is really lovely she has the real oriental type of features with enormous dark eyes & a pretty slim figure. It must be an extraordinary experience for her to come out into the world & go about with her son like a European lady after living shut up in the harem during her husbands' life time. She wore fashionable French clothes & no veil, some of her ladies-in-waiting wore a tiny yashmak over the lower half of their faces. The four princesses were with her, the youngest is six years old, they were all nice looking & one of the middle ones was quite beautiful.

We showed them the books & some of the work we have done this year & they were very interested. The King & the Royal family had lunch in a tent specially erected for him overlooking the desert, & the head of the S. des A. had lunch with us & the Kings English tutor escaped & joined us & we had a very merry time.

After lunch we went down to the Osirion to see the lighting arrangements in the underground chamber, a special engine had been brought out to make electric light but the electrician had not realized the size of the chamber & the globes he had brought were not nearly powerful enough, so Amice had one of our large mirrors brought down & a silver paper covered reflector & by this means flooded the place with sunlight & quite out did the electricians efforts; so our method was used when the King came & he was very interested & went & had a look at the reflector that Sardic was holding & gave Sardic such a nice smile, you can imagine how proud Sardic was.

I forgot to tell you that our own native musicians supplied the music during the Kings lunch, we had got them all collected and ready & Amice asked the master of Ceremonies if they might perform as she could personally recommend them, so it was arranged, & they sang a special song of their own for the king & he was so delighted that he gave them £5 you can imagine the state of

excitement they have been in ever since. Today the zummara player came round to tell us that the Omdah had got an illustrated newspaper & there was a picture of them playing in front of the King; & he said "There was the whole story of it written out so that all the world could read it."

Many of the well-known names in Egyptology also visited, such as Alan Gardiner and Hermann Junker. Hermann Junker was a special favorite of the women.

Broome MSS171

We have had Dr Junker staying with us the last three days, he is such a dear & the most unpriest like priest I have ever seen. He is most frivolous, loves a joke & is most broadminded in every way. He has been going over the ceiling inscriptions to be sure we have got everything correct, & not missed anything in the broken parts & he says we have done it wonderfully considering the difficulties.

He had no objection to working on Sunday, he considered it the proper thing to do under the circumstances, he said, "of course it does not matter, will I not be heavenward all the time". We were quite sad to see him depart by this morning's train.

James Breasted and Dr. Nelson from the Oriental Institute were also frequent visitors, along with many others over the years. Some came to work, others were friends, and still others came just to admire the work being produced there and of course the temple itself.

Upon hearing of the death of James Breasted in 1935, Myrtle had this to say to her mother:

Broome MSS356

I wonder if you have seen the notice of the death of Prof. Breasted, we saw it in the Egyptian Gazette yesterday, it must have been very sudden as he had only just reached New York. The Egyptian paper reminds its readers that he was present at the opening of Tutankhamen's, & hints again of the curse being the cause of the death of all who assisted at the opening. We are all very distressed at the news, especially as he was our guest so recently.

The women built up quite a reputation for their hospitality and it was all done on a shoestring, with a lot of the costs coming out of Amice's pocket. But as with all things, they also had the ones who would take advantage of this hospitality, as Myrtle wrote indignantly in a letter:

Broome MSS117
We have had another invasion, I told you about the previous one in my last letter.

Some more people, again perfect strangers wrote to ask Amice if she could put up a party of four people who were motoring from Luxor for two nights. We thought it pretty cool cheek, & she wrote & said that we had only a very small staff & could not accommodate so many & again suggested they might apply for the Antiquities rest house. She had a letter a few days ago to say they were putting up at the rest house, & could we lend them extra bedding, cooking utensils, crockery etc. & get in provisions for two days, & wire reply. She sent a telegram to say we would do everything we could to help them. & the next day being market day purchased two chickens, a leg of mutton, eggs, tomatoes, lentils, oranges etc. The following day the party arrived, They were a very dull uninteresting lot of youngish people, a Mr Jones & his wife he being a minor government official & a Mr & Mrs Mackintosh – who proved to be vegetarians!! they told us that M. Lacau would only issue a permit to the Jones couple for the rest house, The others not being Archaeologists or government officials were not allowed to use it, so what could we do about it.

Well, under the circs – the only thing we could do was to offer to put the two up. We gave them all tea in the Temple & invited all four to have dinner with us that night, it was then that we heard that the M's were vegetarians, rather difficult to cater for out here. After tea the party went to look round the Temple & we were just returning to our work when in came two delightful friends, Mr & Mrs Sandford, I do not know if I mentioned them in an earlier letter they are quite young & both Geologists, she was a Girton girl, & they are now touring up & down the desert level of the Nile valley making a geological survey & collecting data for an early history before Neolithic Times. They go about in an ancient Jowett car & a still more ancient Ford, & where cars can't go, they travel by boat or camel or donkey. They

had promised if ever they were in our locality they would come & stay a day or two with us. Imagine how sick we were at being cluttered up with dull tourists just when our nice friends turned up. When they heard of the invasion they said of course they wouldn't bother us, they could easily pitch their tent near our house, but we wouldn't hear of it, They'd been sleeping on camp beds in a tiny tent that they carry on the car, for several nights on end & a comfy bed & washing arrangements were a great treat to them, so we insisted that they had the guest room & we'd make shift in the smaller room with a couple of camp beds for the tourists, They'd just come from a luxurious hotel in Luxor so it wouldn't hurt then to rough it a little.

So Amice & I hurried back to the house to break the news to poor Nannie & to prepare the extra room, the tourists arrived in the middle of it. They stood & watched Amice put up the camp beds & make them, & never offered to lift a finger to help. I was busy filling a basket with provisions we had got in for them, for the Jones to take back with them to the rest house after dinner, also sorting out extra crockery etc, it was rather a strain on our resources. Nannie of course was hard at it preparing dinner & Abdullah was laying the table. The guest room that we insisted on the Sandford's having was all ready except making the beds. & Nannie said she would see to that while we were at dinner, but as soon as the Sandford's arrived they brought what they needed from the car & made their own beds & then offered to do anything they could to help us.

We learnt afterwards that Mr Sandford found the tourists car stuck in the sand on the way from the Temple, so he & his native servant (who drives the Ford) got out & put their shoulders behind & shoved it out while Jones & his friends looked on.

Nannie had prepared a huge bowl of barley broth, & a dish of stew to follow & cooked one of the Xmas puddings that we had over from the Xmas stores for the sweet, so we gave them a good dinner. During conversation, Mr Jones said to Amice "I suppose you have a hospitality grant" I am afraid we all stared in amazement. & Amice said "Oh no, the society provides us with everything necessary for the work, but all such extras have to come out of my pocket". I don't know exactly what reply they made to that, but the subject was quickly changed.

We sat up talking till long past our usual bed time & it was past 10.30 before the Jones made a move to return to the rest house, we had to send a man to show them the way.

Broome MSS67 contd.
Our hospital parade is going strong just now. we have a most attractive patient, a young man whose profile would be worth a fortune on the films, a delicate aquiline nose, perfect shaped mouth & chin, & black eyes & eyelashes that are simply sinful to be wasted on a man, of course these features are shown to perfection by his picturesque national costume & his manners are as charming as his face. We have been having a very anxious time with him, he came to us with the most ghastly hand I have ever seen, he had been working with a native spade & got a blister at the base of his little finger & the next, this got septic. & gathered, & spread for 20 days. Then someone told him about the English people at Arabah, & he came 8 kilos to see if we could do anything for him, it was dreadful. The outer skin of the palm had rotted, the other skins were all separated & the tendons exposed & the stench nearly made us sick. Miss C. told the man he ought to go to the doctor & he said "I am a poor man & the doctor will do nothing unless he receives money I cannot pay him."

We knew this was true, local doctors are not friends of the poor by any means, so we wondered what we could do. Miss C had some hospital training during the war so she has a good general knowledge. She washed this dreadful hand in hot lysol water & tried to remove the rotting skin. Then I suggested a bread poultice, we made this with boiling water slightly salted. Tied it all over the mans' hand & told him to return early next morning. When he came again he offered us a bundle of beans from his little bit of land, it was so pathetic. We thanked him but could not accept, to take any sort of payment even in kind would get us into trouble for illegal practicing. We got the poultice off & it had softened the skin & drawn out a lot of bad stuff & made it easier to wash, but we were both frightened at the look of it. Miss C was afraid of gangrene. So she told the man he must go to the doctor at Baliana straight away & she would pay the doctors fee, she wrote a note for him to take asking the Dr to look at the hand & send written instructions how to treat it. So the poor man had to go

another 11 miles there & back & he was weak & ill with the pain of this hand, but we didn't know what else to do. However at sunset he was back, he was quite done up as it was Ramadan & he was fasting. They are allowed to drink & eat a little at sunset, so we told Sardic to take him into the kitchen & see he had a meal, we had quite a job to make him accept food, he said all he came for was to beg us to save his hand, however we said our house would be shamed if he left us hungry, so he ate a few dates & some bread. He brought a letter from the doctor to say it was a bad case & had better be washed with lysol twice a day & treated with iodine & antiseptic gauze dressings, which was exactly what we had done.

So we have been dressing this hand night & morning & it is really getting better, it is now clean & healthy looking, & after a weeks treatment shows signs of growing flesh over the tendons. One day we had a bad fright, there was fresh inflammation & the whole hand & arm was hot when we took the dressing off, we both agreed a good dose was needed but the problem was how to make a Moslem drink in Ramadan & to wait till sunset would mean spread of inflammation. So we got Nannie to talk to him & explain that he must take the medicine at once to drive the poison from his blood, the poor man had an awful mental struggle for he firmly believed that if he drank he would be eternally damned. We quoted the Koran which gives exemption to travellers, to women with child & the sick & we told him his hand had made him a very sick man indeed. So he said. "It shall be as you say Oh excellencies" so we prepared the father of doses of Epsom Salts. & he took it & prayed to Allah to forgive him for his great sin & then swallowed the beastly stuff. He was given hot tea an hour after & the next day the hand was cool & much better so we said it was a sign that he had not sinned but had obeyed the law of the Prophet. It will be a long time before the hand will be fit to use again. & probably the little finger will be always stiff but he is wonderfully patient. He never even winces, & once Miss C. had to cut away a bit of the tendon that was forming proud flesh & he always says "It does not hurt" when we dab Iodine on. He is always here at dawn & we get up a little earlier to attend to him before we go to the Temple, & at sunset when we return he is squatting outside the garden gate. We shall be glad when he is quite cured, but we shall miss our nice Mahomed.

We are being very holy this evening a man has come to sing the Koran to us, in a few days Ramadan will be over & then they will all eat a tremendous meal at the great feast & get bad indigestion & Eppy will be in great demand.

This seems a very hospitally letter but I know you are interested in our cases so thought our Mahomed of the beautiful face might interest you.

Broome MSS68
March 4ᵗʰ 1930.
Dear Mother & Father.
This is just a hurried note while waiting for my bath, we have guests & I may not have a chance of writing again in time to catch this mail.

Our guests are a Doctor & his wife & another doctor who is Miss C's prospective fiancé. Her aunt is hard at work matchmaking & Miss C is hovering on the brink, she isn't a bit anxious to be married, in fact has done her best to avoid it so far, but this time it seems relations & circumstances may be too much for her. Dr Gardiner is dreadfully upset at the prospect of losing her. & has written to her such a charming letter & he says if she does finally decide to leave the Society will she do her best to persuade *me* to take on the *Directorship* – salary & all. Of course the mere thought of undertaking such a thing scares me stiff. The Rockefeller grant for this publication is twenty two thousand pounds!!! However it is only a possibility that the Directorship may be vacant but I am tremendously thrilled at the compliment Dr Gardiner has paid me. What do you both think about it?

I hope to tell you all about the feast after Ramadan in my next letter I have no time in this as I have to go & be polite to the guests.

14

RAMADAN AND MY TURN TO BE A VISITOR

Broome MSS69
March 5ᵗʰ
Dear Mother

I posted rather a scrappy letter to you yesterday as time was limited. Today our guests have exhausted themselves plodding through the sand to the temple & back, & have retired to their rooms to rest. The situation here is decidedly comic. Nannie hates Miss C's intended with a venom truly oriental, her feelings are shared by Sardic who goes round with a face of gloom & has taken to shadowing me. This morning in the temple he came & begged me to say I would return next season & Old Ahmed & Mahmud Zinaia added their entreaties. I said "Inshalla Allah." (If God is willing) which brought forth smiles & exclamations of "Allah is good & great." The loyalty of these people gives one a tremendous feeling of responsibility. They come with their troubles etc. in the firm belief that you are able to help them if you wish & if help is not forthcoming it is only because you can't be bothered.

I promised to tell you about the end of Ramadan. In the morning all our servants wore new galabias & greeted us with. "May all your years be prosperous." & we touched their hands, & said. "And may yours be also." Our nice patient Mahomed was waiting to have his hand dressed & he too wore a new galabia of blue & white stripes. When we had got him nicely bandaged up I got my camera out as I wanted to get a picture of him. He was delighted to be photographed but oh dear the effect on him was awful. One can put boiling hot dressings on him & cut big lumps of bleedy flesh & stray bits of tendon off, & he just

161

smiles sweetly & says it doesn't hurt but just show him a camera & he becomes as stiff as a ramrod. Tightens his facial muscles up to such a degree that [it] is difficult to believe he is the same beautiful graceful creature. Of course he thought he was showing what a really fine man he was & I couldn't hurt his feelings by saying I didn't like the effect, so I took the photograph, but I shall try to get another sometime when he does not know he's being taken. I have been attending to him in the mornings lately but if Miss C can take it on once again I'm going to try to get a snap then. I shall pretend to be taking her picture.

After the hospital parade was finished we did our usual mornings work in the temple but Miss C & I took the afternoon off & visited all our friends. We set off with all our servants as escort & started at the north end of our nearest village, we went first to see Ahmud Ibrahim, our chief guard & very good friend. We wished him & his wife & family many years of prosperity, we sat on the divan & were offered feast bread. dates. cream. sweetmeats etc. we each accepted a tiny morsel to "bring a blessing". (our servants had a good tuck in) & then went on to the Omdah, whose house was next, here we partook of dates & coffee. Then to Sardic's house, his wife gave us tea, spiced feast bread & nuts, & showed us three fine new dresses he had bought her & so we went on, from house to house in order to bring prosperity to all our nice people & bless their family's & their food. It was quite dark by the time we had finished, & we were feeling tired, dusty & rather sick. As we left the last house we suddenly remembered poor Mahomed had been waiting about two hours, so we rushed back as fast as we could got him attended to & sent home. His village is five miles away so he has to walk 20 miles every day to be attended to, we hope soon one dressing a day will be enough. I must tell you a funny story about him soon after we took him on, when we returned from the temple in the evening we found him sitting by the gate as usual with another man & we thought "Oh dear. another patient", & asked who he was & what he wanted. Mahomed explained he was "a friend who had come to save him from the afreets on the way home. He said the night before as he went by the ancient fortress in the desert a dreadful afreet twice the height of a man, black & terrible rose up in front of him. Then it took the shape of a dog, a fox, a sheep, he uttered all the names of Allah. & still it remained before him. Then he said "Oh Blessed One permit me to leave you" & it made

an awful noise Ki-yi-yi-yi & he was overcome with terror. He says these afreets haunt lonely places & waylay lone travellers at night, they never appear to two together so he had persuaded a friend to accompany him. I am afraid we both roared with laughter at this tale, & told him his eyes were seeing what was in his mind & that there was nothing to be afraid of etc. It seemed rather brutal to laugh at him, as the poor man was in a dreadfully weak condition, what with fasting & the sleepless nights with the pain of his hand, I really don't wonder he was seeing things, but sympathy would certainly have reduced him to a nervous wreck. We told him if he saw that afreet again he was to come back here, & one of us would go alone & drive it away as English women won't stand any nonsense from such silly things, it had the desired effect. Mahomed isn't going to be laughed at any more even by such superior beings as the English ladies, the gentleman friend is left at home & we haven't heard anything more about the afreet.

We are very pleased with Mr Little he is like his name very thin & delicate looking, he is very much like Harold & has the same rather shy manner, he draws very well, has some knowledge of hieroglyphs & is out to learn all he can so altogether he is a very welcome addition to our camp. He had been working at a camp in Syria & had been obliged to give it up on account of Malaria.

Sardic is most awfully funny when any one new comes he is extremely proud of the high standard of the work the society produces, & makes a point of personally examining the efforts of new comers. He visited Mr Little's scaffold yesterday & respectfully requested to be permitted to see his drawing. He had a good look at it, discussed it with Ahmud, & said to Mr Little "May the Lord be praised" He also Praised the Lord on account of my drawing soon after I started work but Beazley troubled him exceedingly. He said to me once the Kawargeh [gentleman] does not understand the custom of the work here.

Yesterday Ibrahim the weaver brought home the white table runner he has made from the fleece of Ahmud's white sheep, it is a wonderful piece of work. At present it is stiff with the rice flour which was used to stiffen the warp but when it is washed it will be soft as linen. It is 2¾ yards long with a fringe 10 inches long at each end & 17 inches wide, I expect it will shrink up a bit when it is washed, one cannot order any special length one sends so much wool to be woven a certain width.

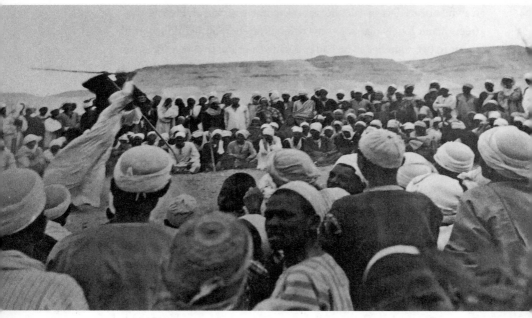

Nabout men

March 6ᵗʰ Had a great day today we gave an Arabic party. We had the tip top nabout stick man from a village some way from here & invited all the men in the neighbourhood to come & try the skill. They came from about 8 villages, & we reckon we had 500 guests. They formed a great circle in the desert & the nabout men perform in the centre, the play is rather like quarter staves only the sticks are longer about 5 ft. The performers strike attitudes rather like fencers & leap & twist & turn whirling these long sticks with marvellous agility. They hardly ever touch each other or clash their sticks they make a movement of attack & the other instantly falls into a position of suitable guard, it is a series of very refined postures. Directly one fails to make the proper guard the game stops. Of course sometimes they rap sticks together but only to make it look more spectacular & sometimes they lose their tempers & go at it in real earnest. This happened once this afternoon but the guards rushed in & separated them. They have the drum & zummara as accompaniment & their movements keep perfect time with the music.

The guests were provided with cigarettes & the Omdah & several other most important people had tea with us in state.

It was a great success & we are told that for some time events will be dated by it as happening the week or the month after the great nabout party.

Today I received your letter with the pencil note to say you had received my long letter about the great adventure I shall look forward to the next to hear your comments on it. I always like to know what you think about my various doings. I haven't heard about the wool yet, but parcels take 3 weeks to a month to get here. I have notified Cooks & shall hear in due course.

Broome MSS70
Arabah el Madfunah March 7ᵗʰ 1930
Dear Mother

I am sending you a few more Kharga photos, they are not very clear, as they were taken in bad light. Kodaks developed them but did not think them good enough to print from so Nannie made me some, as they are interesting records in spite of being indistinct. I have written the description on the back of each as usual.

Tomorrow I go to the Bruntons for 5 days. Sardic is coming with me to Baliana, to see me safely on the train & the Bruntons are sending someone to meet me at their nearest station Abu Tig. So it ought to be an easy journey I do not know what their postal arrangements are so I may miss a mail but this is not such a perilous adventure as the last.

Broome MSS71
Sahil Selim.
March 10ᵗʰ 1930
Dear Mother.

Here I am in the Bruntons camp at last. I arrived the day before yesterday & had such a rush round the morning I came. I will tell you all about it. You will remember in one of my last letters I told you how Mahomed's hand was getting on so well. The evening before I came here I was dressing it & I noticed it was looking rather swollen & felt hot & after much questioning him he admitted it hurt him just a little bit as far as the arm so I kept him till Miss C came & she didn't like the look of it any more than I did so we thought it would be best for me to take him with me to Baliana the next morning & let the Doctor see

it again. You should have seen poor Mahomed's face at the mention of the doctor. He quite thought we couldn't bother with him anymore & that seeing the doctor was the preliminary to going to hospital to have his hand cut off. However he bucked up when he heard I was going to talk to the Doctor myself. So next morning I was ready in good time. Sardic & Mahomed squashed into the front seat by the driver of the car & I sat in state behind. When we were going by the police outpost in Arabah someone waved to us to stop, so we pulled up & a man said the Omdah wanted to go to Baliana & could we give him a lift? so I said "Certainly if he was ready to come at once." So the Omdah joined me & we exchanged a few polite remarks. They were making up the road in parts ready for the next inundation. one half was about 3 ft of earth higher than the other, we were able to go along the old wall beaten down part for some way but at last it was too narrow & we had to get up on the new part to continue our journey. The Omdah got out of the car & began shouting at the work men & they all rushed & began tearing down the new made high part to form a slope for the car to go up, then the driver made a rush at it. All the men shoved behind & we bounced up on to a road a little worse than a newly ploughed field. I was glad the Omdah was there as probably we should have been delayed some time otherwise. We got to Baliana without further adventures. The Omdah got down & we proceeded to the Doctors. I had to wait a little time as he had not arrived at the surgery but his servant served me with coffee. When he did come he saw Mahomed at once, he said the hand was going on very well, the symptoms that had alarmed us were most likely to do with the tendon tightening. He promised to write out directions for continuing the treatment & send them back to Miss C by Mahomed. He spoke quite good English & was of course very polite to me but the natives are terrified of him. I saw Mahomed safely disposed of & then rushed off with Sardic to catch my train.

When I got to Abu Tig I got out & looked round the platform. I saw a large stout Arab clutching a note, also eagerly looking round so I went & asked him if he was from Mr Brunton. He gave me the note & took charge of my small bundle, & we set off. The river is near the station so we walked to the bank where a dahabiah with a mixed crowd of natives & animals was waiting. He tucked up his garments,

lifted me up like a doll & carried me & put me on board; there was a fair wind & we did not take long sailing across & here I was carried ashore with my belongings. The natives & animals scrambling as best they could through the water & up the bank. Lots of donkeys were waiting on this side. Mr Brunton's man selected one, & I prepared to mount, expecting he would give me a "leg up" as Sardic does but he had other ideas. I was seized by my middle & plumped onto the donk. my bundle was taken over by a small boy on another donk & off we set. It was a very pretty ride, part across stretches of sand along the river bank part along by the canal & part by the cultivation & finally to the desert itself where the camp is situated. It was about 3 o'clock when I arrived.

Mrs Brunton & her sister in law Mrs Newberry were in the house & made me very welcome & showed me my room. The camp is not so big & compact as ours, being only intended for a season or two. The house is mud brick with sand floors & roofed with palm branches & furnished with camp furniture helped out with packing cases all very nice & quite comfortable (but I very much prefer ours). At tea time Mr Brunton & his assistant Mr Bach came back from the "dig". Of course I was shown all the finds, nothing very exciting as this cemetery was for poor people, & therefore has remained untouched, but interesting as it is possible to date the types of beads & amulets fairly accurately.

In the morning I went with Mr Brunton & Mr Bach to visit the dig. The workmen were carrying the loose sand in baskets out of a number of graves seldom more than 4 foot deep. When they got down to the coffin they scraped the sand away from all round & waited for one of the staff to come & examine it. Mr Brunton got down into one & began to remove the rotten remains of the coffin cover, it crumbled into dust at a touch. Then he carefully scraped where the wrists would be & had all the earth & sand round about sifted to find beads, scarabs amulets etc. He did the same at neck & feet, then examined the pelvis & skull to sex the skeleton, made notes on the position of the body etc, then when the loose sand had all been sifted, the bones were replaced & the grave filled in. About 9 scarabs & a good many beads & amulets came to light while I was watching, but some burials contained nothing of archaeological value whatever, only bones & wrappings.

I am going back on March 12th & Mrs Newberry is coming with me for a short visit to Abydos it is her first time in Egypt & she may not be able to come another year, so Mrs Brunton is anxious for her to see all she can.

Broome MSS72
Dear Mother
I've some different sort of news to tell you in this letter I think I told you in my last that Mrs Brunton's sister in law Mollie Newberry was coming back with me for a few days visit, she was so excited. She has been staying in their camp since Nov. & has never been anywhere as they don't go about at all & she cannot go alone very well. The donkey ride & crossing the river in a native boat simply thrilled her.

When we got to Baliana station Sardic was waiting of course & took our luggage & when we were in the taxi he gave me a note from Miss C, it was a hurried scribble to say she had broken her engagement definitely & had run away to friends in Alex so as to avoid seeing the man in case he came here afterwards & would I carry on in the meantime. I must say I was truly glad, I didn't like him at all & I do like her very much indeed. She wasn't a bit fond of him, but her aunt was all for it as he has money & a good position she had manoeuvred things very cleverly & started gossip in Cairo & all that: the strange thing about it was that Miss C has said all along that he has a strange effect on her when she is with him, she has no will of her own but has to agree to all he suggests, & afterwards she hates herself for being a weak fool as she calls it, three times she has gone with the definite intention of refusing him definitely & each time has been obliged to say 'yes' instead. Things were in this state when he came here for a visit with another Dr & his wife from Cairo. While he was here she was like a person in a dream, neglecting her work, went about with him, did everything he suggested, as if she were a young girl with her first sweetheart, but he hadn't been gone more than a day when she suddenly woke up & had a positive horror of him & everything connected with him. It was a pretty clear case of hypnotism, he is a psycho-analyst & while he was here he boasted of being able to control people by hypnotic influence & make them obey him without them knowing anything about it, so now she realizes the only thing is

to absolutely avoid him. We are now awaiting the next move. Today I had a note from her with instructions about the work etc. Next Tuesday the King & Queen of the Belgians & King Fouad are coming. & if they wish to see the drawings I shall have to receive them and show them the work – won't it be awful, I hope I survive.

I have been giving Mollie a good time, yesterday morning she saw the temple & in the afternoon I got Sardic & Nannie to take her to see the old weaver in the village. This morning she went over the Osirion & this afternoon I am leaving work early & going to the wady with the sand slope for tea & my nice camel man is bringing his camel for her to ride – so she will have a variety of entertainments.

Mahomed's hand is going on well. The Dr only looked at it, said there was no fear of ill effect, the swelling to be treated with hot compresses & dressings as usual. We have to be so careful now the weather is getting hot, the wound heals from underneath & the skin that forms on the surface & round, goes dead & rotten & has to be removed so as not to spread infection, I have to carefully cut & scrape it away, it is just like cheese, he says it does not hurt at all. He is such a nice man, he takes his bandages home with a bottle of diluted lysol & his wife washes them & he brings them back the next morning all neatly rolled up.

I must close now.

15

COMINGS AND GOINGS

Broome MSS73
March 18th. 1930
Dear Mother & Father.
We are busy preparing for the Royal visit tomorrow. I believe only
the Queen of the Belgians is coming after all. Miss C wrote to say she
hopes to be back in time to see her, so I shall be very relieved, as it is
a great responsibility showing delicate pencil drawings & seeing them
safely back with tissue paper over all the top surfaces & being polite &
answering questions at the same time; with two of us, one to hand the
drawing & the other to replace it when looked at, all goes smoothly.

Capt Calverley is leaving on the 28th of this month he is spend-
ing some time in England on his way back to Canada, & proposes
coming to see you if he may to tell you all the latest news of the camp
etc. I wonder if you could arrange to put him up for a few nights, he
will want to have a look round London before returning to Canada, &
none of his relations live near, & he does so hate hotels. He is awfully
nice & very interested in everything & very homely, & being a Cana-
dian farmer does not expect or wish for elaborate hospitality, in many
ways he is very like Christopher, eager to be friendly to everyone,
rather high strung & excitable but of course he does not go off the
deep end like Christopher does. I am sure you will both like him.
& if you could make him 'feel at home' for a few days I would be so
pleased, I have received so much kindness from his sister that I feel I
am greatly in debt to both of them. I will tell him to write to you when
he arrives in England – (he eats anything & is fond of children) you
will probably have great difficulty in keeping him out of the kitchen,

as he is sure to want to discuss farming with Mr Childs.

I hope to send you some photos next letter I am keeping them for Miss C to look at before parting with them.

I am sure you will be delighted to hear that Mahomed's hand is almost well, my surgery had a wonderful effect, he is so grateful for everything we have done for him.

English mail just in. your letter of March 9 has arrived, letters seem to get here very quickly.

I haven't heard anything of the wool yet but being large I expect it will come cargo – More news in my next letter.

Broome MSS74
March 19th 1930
Dear Mother

Miss C wasn't able to return in time for the Royal visit after all, she has had to visit the dentist again & he means to finish her properly this time. So Capt C & I had to receive the Queen of the Belgians she was so nice & friendly & so pleased with the drawings, I had Sardic beside me to look after the pictures as they were finished with, so was able to give my full attention to the Queen. She spoke English beautifully but in a very soft low voice & was dressed all in white. She thanked me for showing the drawings & shook hands again when she said goodbye to me. Capt C went with her to the Osirion to see that the man worked the reflecting mirrors properly, there is some beautiful relief work in an underground chamber. & the best way to see it is to reflect the sunlight with two big mirrors, I did not go as I did not wish to seem pushing, Capt C said she was delighted with everything so we feel the visit was a success in spite of Miss C's absence.

I am so glad you were interested in Mahomed of the injured hand. I really feel it is one of the best jobs I have ever helped with, this morning I was able to reduce the dressing to one tiny bit of boric lint about 11/2" square, he is doing finger exercises to try & get them supple again. The little finger will always be stiff because the tendon is destroyed, but the way the new flesh has grown round & over is simply wonderful.

I am very much relieved the post of Director is not vacant, I do not at all wish to have the handling of large sums of money, but if

you had both advised it I should probably have taken it on, it is very nice to feel I should have had the offer, as it is, I am more than content with my salary & nothing could make up for the loss of such a delightful companion. & it is lovely to feel we can carry on together in the future.

Latest news is that the King of the Belgians is to visit us, really this glut of royalty is past everything. I think you had better attend a few Bushey tea parties & casually mention, oh yes my daughter entertained the Belgian Royal family last week. She hopes the other crowned heads of Europe will not interrupt the work again this season etc. what fun, of course they wouldn't believe you, although that "Girl from Grange Road would do anything."

Don't think my head is getting unduly swelled, I can still get my hats on quite comfortably, & any false pride is soon evaporated when I attempt to exchange polite greetings with Sheikh Abdu Wahid. Arabic is a ghastly language to learn, there are a dozen ways of saying the same thing. I seem to have got as far as a few general remarks & there I have stuck.

I must be off to bed now, we had a friend of Dr Junker's spending the day at Abydos I invited him to supper so I had to play hostess which hasn't left me much time to catch the next mail.

Broome MSS75
March 25th 1930
Dear Mother.

Your letter with the gloves for Mahomed has just come, what a splendid idea. Thank you so much for sending them, I am sure Mahomed will be getting a very swelled head with all this attention. I am enclosing his two pictures in this letter, they do not do him justice I am afraid, as he is really beautiful, but you can see what a fine type he is, I am glad to say his hand is practically well & he is fit & jolly, it is hard to imagine him as the pitiful wreck he was when he first came. Both Miss C & I are tremendously proud of our "show patient".

I am sure you will all fall in love with the other Mahomed, my nice camel man. Hasn't he got just the loveliest smile, he was looking very severe when I got the camera ready. so I said "Oh Mahomed, is your camel still looking for his tea?" he burst out laughing at that &

before he could compose his features again I pressed the bulb. I will explain the joke. On our way to Kharga we carried our tin mugs tied onto our bundles on our camels, & one day my camel had a good sniff at Miss C's mug, & one of the other men said "he wants his tea" this developed into a regular saying & caused a lot of fun.

You ask in your letter about wild animal tracks in the desert, on the first days journey we saw tracks of wolves & foxes, & saw hawks, kites & vultures, but after about 20 miles there was no sign of any living thing except tiny lizards & beetles.

Broome MSS76
March 27ᵗʰ 1930
Dear Father.
Thank you ever so much for your lovely letter, I was so glad to know you were both delighted at Dr Gardiner wishing me to fill Miss Calverley's place should it become vacant. Of course you know now that she has renounced matrimony, so we are hoping to carry on the work together – which to my mind is the best of all, as she is far more capable of attending to the business side than I am. She speaks French, some German, Italian & Spanish as well as Arabic, which is very useful, as one meets all nationalities here.

Yesterday was a great day, the wool arrived. Sardic went in [to] Baliana to fetch it & we spread a sheet out on the divan & Ahmud & Abdullah came & helped pull it out of the bolster, they did have a struggle, it was fun. Of course they wanted to get at the coloured wool, which pleased them very much. They were very interested in the little packet of merino wool & wanted to know if it came off a very little sheep.

Nannie has seized upon the bolster. I told her she might have it, so you will have to charge that up to me too.

The weaver has finished the curtain he was making for me, he brought it home a few days ago. It is in two strips which have to be sewn together & then the fringe has to be twisted in a special way, old Ahmud will probably do that, he did the fringes of my table runner most beautifully. I think this runner will do for the dining room table it will go long ways with the fringes hanging over the edge.

I am sending you a picture of the great bass zummara, these instruments are getting very rare. The player is a Soudanese & his

cheeks have grown to an enormous size with constant playing, his wind power is marvellous.

I hope Capt Calverley will come to see you I know he will be very interested in your wood work & the garden, he is sure to ask endless questions. Miss C. says she does hope he will not bother you too much, he is so like an over grown school boy.

I am hoping to bring Miss C to see you when I come home. I know you will like her she is a dear. & you will have one great subject in common – music! She composes temple ritual to the gods of Egypt & sings it as she draws – some of it she has written down, she will be able to sing you the wind Arab chants too.

Broome MSS77
April 4ᵗʰ 1930
Dear Mother
Nothing very new in the way of news to relate this time, we are all very hard at work.

The hospital parade has been a little amusing lately, with our wonderful cure with Mahomed we have had an epidemic of hands. We now have a man with a boil between two of his fingers & another with a poisoned thumb, the latter is an awful old rascal. He's a bundle of rags, his wife is dead so he just wears his clothes until they drop off him. Nannie goes out & puffs Flit all over him before we start operations. We call him Abu Dubban (Father of Flies) because he brings swarms with him, he is probably Father of a great many other things still more unpleasant. These two arrived together one evening just before our evening meal, so two large fruit tins were filled with hot lysol water & they were told to squat down outside & soak their hands while we had our meal, you can imagine how funny it was to see these two men sitting on the sand each with his hand in a Tin.

After dinner we went out & dealt with them in the usual way a nice hot bread poultice made with some salt in the water. Sheikh Abdu Wahid's youngest son was here this evening with a very puffy lip, he was sent off with a dose of Eppy & some Milton to put in hot water to bathe it with. It is very difficult to know how to deal with some of these things, on the whole we make pretty good guesses – certainly one cannot say life is dull out here.

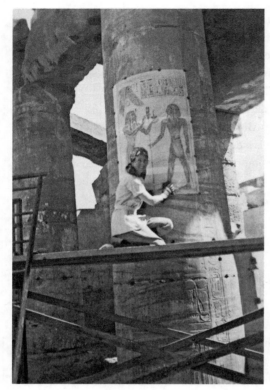

Cleaning a pillar

You will be glad to hear that Miss C's late suitor has retired grace-fully, her aunt is very angry with her about it but we are all delighted.

The weather is getting pretty hot now, we are getting up very early & having a rest midday.

April 5.

There was a death in Arabah today a boy who had been ailing for 4 years popped out, there was a great wailing in the village. Miss C inquired if it would be appreciated if we went to offer sympathy to the Lady of the House. Sardic said it would do them great honour so we went along. It was a large house the courtyard was filled with wail-ing women, there were the hired wailers & friends & relations of the family & they kept up a series of shrill yelps rather like a puppy when someone treads on its tail.

The men were all collected on the other side of the house they just squatted on the ground muttering occasional pious remarks. We

saw the bereaved lady & offered her condolence – "all things are in the hands of Allah the good the merciful etc." We gave a little money for the hired wailers & departed glad to escape from the din but glad to have seen still another glimpse of Arab life. Of course the corpse has to be buried within a certain number of hours, but the funeral observances go on for seven days.

We have been having lovely baby carrots from Father's seeds & the lettuces have been going strong. We have had them every day for about 2 months, marigolds have done well also & some other flowers that I do not know the names of.

The Observers come very regularly the old ones serving many purposes. Nannie bags some for shelves etc. & we keep a supply handy for hospital parade, all soiled dressings are dropped onto a sheet of Observer & afterwards the patient has to take it out to the fire & burn it up, quite a lot gets used up this way. I am sending the snaps from The Brunton's camp this time, you must be getting quite a pile. I shall have to put them all in an album on my return.

Broome MSS78
April 8th 1930
Dear Mother.
I have two amusing incidents to relate in this letter. First of all I must give you Mahomeds message, he says may Allah increase your prosperity for sending him the gloves. I shall never forget the effect of his tall black robed figure with cream coloured turban going off wearing one large white glove & very carefully carrying the other. He came to sit for me again last Sunday afternoon, he makes a most perfect model he seems to know by instinct exactly what is required. I was afraid after the effect the camera had on him he would be stiff & rigid, or very self conscious but he isn't a bit. He sits perfectly naturally. & if I speak to him or call his attention, he turns his head for a moment to answer but gets back into the correct pose again at once. I rather expected he would dress himself up in his fine new blue & white striped galabia but I was relieved when he came for the first sitting in his picturesque black one that has faded to a nice purplish blue & is a splendid foil to the rich browns of the skin & the cream turban. I forgot to tell him to wear exactly the same next time, so imagine my horror when I came

back on the donkey Sunday afternoon to see him waiting outside the garden gate in blue & white stripes!

I got my paints & everything ready & called him in – & if you please he had bought his old black galabia with him & had put it on over the other one so all was well. I had a lovely afternoons work & have got an excellent likeness. Mahomed had never seen such a thing done before, & was wonderstruck when I told him he might come & see himself.

The other amusing thing is as follows – Sheikh Abdu Wahid's two daughters have made us each a doll this is a tremendous favour, these people do not make gifts of an intimate nature to Europeans as a rule. These dolls are most curious, their shape is somewhat weird & they have no faces since Allah alone can achieve perfection it is presumption for mortals to attempt it so no good Moslem ever attempts to make a complete representation of anything living (what Christians do does not concern them, it's their look out if they burn for their sins afterwards). So Miss C & I made an English doll to give in return, the body was made out of white kid gloves, the face painted with big blue eyes & pink & white complexion. The bobbed hair was some of the yellow dyed sheeps wool. I made knickers & petticoat in pale lemon crepe 'de chine' trimmed with lace & a light pink silk frock & a cute little black velvet hat.

Sheikh A.W. brought Fatima to the temple to receive it, there were great rejoicings & the dignified old Sheikh examined every detail with great care, even to lifting up its skirts & looking very intently at the lace on the knicks! Imagine our joy at this!!! We did have a laugh afterwards we wonder if he imagines *we* are dressed like that underneath!!!!

The doll has caused a lot of fun both Sardic & Old Ahmud played with it & I believe they would love to have one of their own.

Another letter arrived today containing still another glove, I think this will be quite enough at present thank you very much for sending them. The Home journal has also arrived I think this is the last you had better send as we hope to be able to leave here by the second week in May.

16

PREPARATIONS FOR HOME

Broome MSS79
April 10th 1930
Dear Mother.

There is corn in Egypt, the Nile valley is now a yellow strip of golden grain, we have watched it change from the waters of the inundation to black mud, to vivid green & now to light yellow. At this actual moment I am writing it can't be seen at all as there is a sand storm raging, it was very hot this morning 98 in the shade before midday, we sat & dripped. I had a bowl of water on my guntera [platform] to keep cooling my hands, I got tired of climbing down every half hour or so to rinse them so got Sardic to bring me a private bowl of my own. I hope this storm will not last till tomorrow as it makes drawing impossible even in the house there is grit everywhere, it is on the paper as I write.

I had such a nice letter from Dr Gardiner a few days ago. I am enclosing it for you to read, please keep it for me; isn't it nice to work for a boss like that?

April 11th The sand storm is over it seems to have cleared the atmosphere. There is a north wind, so it is much cooler. Nannie is in great fettle just now her only daughter has just got engaged, she (Nannie) is going up to Cairo on Monday for the formal betrothal which seems to be a very serious affair & nearly as binding as a wedding. It seems the young man is desirable in every way. He owns a paint shop in Cairo, he is a Syrian, a Catholic, of a suitable age, good looking & does not desire a dowry with his bride so at present everything in the garden is lovely.

The poor garden here is looking a little sad the heat & the sand storm has nearly done it in, there are still some hollyhocks & larkspurs in bloom but they look a little the worse for wear.

I hear the Bruntons are leaving their camp next week. I expect we shall be about the last to go, we are having a hard struggle to get as much work finished as we hoped to.

I expect you have been remarking that my writing has not improved since I have been here, it's the result of having so much to say in a short time. I really haven't that excuse in this letter as there is really no news this week, but it's got to be a habit now.

Broome MSS80
April 14th 1930
Dear Mother
Your letter of April 2nd has just arrived it has taken longer than usual to get here. I am glad to see by the P.S that the photos have arrived. I expect by now you have the ones I took at the Bruntons camp.

We have had Dr de Buck here all the week going over the hieroglyphs. He is a Dutchman & most awfully nice, we have had a jolly time in spite of a great rush of work. He is leaving for England on the 17th of this month & he returns to Cairo tonight, we shall be sorry to see him go, he has treated all our sins of omission in the most kindly manner. Thank goodness there were not very many.

I have been buying lumps of amber from some of the native dealers, now there are no more tourists we can purchase at a reasonable price, these lumps are pierced for beads & probably come from the numerous Roman burials around here. I think they will look beautiful if they are re-polished, & if spaced on ribbon or cord will make beautiful necklaces.

I thought they would make a nice present & if possible I shall get some more. Miss C is collecting a carnelian necklace, buying a bead or so at a time, now the natives know she wants them they come with all sorts of strings & she sometimes selects 2 or 3 out of a string of 50, she thinks it much more fun than just buying a necklace of matched stones. She is going to the other extreme & getting them as different in shades as possible.

Later. The old bead man was waiting for us when we left the temple this evening I purchased a short string of the lumpy amber beads & Miss C acquired one more carnelian for her necklace. I expect he will always way lay us now as we are his only hope, we drive a hard bargain with him just for the fun of it but usually give him an extra PT baksheesh.

We now have a middle finger to deal with a man has cut his nail clean off, fortunately he came to us the very day he did it, so it hadn't got septic, we are giving basic dressings & it seems to be going along all right but of course it will take a long time for the nail to grow again, he is a Copt & a relation of our carpenter.

Yesterday being Palm Sunday the Coptic Priest brought us a cross made of palm branches & a loaf of blessed bread with little crosses over it we ate it for supper & hoped we benefited with the blessing.

Many years later, in 2008, an oral history project in Bushey recorded the musings of a lady called Eileen, who knew Myrtle and visited the house on many occasions. She recalled the beautiful jewelry Myrtle kept in a box that would be brought out for inspection. She spoke of a particular visit when she took her daughter Anne with her:

She said they had visited the tombs and she'd got quite a lot of little beads and things and she went upstairs and came down with a little box of beads for Anne, which had come from a tomb – minute little things almost too fine to thread but beautiful colouring and she also gave her a long, very heavy amber necklace – she had a lot hanging in the windows in the lounge and they caught the sun – the sun shone through them and you got beautiful amber, yellow golden colours shining through these beads and she said they were dowries that were given to maidens – so she gave Anne an amber dowry.

Broome MSS81
Arabah el Madfunah
April 18th 1930
Dear Mother
We had another adventure last night, there was a very big festival taking place in a Moslem cemetery about 4 miles from here. People come from

many miles round & they gather round a certain holy sheikhs tombs & chant parts of the Koran & go through various fanatical exercises.

This festival takes place at night so we had supper early & then the three of us mounted on camels & set out with a large retinue including our very holy cook, two of our party carried lamps. It was a glorious star light night hot as a summers day in England, what wind there was came in little warm puffs, it was lovely sitting perched up on our tall striding beasts, of course.

I had my Kharga camel, nice old Mahomed Abdu Rachman, would be dreadfully injured if I did not have his camel. (his name means – "Servant of the Compassionate," which is one of the names of God) When we got near our destination we could see the glow of the lamps & the sound of hundreds of voices chanting in unison. We wended our way among the lesser tombs to the large mosque like buildings round which the great multitude was gathered. There were thousands, it was a sea of turbaned heads & from our camels we could see everything beautifully. It was rather a terrifying sight rather like the atmosphere at the Zars one feels these people are swayed by emotions and instincts utterly beyond our comprehension, we watched one immense group for some time. There were squatting figures covering a space quite twice the size of our garden in their midst stood a holy man, chanting the Koran, at the end of each verse the entire company would repeat the names of God, it was simply deafening. Round another tomb in the centre of another huge crowd were a line of men standing in front of a holy man, he beat time with his hands, & they all shouted Allah at each beat, & with each repetition they bowed their heads. then the pace quickened & they bowed from the waist, tossing & twisting their bodies to the rhythmic beat of the priests hands the name of Allah was no longer distinguishable, only a sharp hiss as they took in breath, it was like the sound of a huge saw cutting through hard wood. & I cannot attempt to describe the weirdness of these tall swaying figures in the flickering lamplight with the background of the curious domed tombs, it was like a scene from Dante's Inferno.

We did not stay long – needless to say we were the only Europeans & we felt we were intruders, & the temper of a fanatical crowd is a very brittle thing & it would have been unwise to show too much curiosity, so we just passed through pausing for a few minutes here & there & then came away.

An experience such as this makes one realize how utterly different these people are, one can be friendly with them, but one cannot get to the bottom of their minds, their actions are controlled by a form of reasoning utterly different to ours. It was half past twelve when we arrived home we were dead tired so had an extra hour & a half in bed this morning.

It has been a very hot day with a south wind, it is like the breath of a furnace, the temperature midday registered over 100 in the shade.

I have bought still more amber & I have spent over 10/- for the lot. I wonder if you would like some of the nicest pieces polished for a necklace, they are rather rough shaped lumps like the necklaces one sees in Libertys for which they ask huge sums.

The last large glove you sent I have given to the man who had the boil between his fingers, his hand is naturally very tender now it is healing but I think he can use it if he has it protected. He is a very big burly man with large hands, so the huge gloves do very well; our beautiful Mahomed has small delicate hands so the other pair do him splendidly.

Broome MSS82
Arabah el Madfunah
April 23rd 1930
Dear Mother
This is the first week I have missed writing to you on a Market day, I am hoping this will not be too late to catch the mail after all. Yesterday we went over to visit the Ellisons at Nag Hammadi & I was absolutely tired out when we got back & before we left we had rather a bad case to attend to, so there wasn't any time to write. I will tell you the history of our day of rest!!!? In the morning directly after a disgracefully late breakfast at 6.30, we tidied up the big box of drawing materials & put away all the finished signed drawings, this was rather a long job. Then a patient came he was a poor old man with a dreadfully burnt arm. We got Sardic to cut the sleeve right out of his galabia as it was in scorched rags & indescribably filthy, he'd been in that condition two days before he came to us so you can perhaps imagine the sort of job we had, There was no chance of getting the dirt off so all we could do was to pack the poor old chap up in cotton wool soaked in oil & trust

to the dirt coming away when the dressing is removed. This is how it happened, – I think I explained to you how the peasants live out in the fields after the flood water has quite gone down, they build little enclosures with the long straw called bouse. These straw stalks are about 7 or 8 ft high so they make splendid enclosures. The family live there while they work in the fields, & at night the cows, the goats, sheep etc. all are quartered inside with the people. The Egyptian government in its *wise forethought* have made a rule that these straw enclosures must be built side by side instead of each mans shelter being in the centre of his own little bit of land. The Gippy official considered mass grouping was a protection from robbers but his mind never considered a worse evil – fire. As a result, a woman lighting a fire for her evenings cooking in a high wind set fire to the straw wall, the wind carried the flames & not one enclosure but *10* were burnt.

This poor old man has lost his cow & two calves & all his grain – & got severely burnt himself trying in vain to save his beasts. We wanted to take him in to Baliana with us on our way to Nag H – & get the Doctor to look at him, but the mention of that reduced him to abject terror, & we were afraid the jolting in the car would perhaps be too much for him. so we called on Dr Abbas on our way & gave him a polite invitation to tea this afternoon & hope to produce the old man afterwards.

Later The Dr came & had tea with us & was very pleasant, we asked him if he would look at our poor old patient, when he saw him he said his only hope was to go to the hospital at Sohag first thing tomorrow morning as irrisipules (cant spell it) was already setting in & unless he had the necessary injections and treatment he would be dead in four days – so we have arranged for a car to take him in to Baliana & the Dr will see he is sent straight to the hospital by the first train. (Sohag is about 2 hours journey by train from Baliana) It is the best we can do there is no proper treatment to be had nearer but we are both feeling very sad & depressed about it.

Broome MSS83
April 25th 1930
Dear Mother
We had a very nice day at Nag Hammadi, we went by car & arrived at the Ellisons house about 1.30, lunch was at two, we had roast duck &

the usual etc. with a very nice banana pudding to follow; after coffee Mr Ellison took us over the dam. About two thirds is completed & the other third has the water pumped out & they are putting down the foundation. We went down & walked along the river bed, we felt rather like the Israelites crossing the Red Sea of course now the Nile is very low. There is still a lot of work to be finished before the first flood which is usually in August. Mr Little had not been before so he was very interested. We had a very nice tea on our return & our car came to take us back about 6.30, so we were home soon after 8.

Your letter with the hankys came today. I think I shall give two to Sardic's small daughter's & the others to Ahmuds little girls, I am afraid our own people would be very hurt if Mahomed received all the favours, I finished his portrait before Dr de Buck came; of course it is only a sketch, I cannot spare the time for a finished painting – so have not seen him for about 3 weeks, I expect he is a very important person now that he has gloves.

I expect to start for England about the middle of May. I am writing to Mr Jackson to inquire about boats Miss C may have to stay a week or so longer as there are affairs to be settled etc

Miss C is rather worried that she has had no letter from her brother since he was in Naples. She asks me to send you her love, she feels you are both old friends & is longing to meet you.

Broome MSS84
Arabah el Madfunah
Dear Mother
Today the letter with the other hanky arrived. I have given the silk ones away & they caused great delight but I am keeping the linen ones myself as the people here do not know the different qualities in cotton & linen. It is all cheap stuff to them & as a hanky that the children wear on their heads the size of a large duster costs 1 1/2 piastres (about 3d) they would think a tiny one that wasn't silk of no value whatever – so as they are rather nice & I am always getting short I am adding them to my stock. Of course the people here never blow their noses on hankies they tie theirs round their heads.

Two days ago I wrote to Cooks to ask if they could book me a passage on the N.Y.K boat Atsuta Maru due Port Said 14th & arriving

England 27th or 28th. I hope I can get a berth on this boat as this line issue fares at summer rates this month so I shall travel First Class. All the other lines do not start reduced fares until June. If I cannot get accommodation on this boat I have asked Cooks to try for the City of Calcutta P.Said 16th, or the City of York P.Said 18th. These are Ellerman's City & Hall Line, failing this my next choice is a British India leaving P.S on the 17th & a P&O on the 18th so I ought to be able to get a berth on one of them.

I am feeling now that I want to come home I am getting a little tired & it has been a long time away hasn't it. But it has been a wonderful time & I have loved every moment of it.

We heard from Capt C. today, he took the opportunity to see a bit of France on his way back so his arrival in England was somewhat delayed, he says he hopes to visit you before leaving for Canada.

Today I took a snap of Sardic spinning & Ahmud twisting the fringes of the rug to complete the rug making series of pictures. The things I am bringing are not at all gay just natural colours but they are unique & unobtainable elsewhere.

News is scant just now – some days ago we had a taste of the west wind it is scorching hot, the harder it blows the hotter it becomes. Of course it is because it has to travel thousands of miles across the Sahara & Libyan Deserts which are burning hot at this time of the year. Fortunately we only had it for one day.

Broome MSS85
Arabah el Madfunah
May 2nd 1930
Dear Mother.
I have just had a letter from Mr Jackson (at Cooks) to say he will do his best to get me a passage on the Japanese boat & will send me a telegram as soon as he knows what accommodation is available –

Nannie was delighted when I gave her your congratulations on her daughter's engagement.

We have had a luncheon party today Mr Ellison sent one of his engineers over to see our engine to advise Miss C what spare parts to bring out next season. Mr Milne came over in the Government car & brought his wife & daughter with him so it made a nice change for us.

I forgot to tell you some time ago that the Prince of Wales flew over Abydos we saw the plane he was in & the escort following, they passed right over the temple of course we all went on the roof & waved.

I expect Charles Barnard came over also on his way to the Cape & back but we did not know till afterwards so did not look out for him –

I have collected quite a long string of amber I think I shall be able to make several necklaces out of it by stringing them on silk cord with knots to separate the beads. They don't really look well strung close as they are roughly shaped.

I do not know if I shall be able to get the bag for Uncle Jimmie, if I get the boat I want I shall be in Cairo during Byram week, which is a very important Moslem festival & all Government institutions, museums exhibitions will be shut. Also the Mousky so I may not be able to do any more shopping in those quarters; the public holiday ends the day before the boat leaves so if I can go by the evening train I may just have time to get the few things I want.

Later Such an amusing thing happened this evening, the Omdah came to call & brought a friend with him, after the usual salutations Miss C sent a message to the Hadj [the cook] to make coffee for the guests, Sardic brought it on a tray & they each took a long noisy guzzle & then – oh dear you should have seen their faces. Our holy cook had been so absorbed in his prayers that he had put salt instead of sugar in the coffee, one of our guests had to retire to the garden to spit. We made profuse apologies & sent for more coffee with sugar, they took it in very good part & roared with laughter. When we went to the kitchen afterwards to inquire into the matter we found the Hadj also convulsed with mirth & not at all in a contrite state of mind, it seems the salt tin stands next to the sugar tin, but since the sugar is in lumps & the salt in powder it is not easy to understand how one could be mistaken for the other.

We are struggling hard to get the remaining drawings finished, where possible we are leaving repeating details to finish in England as there is quite a lot to do still. We work for six hours in the morning after that the temple gets too hot to work in, it has been 115 in the shade midday, fortunately it is cooler in the house about 102 in the inner room.

Broome MSS86
May 4th 1930
Dear Mother.
You will remember the poor old man I told you about who got his
arm badly burnt, we had ordered a taxi to take him from his village
to Baliana to get the train to Sohag to go to the government hospital
there. Well, we heard that he got in the taxi, had his ride into Baliana
(at Miss C's expense) & got out & walked back to his village!!! you
can imagine we felt a little annoyed about this specially as the Dr had
warned us that he ought not to be about in that condition as he might
spread infection. Miss C sent a message to our local police officer &
he came along the same afternoon, so she reported the case to him
& asked him to see that the poor old man was sent to the hospital
& properly treated. The Melahez [police superintendent] of course
knew nothing about the fire or anything, (he is a fat fool) but said he
would make all necessary enquiries.

The next morning when we got up at 5 o'clock, there was the
poor old man waiting outside he was in a simply appalling condi-
tion, he said he had been to the hospital & they wouldn't take him
without a letter. This of course was a fairy tale of his own – he had
not realized it took a whole day to go to Sohag & return, & he
was back in his village a few hours after he left it – we couldn't do
anything for him it would have been very risky without the suitable
apparatus for disinfecting etc. so Miss C sent him off to the Police
station with Sardic on the donkey & wrote a note to insure him
kind treatment etc.

She is going to Sohag tomorrow on a visit to the Mudir to
arrange for the guards who have to look after the house here during
the summer & she will call at the hospital to see how the old chap is
getting on.

To-day Ahmud Waled killed a cerestes (horned viper) outside our
house, it caused quite an excitement.

Nannie has had the gateway into the garden walled up so we have
to step over it to come in & out. This is to prevent snakes getting into
the house as they are evidently waking up from their winter sleep.

Tuesday May 6th I have not heard anything more from Cooks so
imagine there is no accommodation on the boat that leaves Port Said

on the 14th. They usually know 10 days before she is due here. The next boat on my list leaves 16th I will send you word directly I hear. I hope I can get a passage all the way by sea.

I was so glad to hear Capt C has been to see you what a pity it was such a short visit, I expect you did have a lot to talk about. I had a hasty note from him by todays mail to say he had been to see you & that you were both looking very well etc. etc. I was sure you would like him.

We are all working as hard as we can to get through the remaining work. We cannot complete everything, but there are parts that can be done in England so we are leaving them till we get home. I have suggested that Miss C comes to stay with me for a couple of weeks or so & we work together in the studio, I am sure you will second me in the invitation. She makes herself at home under any conditions, once when she was at her brothers home in Canada she had to nurse her sister in law, look after 3 small children & cook for 14 harvesters all single handed!!! I expect you have heard the father lives in Devonshire & is much more concerned about saving his own soul than considering his own children, so Miss C usually stays as P.S with some people at Barnes when she wants to be near London. I thought it would be much nicer if she stayed a little time with us to complete the work otherwise we should both have to go up to Tavistock Square & work in the E.E.Soc's rooms there.

I *am* looking forward to coming home we must have some jolly outings, do think of all the things you would like to see & do. I am longing for shops, frocks & theatres & ICES – I am not quite certain what my Barclays account is but I know it must be over £150. I shall probably leave a small deposit to keep on my account in Cairo & have the rest transferred to my Watford bank. (swank. what -) I can arrange about that when I get home -

PS. We have the N wind again so it is not so hot as it was.

Broome MSS87
May 11th
Dear Mother.
I had a wire from Cook's yesterday to say there was no accommodation on the Atsuta Maru but they could offer a passage on the City of Calcutta sailing May 15th first class only.

So I thought I had better accept, as I don't want to stay in Cairo longer than I can help & my travelling allowance will just about cover the expenses. The fare on this boat is £33 & she goes direct to London so there will be no opportunity to write once I leave Egypt. I do not know the day she is due home but Cooks can probably tell me.

I am leaving here tomorrow night & will have about two days in Cairo I may have to leave for Port Said on the 14th.

If we cannot get all the packing done in time Miss C will travel down the following night, she asks me to send you her love & she is looking forward to seeing you.

I expect I can give you more information after I have been to Cooks, this is a very hasty note as we are up to our eyes in packing cases.

I shall soon be able to tell you all about everything instead of trying to get it all in a letter.

Broome MSS88
Cecil House Cairo
May 13th 1930
Dear Mother.
Here I am, back in Cairo, I felt quite sad to leave my nice desert home & all the pleasant desert people.

I had such a lovely send off, such a bevy of callers came to say good bye to me at the house & the taxi was stopped 3 times on the way to the station by friends who wished to offer their salaams. I even had a deputation from the ladies of the village & Sheikh Abdu Wahid has written me a special charm from the Koran, to protect me on my journey & bring me safely back, one portion remains in the house, the other I am to carry about with me on the right side. This is a very unusual gift from a devout Moslem to a Christian & I value it very much.

Mr Little (who is now called Little'un) came to Cairo with me & Miss C follows with Nannie & the luggage tonight. We came by the night train, had a first Class compartment to ourselves so we each stretched ourselves out & went fast asleep until 5 o'clock then we had a wash & tidy up & were all fresh & lively when we arrived at Cairo by 7 o'clock. The Little un saw me safely here & then went to stay with some cousins who had a house near Old Cairo.

I had breakfast, & a gorgeous hot bath then went to the National Bank of Egypt & cashed a cheque for £40 my travel allowance. Then to the hair dressers, had a trim & a wave, from there to Cooks had a chat with Mr Jackson & parted with £35 for tickets etc. He says all the boats this year are absolutely full in the 2nd class but have quite a few passengers in the First – everyone seems to be hard up, I felt a bally millionaire; they do not know yet the time she will be leaving Port Said but will advise me later, it will be either 15th or 16th & she will probably arrive at London 12 days afterwards.

The date of arrival is not given in the shipping list but I expect you will be able to follow her progress in the Daily Telegraph, she is the City of Calcutta.

When Cooks were disposed of I went along to the Industrial exhibition to do my shopping.

I bought a very nice suit case, a size larger than my black Pegamond one, it has a tray inside & is made of cow hide I gave £3.5-0 for it. I think it will stand a lot of hard wear, I could not get the case Uncle Jim wanted they had nothing that size at all. I bought a hand bag also two lengths of silk & a gorgeous pink & lemon dressing gown for myself. I need the latter badly my cotton one looks rather a wreck since its journey to Kharga & is not at all suitable to a first class passenger – dressing gowns are such public garments on board ship this one is artificial silk made up quite square like this [arrow and drawing] it drapes beautifully & there is lots to wrap round ones legs. These numerous purchases required a taxi to convey them to Cecil House, so I went to Hadji Bekir on my way & got some Turkish delight to bring home (I hope it will not melt.)

May 14th Had a gorgeous morning, Miss C arrived to breakfast, she had a bath & a general change of garments & then at 9.30 the Little'un arrived & we all went off to the Mousky to buy things. It was fun – my first purchase was some incense, they burnt the various smells & I selected the one I liked best. I bought a small lump for 10 PT, I know Father will love it, it is quite a new sort of smell. We looked at the street of the goldsmiths & the copper smiths & the spice market etc. then we went to visit a friend of Miss C's who deals in old brass & copper ware, & there we had a regular orgy.

We partook of coffee, Turkish delight & cigarettes, & had the most lovely old Arab & Persian metal work shown to us, mostly 16 & 17th Cent, we wouldn't look at modern stuff at all.

Miss C had several presents to buy & she had to have some for herself because she couldn't bear to part with them. I also fell, I have purchased – but no. I will not tell you. You must wait & see – it's a present for both of you. I simply couldn't resist it & it's something for domestic use that is really required. The amusing thing was that the dealer gave us each a present at the conclusion of the bargain & has promised to give us each a still more splendid present if we come to him again next year.

We drove back here feeling very triumphant, we were just finishing lunch when the Imp blew in to ask us both to dine with him tonight, we are having tea with Dr Junker & at the present moment are taking a short rest.

May 16th The boat train leaves today 11AM from Cairo – Miss C is coming with me & I have asked her to come & stay it would be such a dull home coming for her to have to go to a dull club & we have been so happy together that I am sure you will give her a lovely welcome for my sake. If the spare room is occupied I will sleep in the studio & she can have my room.

We had such a day yesterday we went to look at rugs & had such an orgy – lovely & wonderful things were spread before us. I tried to get our passage rug, but alas. They were nearly all 4 feet wide, the only narrow one was in soft pinks & I couldn't bear to think of it against our stair carpet, all the same I have bought a rug. I don't know where for – we must decide about that together, but it's one of those things that one has to have irrespective of price or anything. It's a treasure & a joy – an old Persian in the most exquisite soft colours & the most unique design – as for Miss C. she adores rugs – she is absolutely depraved in the matter of acquiring beautiful things. She spent £60 & has been gloating over it ever since, she is leaving hers with Dr Junker this season as she has no place for them at present but mine is sewn up in a sack & of course will come with me. (I only wish you could see hers.)

P.S. Mr Lucas took us out to dinner last night & gave us a splendid time. I showed him my amber & he says it is really very good –

So ended the first season, packed as it had been with new experiences and delights and so vividly described by Myrtle.

In a later letter to Miss Jonas, Myrtle talked about the Hadj who had been their temporary cook:

> Do you remember the Hadj, the cook we had the year you visited us? we were sorry to hear he had died from a snake bite during the summer. He was so very holy that we are sure he went straight to wherever it is all good Mohamedans go.

There are no letters for the homeward journey and nothing about the summer. It can be gleaned from letters and from her paintings that she took her parents on holiday, somewhere in the UK. There are various paintings of Cornwall, the Lake District, and other holiday spots recurring over the years.

17

MISCELLANY

Myrtle went on to complete seven more seasons in Egypt, enjoying every minute of it. Her last letter from Egypt detailed her journey home with Amice. As it was to be their last season working together, they traveled home through Europe, in a car that she named "Joey", taking their time and visiting various friends enroute.

In 1934, they had an influx of additional staff and decided to add three extra rooms to the house. This was a relatively simple matter, as Myrtle described Egyptian house building in the 1930s. To paraphrase, it consisted of firstly marking lines in the sand, the size you wanted the house to be, then the men would put up the walls of mud bricks using a mortar board of sand and mud. You then tell the carpenter how many windows and doors you want and he makes them, and after showing the builder where they are to go, they are fitted, with the roof going on next, a bit of whitewash, and after leaving it to dry, you have a house. You see, not so difficult to build a house.

She then added, writing to her father:

Broome MSS302
Sorry to hear of so many delays in the home repairs. Here, we have built one Soudani house of two rooms, one annexe to our house with three rooms, made one table, one settle, two corner cupboards, two washstands, two towel rails, various shelves, in three weeks at the inclusive cost of £20.

Our Soudani guards
Concern over the safety of the women was a primary worry by the male establishment, both the Egyptian authorities and the EES. This was quite

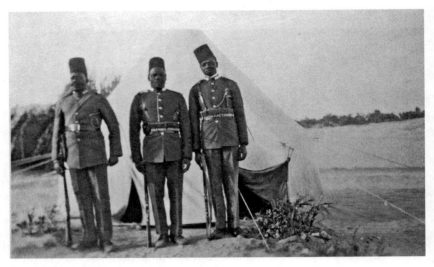

Soudani guards

amusing, as both women were quite capable of looking after themselves. It was agreed that they would have a squad of Sudanese guards, who were members of the Sudanese Camel Patrol and looked very big and fierce.

As Myrtle explained:

Broome MSS147
Our Soudani guards are encamped in the wady a short distance from the house, They have a tent & a straw shelter for their camels, the latter are splendid beasts, white longish coats & tall with very high humps, the men are quite black, have an immense idea of their own importance & are regarded by the village people with the utmost terror, we certainly shall have no undesirable visitors while they are here.

As Myrtle mentions, the women built the guards a house, promising them some nice pictures of soldiers for the walls and a grand feast on completion, and later still a brick floor would be added to the house.

Broome MSS347
Our Soudani guards have arrived, the first night they were here they found a viper in their room curled up in the sand, so I have ordered a brick floor to be put down in the room as snakes will seldom enter

where they cannot make a hole to hide in, the men are now busy putting down the bricks. During the summer a viper was caught in a rat trap they say it was a yard long.

The guard was changed every year, but a favorite, Mahomed Kheir, would return for many years, much to the delight of Myrtle.

Mahomed Kheir

Mahomed Kheir was a master craftsman in leather in his spare time. He would teach Myrtle how to work in leather, adding yet another skill to her portfolio. As has been suggested before, she also had a certain weakness for a handsome face.

> Broome MSS306
>
> Mahomed Kheir is very funny he has made up his mind that he is my soldier & when he is on duty in the temple he always makes a point of accompanying me home, I usually leave first, as I do not wait for tea. The others all have theirs in the temple but I prefer to go straight home & have half an hour to myself to work on my Arabic, & Mahomed always springs to attention & comes with me, two paces behind, but if I show the slightest desire for conversation the two paces are shortened to barely half a pace. Then again if I stay a little late to take moulds for my casts, Mahomed never goes with the others but waits patiently for me. I shall miss him when he goes back to Sohag at the end of the month.

Myrtle relates amusing incidents concerning the guards such as:

> Broome MSS165
>
> We took Nancy [Englebach] to catch the night train to Cairo, & had Balal one of our Soudani guards in the car with us as it was so late. He caused us much amusement by shouting in a deep bass voice every time we passed a man on the road, it was rather like a dog saying wuff. wuff – we call him our blush rose friend – the reason being that though he is coal black, one must not say his face is black because that would mean he was a bad evil man. The correct thing when referring to his complexion is to say he is slightly red, so we are even more polite & call him our blush rose.

Broome MSS240
We had our first game of ping-pong yesterday, our Soudani's helped
retrieve the balls, it was funny to see two tall soldiers bristling with
ammunition chasing after ping-pong balls.

Broome MSS241
I have just returned from Baliana. I drove in with Joey to fetch a consign-
ment of groceries from the station & do various odd jobs there. Just as I
was starting off one of the Soudanis came & asked if he might accompany
me as he had to go by train to Sohag to fetch supplies from headquarters,
he was in a state of undress, so I told him to get ready quickly. He flew to
the tent & I naturally expected he would emerge clothed in his uniform,
not a bit of it, he just grabbed everything & jumped in the back seat with
Sardic, & when we got to Baliana he was correctly clothed & bristling
with ammunition. How he did it I can't imagine, you know how much
room there is in Joey's back seat. Fancy driving a car in England with a
soldier putting on his breeches etc. on behind – I had a good laugh about
it – life here is very amusing in spite of numerous worries & problems.

She also described their daily prayer rituals and religious proclivities:

Broome MSS322
I am sitting by my window & I can see the Soudani's house. One of
them is saying his prayers. He has spread his mat in his little court yard,
he says one prayer standing facing the east, then he kneels down &
says some more, then he touches the ground with his head & there is a
little extra bit added on to his mat to accommodate his head. The mat
is made of very fine plaited straw & rolls up into quite a small bundle.

Broome MSS382
We have three new Soudani's one is a Hajj, that is a Moslem who has
made the pilgrimage to Mecca, this one has been twice so is extra holy.

Chicago House
The work necessitated using the photographic facilities in Chicago House,
the Luxor base of the Oriental Institute of Chicago. Amice would spend many
hours there over the years, and Myrtle describes Chicago House fondly.

Today, the library holds over 20,000 volumes, and I have had the plea-
sure of perusing the folio volumes of the Abydos project there.

Chicago House in Luxor had been set up by the Oriental Institute in
1924, whose basic premise, which is unchanged to this day, was to study the
history and culture of the Near East through the recording of the language.

In Myrtle and Amice's day, the director was Dr. Harold Nelson, and
he would make many visits to the camp over the work period and provide
help when needed.

Broome MSS96

We are now back in our own camp & we do not at all regret the gran-
deurs of Chicago House, it is really a branch of the university & not a
camp at all, it contains a splendid library containing nearly every book
on the subjects allied to Egyptology some of them very rare editions
& the staff includes a librarian.

One thing caused us a lot of amusement, there were two rocking
chairs in our room, of course I promptly sat down in one & to my
amazement found it was made of tin painted & grained to imitate
wood!! We then examined the rest of the furniture & found it was all
metal; chest of drawers – looking glass, writing desk, bookcase etc. We
learnt that there are 70 rooms, & they are all furnished with this metal
furniture which came all the way from America & of which they are
very proud. Of course it is really excellent for the climate as the white
ants cannot eat it; but it is so awful to have it made to so exactly imi-
tate wood, even to grooving & turning & in the lounge they actually
had imitation wicker work chairs made with metal wire painted to
look like the real thing. I don't see why metal furniture shouldn't have
a special design of its own, it could be really nice.

Dr & Mrs Nelson were very kind to us, if we wanted to do any
sightseeing there was always a car at our disposal, (they have five) the
chief colour artist very kindly showed us all his methods & gave us
quite a lot of useful hints & we got quite a lot of information about
retouching photos so we feel our visit was not a waste of time. Of
course we enjoyed going to see Mrs Davis,[9] she has a charming little
house & has given us an invitation to go & stay with her some time.

9 Nina de Garis Davies was and is acknowledged to be the finest of the archaeological
 artists who worked in Egypt.

Myrtle described the work at Chicago House:

Broome MSS105
Amice has gone to Luxor for a few days, Chicago House kindly offered
her the use of their photographic apparatus any time she wanted to make
enlargements, so as we have finished most of the prepared work, she is
going to make enlargements of the photographs taken this year instead
of sending the negatives to Alex as we did before. We have been drawing
in all the detail on the photos of the big false doors & they look splendid,
so we are going to treat other architectural details in the same way.

In 1936, Myrtle had this to say:

Broome MSS385
Amice returned from Chicago House looking like a boiled owl after
three days in the dark room, she says the place seems quite deserted
now they have reduced their staff & Nelson thinks they will have to
close down entirely after three years, he hopes to be able to complete
the work they have in hand.

This was due to the financial downturn in America and, as Myrtle puts it:

Broome MSS369
We had a letter from Gardiner, there is a probability that the work
may not continue much longer, as Rockerfeller [John D. Rockefeller]
is in financial difficulties owing to this new super tax that is being
levied in America, Dr Gardiner is now on his way to New York to
interview Rockerfeller personally.

James Henry Breasted, the head of the Oriental Institute in Chicago, had as
his major benefactor John D. Rockefeller, Jr., son of the Standard Oil Co.
magnate. Breasted would also make many visits to the camp to check on the
work being carried out on their behalf. When Rockefeller was hit by the
crash and following the Great Depression, funds were halted in 1936 but
were reinstated after the war.

When Amice thought she would be leaving, never to return to work at
the temple, she wrote a poem called "Farewell to Seti," which revealed her

involvement with the temple and her heartbreak at having to leave it. She believed the temple was a holy place filled with ancient mystical conviction (see Appendix).

The birds and the bees

It was clear from the letters that Myrtle was very much an animal lover. She took great delight in all of them, be they buffaloes or bees. During their time at Abydos, there was a succession of dogs, and Myrtle always kept her parents up to date on their happenings and those of all the village animals.

They kept a guard dog for the camp called Wip-wat and another at the temple which belonged to the night guard there. Myrtle would take a piece of bread every day to the guard dog at the temple. The dog was very fierce, but she managed to get it to greet her and eat out of her hand—much to the bemusement of the night guard.

> Broome MSS332
> The guards' dog looks for her piece of bread every day and it has got to be quite a ceremony, I think old Mahomed sometimes invites some of his pals along to see it, of course they think we are quite mad, to feed someone else's dog is beyond their comprehension.

They also had a cat called Bijou-Bast-Anta who came in to see them each dinner time and was only friendly while food was about. However, in 1935 the cat disappeared, much to their concern.

> Broome MSS332
> I am afraid something must have happened to our cat, he has been missing now for over a month. We are quite used to him going off on his various love affairs in the springtime, but he has always returned within the week, very hungry & looking the worse for wear, but never for as long as a month – so it seems as if something has happened to him. Amice & I are very sad about it as we were very fond of the strange beastie.

While working in the temple, the women were always amused by the antics of the many sparrows that had set up home there, which had initially resented the women entering their domain.

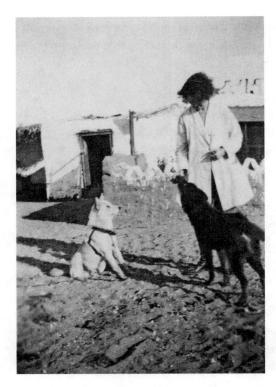

Anticipation! Iswid (Sardic's black dog) has a treat while Wip-wat waits his turn

Broome MSS112

The sparrows in the temple have been causing us a lot of amusement lately, if we are working near their holes there is a great indignation at first, a great flutter to & fro, & shrill protests, you have no idea how much noise a sparrow can make; when the first great haroosh is over, they find a comfortable perch & settle down to make rude remarks about us, we gather the gist of these observations by the tone of voice, they say we have the most inadequate & ugly beaks they have ever seen, our lack of feathers is lamentable, our mode of progress clumsy & our nesting habits ridiculous & unproductive, the only thing they can find in our favour is the regularity with which our lunch appears, but even that is sadly lacking since the main menu does not include the tasty fly, or the succulent grub; when they have proved entirely to their own satisfaction what very inferior creatures we are, they begin to get quite friendly & come hopping on to our scaffolds as bold as anything. I think they must dare each other, or

else the lady sparrows egg the gentleman sparrows on. Possibly the coy young female will not look at a suitor who has not proved his valour, or maybe the claw of the fair princess is offered to the hero who dares enter the dragon's den. But whatever is the cause of all the commotion, evening sees every sparrow safe in his, or her hole, for at dusk the big white owls come out to hunt, & a sad fate overtakes the sparrow who stays out late.

Later, Myrtle recounted the amusing threat of an interloper trying to disrupt the harmony in the temple.

Broome MSS134
There have been great to-does with our sparrows lately – a minx has arrived upon the scene, she is very young & fluffy & hasn't grown a proper tail yet, but she is an outrageous & shameless flirt. Yesterday she hopped into our chapel. The local sparrows were in their respective houses with their wives, so she chirped & chirped until Mr Sparrow looked out of his front door to see what all the noise was about – & she gave him the deliberate glad eye – I am sorry to say he accepted the invitation & went & hopped about with her. Then Mrs S looked out to see what was going on, & saw her hubby & two other gentleman sparrows paying court to the minx, so out she flounced & gave them all a piece of her mind. Then there was a general dust up, for the rest of the day the atmosphere was very strained. Mrs S kept a very sharp eye upon her fickle husband & if he went out of her sight she followed to see what he was up to.

As time progressed, the sparrows became quite tame and even came to expect treats.

Broome MSS185
Our sparrows have been giving us such a lot of fun lately, they are getting so tame today Mrs S came & hopped about on the little table that holds my painting materials & is close up by my side. The day before yesterday I forgot to put the usual piece of bread in my pocket at breakfast, as soon as I got up on my scaffold & settled to work Mrs S came & looked all round for crumbs, she was dreadfully upset when

she could not find any & she gave me such a look of reproach that I felt I ought to creep away & hide. She then went to see if Mr had had any better luck with Amice – but alas, Amice also was crumbless, we felt so badly about it that we sent Sardic to see if he could buy a loaf of bread from someone. He came back with a fine loaf, but as its owner refused to take money for it we felt a little embarrassed, not so the sparrows they were overjoyed & had a feast.

We feel quite sure Mrs S is the Mrs Goodhead who was so friendly last year, the one who was so annoyed with the Minx. She & Mr S live in the same hole just above the broken figure of the little god & when she puffs herself her breast feathers part down the centre, we had noticed that peculiarity last year so feel it must be our same little friend.

Myrtle spent a lot of time with the animals and told her parents all about them.

Broome MSS220

We have a raven, he is called Nuhay which is Arabic for raven. One of our Soudanis caught him & brought him into the temple with his poor legs & wings all tied with rope.

We were very angry & did our best to untie him without hurting him & set him free in one of the open rooms in the temple. He was quite paralyzed with terror & just flopped in a corner panting, so we left water within reach & left him to recover, when we looked at him later on we found him hopping about, but unable to fly although his wings seemed uninjured.

So we took him back to the house in the outhouse where all the ladders scaffolds etc. are stored during the summer, it is empty now except for some packing cases & shavings, we are hoping he may recover the use of his wings. We feed him on scraps of meat etc. & he has an excellent appetite, he does not seem to mind Amice & I picking him up & he will sit on my lap & let me scratch his head. But he is frightened if he sees any of the men & yesterday I took him outside & put him down to see if he could try to fly but he ran straight back into the outhouse.

He is such a beauty & has an enormous beak, he pecked Amice's nose when she picked him up in the temple.

Myrtle Broome
with the raven

He was quite all right until he saw the men, & then he struggled & pecked, so we put him in a box to take to the house. He hasn't attempted to peck since, as we do not let the men into the outhouse.

He must have had something the matter with his wings when the Soudani caught him, as he said he was "standing on the ground" it seems as if he gets cramp or something, he can flap them but cannot rise up, I do hope he will get all right as we will not know what to do with him when we leave.

They had friends, M. and Madame Roche, who ran a sugar factory in Nag Hammadi. Madame Roche loved animals as much, perhaps more so, than Myrtle, and was forever taking in injured and stray animals. She had quite a menagerie in her garden, and Myrtle would often take injured animals to her when they had to leave at the end of a season.

Broome MSS269

We have been spending the day at Nag Hammadi with M & Madame Roche. We were taken over the great sugar factory, we drove through miles of sugar cane on our way there, & we saw the trucks laden with it arriving in the yards & the great cranes unloading it & putting it on a sort of moving staircase which carried it through three crushing machines. Then it was boiled & refined, dried & put in sacks, & the pith used to feed the furnaces & the dregs of the molasses used as fuel also, it was very interesting.

We had tea out in a most beautiful garden & a tame pelican & two storks came & had tea with us. They were so funny, They all caught bits of cake in bills & once when one of the storks snapped up a bit of cake in front of the pelican the pelican took the storks head in his bill & shook it & the stork did not seem to mind a bit. Then the pelican very nearly took one of the tea cups off the table & had a tug at the table cloth, it was fun, I have never had such an amusing tea party before.

There was also a tame wolf running about the garden, we saw him in the distance but he was too shy to come near while we were there.

In 1935, Myrtle developed an interest in the bees that made their home in the temple.

Broome MSS312

My latest interest is watching the bees at work during the half hours rest after lunch, they are amusing, I have seen one building his nest of mud on one of the blocks of sandstone, he makes it like this. Then he goes in head foremost like this.

While he (or she) was in this position I could not resist the temptation to softly stroke his (or hers) little fluffy behind. Bee promptly squeaked it was such a funny unexpected noise for a bee to make, rather like a guinea pig.

The next stage of the proceedings was – bee went into the nest backwards after much manoeuvring of wings, I had to laugh at the absurd sight of bee with his (or her) head sticking out of a mud bag.

These bees are rather like our bumble bees & are beautifully velvety black & golden brown.

Of course, not all creatures were welcome!

I have been mending a rat trap, Nannie used to set it & the rat had a good feed & went off. So I did a few things to it with a pair of pliers & she set it again & in half an hour it had caught & killed the rat, such a huge fellow. Nannie was excited about it.

My next job was to mend the flit spray, I had to adjust the washer & now that is all right. We are having the flea season & have to flit the beds each night to insure a peaceful rest. Yesterday I had to retire to our tent in the temple & undress & have a hunt. I caught him!

Local happenings

The local festivals were of great interest to the women and they were lucky enough to be invited to many, which were usually off limits to foreigners. They also went to the larger gatherings, and Myrtle describes them so eloquently that you could almost believe you were there with her.

Broome MSS132
I expect you will be wondering very much what got me up at 3.45 in the morning –

You will remember my description of the great religious gathering we went to last year, it was held in the cemetery where there are several very holy sheikhs' tombs just before the pilgrims start on their journey to Mecca. They spend the night in chanting the Koran & various fanatical religious performances. Then at dawn they indulge in other excitements in the way of camel racing, donkey racing & displays of horsemanship, as we had seen the night affair last year, we decided to go in the early morning this time.

At half past three our camels arrived, I woke to hear them bubbling & jingling outside my window. We had breakfast at four o'clock by lamp light & then set off in the ghostly light that comes before dawn – we had 8 miles to go across the desert, & we did it in an hour & a quarter which considering we had a large escort on foot was pretty good.

As we drew near Beni Hamael we were joined by many others, on camels, donkeys & afoot all making for the same destination. Some were splendidly attired sheikhs mounted on splendid trotting camels, some bundles of rags trudging along, or crowded five together on the baggage camel of a fortunate friend & the in betweens trotting along on their donkeys, it was a motley crew.

When we arrived at Beni Hamael the whole cemetery & adjoining desert were one cloud of dust & such a pandemonium. There were camels galloping madly urged by the wild cries & antics of their riders, who in several cases were *standing* on their backs. A camel in full gallop has the most terrific action of any animal I have ever seen, it is a marvel how any man can remain on even seated, let alone standing. They do not seem to have any organised races, they do not start together, but just rush about – each man when & how he pleases. We joined the onlookers, & were soon wedged in a long line of camels & their riders lining the course.

The people were very courteous & everywhere made way so that we could have a good view.

We watched the various displays of camel riding for some time & then went to see the horses.

The first group we saw were charging madly at the brick wall of one of the tombs. They would rush towards it full gallop – bringing the horse to a sudden stop a couple of yards away, it was marvellous horsemanship.

The horses were of course pure Arabs. They had gorgeous saddles, many covered with plates of pure gold. & they had their own music, wild shrill pipes, like the squealing of stallions played to the rhythmic beating of drums. This special music is never played except for the horses. & they love it. They prance & toss their manes & are never still a moment while it is being played, but when it stops they stand as quiet as anything. It is the most contagious rhythm one can imagine, even the camels got affected by it, Amice's camel was a lady & evidently very musical, she swayed her head from side to side & took first a step to the right & then a step to the left in perfect time to the music – it was funny & a little disconcerting for Amice as the camel next her was doing the same thing & occasionally they bumped – however nothing would stop her while the music played.

It was pretty to watch the horses dancing, Their movements guided by the long lances their riders carried, they circled & pranced & reared & knelt, & all the time the men playing the pipes & the drums danced in & out with them – you can't imagine anything more wild & barbaric.

In 1931, Myrtle visited the local snake charmer.

Broome MSS125

My last adventure was to visit the tomb of Sheikh Ali. This Sheikh was a very holy man & a member of a sect of snake charmers, as are all his descendants. They have a large walled enclosure by the tomb where the snakes live.

If a woman wishes her son to be immune from snake bite she takes him to the Sheikh in charge of the place (who is the great grandson of the original Sheikh Ali) & he places a big snake round the boys neck & writes him a charm & after that no snake will ever harm him. Also, if a snake is found in any person's house he sends for the Sheikh, who comes & takes the snake away, he calls to it & the snake will follow him.

Having heard all these wonders I said I would like to visit Sheikh Ali, if it were possible, Sardic said oh yes, it could be arranged.

So I had the camel & started early in the morning with Sardic on his donkey, Ahmed on a borrowed donkey & Mahomed & Senman on foot.

This time our way led through the green, we went along narrow footpaths through the corn which was shoulder high, there were fields of beans & clover also, in the clover the sheep & the goats with the lambs & kids, The cows, buffaloes, camels, donkeys also with offspring were tethered to graze. There were even geese & goslings (not tethered.) It was so pretty to see the various happy families with usually a small boy or girl & a dog to guard them. It took about 2½ hours good going to reach the little village where the tomb is. The village has some very fine pigeon houses, you will see them in one of the snapshots. The Tomb stands in a sort of courtyard where there is a special place for leaving camels & donkeys.

Our arrival caused quite a commotion, the people are used to many & various pilgrims but a white woman was a novelty. The Sheikh

was very polite & said I might go into the tomb if I wished, so I removed my boots. (The zip fasteners caused great astonishment) & went in. The tomb was gaily decorated inside with painted plaster walls, the floor was just sand & the actual burial was enclosed in an elaborate screen of open wood work. All the Moslems kissed this screen, (Senman rubbed his face hard against it in the hopes of getting extra blessing) I merely walked round. When I came out again the Sheikh invited me to rest on a divan while coffee was prepared, & he wrote me a special charm to protect me from snakes. for which I gave him 10 P.T. Unfortunately I couldn't see the snakes as the old man who had charge of them was in Girga that day & had taken the key with him. The Sheikh was very sorry about it & he said he would himself bring a big snake to Arabah for me to see next Friday. I said I did not wish him to go to so much trouble but he said, I have promised it – so I am bound to come.

On Friday the Sheikh came with a big cobra, he had it wrapped up in a shawl. He put it down & it reared & put its hood up, it realised it was in a strange place & it slithered up to its master as though seeking protection. He picked it up & I took a photo of him holding it against him, & then another photo of it on the ground with its hood up. I hope they will be successful. The Sheikh refused to take anything for his trouble in coming over.

Arabic lessons

Because of their great interest in the locals and their wish to be able to communicate a little better, Myrtle and Amice took Arabic lessons with the local schoolmaster, Sheikh Sarbit.

Broome MSS125
We had our first lesson in Arabic writing on Saturday, the schoolmaster arrived punctually at 5 o'clock, very fine & handsome in his best clothes, & after an exchange of polite salutations Amice & I sat down with our pencils & paper to learn our Aleph – Be –Te – we did our best to be very serious & attentive. The schoolmaster wrote a letter & told us its sound value & we did our best to repeat it after him, we got along very nicely until we came to و. "wow-w-" said the schoolmaster "wow" said we in chorus. wow-w-w- said the cat solo fortissimo. This was too much – our gravity gave way, we laughed & rocked with

joy, the schoolmaster joining in our mirth, it really was the funniest thing I have ever known happen – we still jelly with laughter every time we think of it, We have since been struggling hard to memorise the alphabet, it is rather difficult as the beginning, middle final letters are different & one has to learn three sets. My writing of the Arabic characters has been very much admired, Nannie says I write a better hand than any of the Sheikhs. Amice as usual is very ambitious & has already ordered an Arabic newspaper!!!

Needless to say, Amice soon dropped out due to time pressure, but Myrtle went on to be able to write stories and fables in Arabic for the schoolmasters, which they enjoyed immensely.

Broome MSS256

I thought of such a good story to write in Arabic for my last lesson. Do you remember in Bernard Shaw's play of Cleopatra how she sent for the harper & asked how long he would take to teach her to play the harp, & when he had made a flattering reply she told him if she made any mistakes after the time he stipulated he would be beaten. I made this up into quite a good Arabic story with a few frills & when the two schoolmasters turned up as usual I produced it. Sheikh Sarbit set to work to correct it, reading it out sentence by sentence, by & by I saw a very puzzled look come over his face & he went back & read it over again to see if he had mistaken anything, Sheikh Jed el Karim who was listening saw the humour of it at once & burst out laughing, Then Sheikh Sarbit also saw the point of the story & laughed too. They were very tickled at the idea of the master being beaten for the pupil's faults. I told Sheikh Sarbit that it was fortunate for him that I was not Cleopatra when he was giving me my dictation lesson –

She even had homework to do during the summer—sending off her work by post. This of course enhanced the importance of the schoolmaster among his friends and colleagues; receiving post from England was very special.

The residents were in awe of her mastery of the language when she traveled throughout the area, and she took advantage of her ability to converse with them everywhere she went.

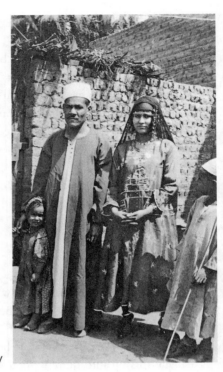

The Sarbit family

Interestingly, one of Myrtle's loveliest paintings is of Sheikh Sarbit's wife. Even after he was transferred to another school and replaced by the next schoolmaster, Sheikh Jed el-Karim, the two women remained very good friends with him and visited his new home several times.

CONCLUSION

M yrtle's wonderful adventures ended at the conclusion of an eighth season in 1937. The Great Depression had ended the Rocke-fellers' support, and her parents were now in need of her. Her father was ill, and her mother was struggling to cope. Whether she was already showing the first signs of the dementia that would eventually claim her, we don't know.

The next few years were devoted to caring for them, with a little epigraphic work coming her way via Alan Gardiner, who considered it a waste of her considerable talent not to use her.

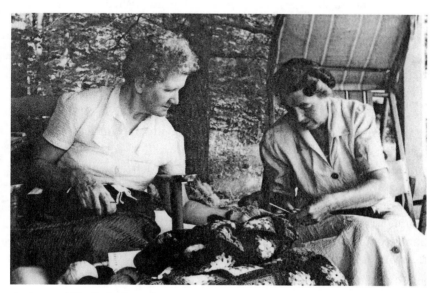

Amice and Myrtle in Canada

After the death of her parents, Myrtle began traveling again, with visits to Norway, France, and an epic road trip with Amice in Canada and the US. She spent a summer with Amice in Canada and the two women settled back into the easy relationship they had shared in Egypt.

In her final years, she worried about being on her own, initially taking in lodgers but eventually giving her home, Avalon, to the Abbey-field Company to run as a care home—with the proviso she be allowed to live there until she died.

The women had noticed the signs of the coming war toward the end of their time in Egypt, inlcuding Italian troopships carrying the wounded at Alexandria and seeing a German Zeppelin bedecked with swastikas from the ship. There is no mention of Myrtle during the war, but Amice remained as busy as ever.

During the war, she took on various roles, including becoming a driver for the Invalid Children's Aid Association. It was also said she worked in Cairo on propaganda, but there is no evidence of this—although on reflection I suppose there wouldn't be!

She was later commissioned by the Royal Air Force (RAF) in 1941. She had hoped that she would be put to drawing, but instead she was given close figure work, which took a great toll on her eyes. When off duty in London, she was able to work on her unfinished drawings at the British Museum; the drawings having been stored there in the dismantled board room.

In 1944, she became a civilian relief worker with the United Nations Relief and Rehabilitation Administration (UNRRA) in the Balkans.

Immediately after the Second World War, Rockefeller again came to the aid of the Temple Project with a further grant of $17,000. This enabled Amice and her new colleague, Miss Collis, to return to Abydos to continue the work there.

Amice kept Myrtle up to date with the news from Egypt, including the news that the tower of their house was being pulled down.

Breasted had predicted that to be complete, the publication of the temple would require eight folio volumes, plus a series of smaller format books containing the texts of the inscriptions, but in the autumn of 1948 the work at Abydos could not resume.

In the words of the Foreign Office in April of 1949:

> It appears in addition to her work of recording the scenes in the temple
> of Seti I, Miss Calverley decided, on her return to Egypt after the war,
> to make a cinematograph film in colour of the inscriptions at Abydos
> and of scenes of present day local life which would illustrate the manner
> in which the Egyptian hieroglyph was evolved for the common objects
> and activities of life. This was a purely personal venture. The object of
> this film – to draw comparisons between ancient and modern rural life
> – is unfortunately offensive to Egyptian susceptibilities.

The implication here is that the Egyptian government was not happy with
having Egypt portrayed as not having changed in over two thousand years.

The EES tried to distance itself from the row that developed, asking
Alan Gardiner to have a word with Amice, essentially to tell her to bottle
her natural indignation.

The outcome was that Amice was declared persona non grata in Egypt
and was not allowed to return to Abydos. After spending a little time in
Crete, hoping to get the situation resolved, she decided to get involved in
what we now consider war journalism.

Greece was at that time in the middle of a civil war between commu-
nists and the national government. Amice became heavily involved, filming
the struggle and helping with the wounded.

She spent her final years living in her hometown of Oakville, to the
west of Toronto. Her home became famous in Toronto music circles as the
place for chamber music concerts.

Here, surrounded by her decorative collections from all her travels,
although in poor health, she continued working on the remaining (and as
yet unpublished) two volumes of work. She was working on them up to a
month before her sudden death on April 10, 1959.

Myrtle was bereft when the news of Amice's death reached her. She had
lost her great friend. Amice had been younger than her, but Myrtle lived on
to reach the grand old age of 90, dying in 1978.

The work of Calverley and Broome is a great achievement. It is a work
that owes much to its creators, and those with the foresight to put the proj-
ect into action and fund it. Gardiner described Amice as "among the most
remarkable women of her time." The same could be said of Myrtle.

The two women lived in the desert, doing their work diligently, working hard, and enjoying their life to the full. They had many adventures, entertaining people from all walks of life. All of this was duly reported to Myrtle's parents in her letters, with a mixture of sharp observation and humor, but the grand occasions never seemed to go to their heads. They much preferred the warm relations they had developed with the local people.

APPENDIX: THE EGYPT EXPLORATION SOCIETY AT ABYDOS

The first attempts by the EES to record the reliefs of the Temple of Seti I at Abydos were made in the early twentieth century and consisted of only photography. The intention was to create a photography folio documenting the reliefs. The photographer engaged to do this work was a professional photographer called Herbert Felton who was renowned for his architectural work.

They soon realized that photographs alone would not be enough and that a complete publication would be needed. Eminent philologists Raymond Faulkner and A.M. Blackman were subsequently engaged to collate the inscriptions. Line drawings were then added on the basis of the photographs.

Amice Calverley had come to the attention of the EES and was hired by Blackman, and she worked under his supervision from August 1927 on a temporary basis. From January 1928, she was sent out to Abydos to collate the drawings in situ. She was a competent photographer, so she was also able to add to the photographs from Herbert Felton.

Calverley demonstrated such a high standard in her draftmanship that it soon became apparent that only full facsimiles of the temple would do it justice, and the search for funding began.

This was obtained from John D. Rockefeller, Jr. He had been taken to see the temple by James H. Breasted, the pioneer of Chicago epigraphy based at the Oriental Institute of the University of Chicago.

Rockefeller was Breasted's principal benefactor, and, after seeing Calverley at work during the visit, he was so impressed with her expertise that he agreed to finance the project.

It was arranged to be a joint undertaking between the EES and the Oriental Institute, and it was agreed that Alan Gardiner would be the editor.

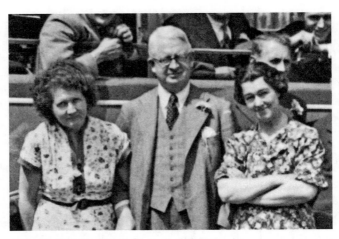

Amice Calverley, Alan Gardiner, and Myrtle Broome

After seeing Calverley's work, Rockefeller wanted as many color plates as possible in the publication. What had started as quite a modest project expanded into four magnificent folio volumes, the like of which has never been seen since.

The funding enabled Calverley to engage an assistant and, in 1929, Myrtle Broome began the first of eight seasons working on the project.

It was to be the lifework of Amice Calverley, who worked on the project up to her death in 1959. Material was gathered for a fifth volume, but to date it is unpublished.

Amice Calverley

Amice Calverley, who was to become the director of the expedition at Abydos, was born in Chelsea in 1896. She spent most of her childhood in England, although her family moved to South Africa for a few years when she was ten years old.

She studied art at the Slade School of Art in London and also studied the piano. At this stage, music was her first love and would remain very important to her throughout her life.

Her family eventually moved to Canada, settling near Toronto in a town called Oakville on Lake Ontario. Here she continued studying music at the Toronto Conservatory of Music. During the First World War, she worked in a munitions factory and in a hospital. Post-war, she traveled to New York to study dress design, working at Wanamaker's department store.

In 1922, she won a scholarship to the Royal College of Music, returning to England to study with Vaughn Williams. During this time, she set her heart on writing an opera, finishing it in March 1926. The opera was given an audition at the Vienna Opera House, but sadly it was never accepted.

Her life in Egyptology started when she was offered a job as a draftsman at the Ashmolean Museum in Oxford. There she met Leonard Woolley and other archaeologists, who all encouraged her to develop her skills as an archaeological illustrator. They recognized this rare ability of hers to draw an ancient artifact without taking any artistic license. Every artist has their own unique style, which shows in their work, and to suppress this style is extremely difficult.

In the preface to Volume 1, Calverley included notes on the methods used, which were quite innovative for the time. Over time, Calverley devised further new methods to deal with problems as they arose.

Methods

Basically, for line drawings, the photographs were first enlarged to scale, and were then traced by hand over a specially constructed tracing board, which consisted of a box furnished with a ground-glass top and containing powerful electric lamps. The use of such a tracingboard had a double advantage over the bleaching-out method often employed, as the enlargements could be preserved for future reference, and also fine drawing paper could be used.

The bleaching-out method mentioned by her is still used to this day by the University of Chicago team, but the process has been improved over the years to produce the copies we see in their current ongoing publications.

Once the tracings were done, the drawing was finished in front of the originals, with experts finally called in to check the inscriptions. Gardiner remarked that rarely did they find any errors in the work by Calverley and Broome; in fact, their copies were so good that they would pick up errors by the original artists.

Parts of the surface of the temple walls had been damaged by natural erosion or by human destructiveness. To deal with this situation, all definite lacunae in the inscriptions were outlined, and indistinct areas were hatched. With the sculptures, broken outlines were discontinued, with the flow of the drawing being interrupted as little as possible, no reconstruction was attempted.

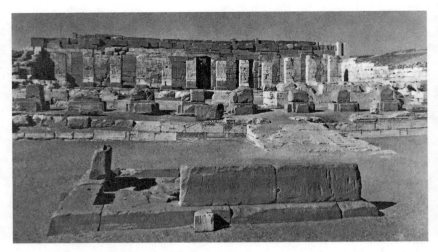

Photo of the temple taken by Myrtle

For instance, line drawings did not seem to work for the false doors and the thickness of the entrances, so a process of drawing on photographs was evolved that combined the advantages of both methods. Rubbings were also made on fine tissue paper with soft red carbons; this dealt with the curved areas of ceilings and columns. These rubbings would then be photographically reduced, and drawings would then be made of them.

The Temple of Seti I at Abydos

The Temple of Seti I at Abydos has long been regarded as one of the finest religious monuments still standing in Egypt. As with any structure lasting through millennia it has had a checkered history.

Construction work probably started soon after the beginning of the reign of Seti I (1290–79 BC). The work was continued during the reign of his son Rameses II (1279–13 BC) and added to once again by his successor Merneptah (1213–1204 BC).

It remained a sacred site through the ages, although by the seventh century BC large areas of limestone had been removed for building materials. In Greco-Roman times, it became the site of a local oracle of the god Bes, with early Christians also using it as a dwelling place. After all this activity, the temple would then stand neglected and forgotten until the eighteenth century.

Seti I's mortuary temple was a monumental construction with two vast courts, two hypostyle halls, a butchery hall, two Osiris halls, and an array

of other features. It was eventually rediscovered in 1731, with further exca-
vations carried out in the nineteenth and twentieth centuries. Although
large parts were destroyed, as with many ancient structures, the rear of the
temple had been protected by drifting sand, which preserved many of the
sculptured scenes. When the sand was cleared in the nineteenth century,
the bright colors of the original sculptures were revealed in all their glory.

The temple has since been restored and reroofed by the Egyptian
Antiquities Organization and is now rightly regarded as one of the jewels
of the Egyptian tourist industry and a prime tourist attraction.

Many well-known names have been associated with the work carried
out there, including John Garstang, Eduard Naville, Flinders Petrie, and
Margaret Murray. One of the more recent well-known characters associ-
ated with the temple is Dorothy Eades. Otherwise known as Omm Sety,
she was a well-respected Egyptologist who believed she had lived in a pre-
vious life in the court of Seti I.

The Temple features seven chapels made up of the Osiris triad and the
great gods of Thebes, Heliopolis, and Memphis. For the first volume, the
women concentrated on the chapels of Osiris, Isis, and Horus (5, 6, and 7
on the plan). Volume 2 would cover the chapels of Amun, Herakhti, Ptah,
and Seti I (1, 2, 3, and 4 on the plan). Volume 3 covered the Osiris Complex
and Volume 4 detailed the main features of the Second Hypostyle Hall.

The theme of the chapels is the performed daily ritual, consisting of a
number of episodes recording the approach to the shrine, the purification
and fumigation of the deity, and lastly his adornment with clean apparel
and the appropriate insignia.

Farewell to Seti I, Abydos
Seti, the beloved of Ptah,
It's ten long years we've lived together
And now I'm leaving you for ever –
Shall I see you where you are
(In Osiris' kingdom) when I'm dead?
And will you know that you were wed
To a last and foreign wife,
Who gave you ten years of her life?
Or is all thought of life too far
Departed, Seti – Mer-n-Ptah?

Mer-n-Ptah and Men-Maat-Re,
Did your ka partake each day
Of our small lunch, and think how strange
The offerings were? Mayhap the change,
Both in the food and in the priests,
Delighted you; for your stone feasts
Must have got very dull and trying
After three thousand years of drying
And perhaps a little breath
Of life is pleasant after death?

And when I thought myself alone,
And filled your silent halls with song,
Did your royal shadow walk among
The echoes? – which were caught and thrown
As though the gods upon the wall
Played with the sound, as with a ball
Until, so joyous was the ringing,
I caught again my voice while singing
And sang in canon!
Surely then your ghost came near,
Listening unseen that you might hear
The curious praises that I sing
To you Beloved – of-Ptah, the king?

And now it seems I'll come no more,
Nor hymn your beauty as I draw –
Forsaking you, and sun, and sand,
For a grey and chilly land –
But in the Under-world so far
From England, Seti Mer-n-Ptah?
Could you not come and take a look
At your great temple in our book,
And see again your wife one day
In England – Seti-Mer-Maat-Re?

—Amice Calverley, Christmas 1936

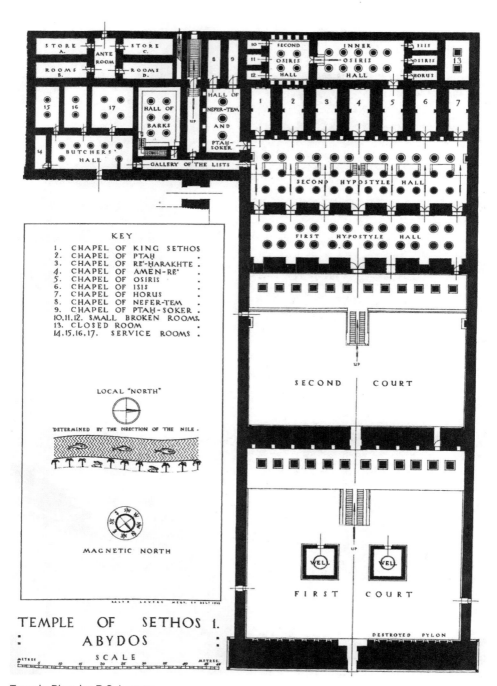

Temple Plan, by R.S. Lavers

A NOTE ON THE LETTERS

Myrtle's letters are housed at the Griffith Institute Archive in Oxford. Born out of the personal collection of Francis Llewellyn Griffith, the first professor of Egyptology at Oxford, the archive has grown to be a highly respected and internationally recognized resource. Established in 1939, it houses the work of many eminent Egyptologists spanning excavation records, watercolors, photographs, and, of course, correspondence.

The 415 letters were donated to the Griffith in June 1986 by Miss K.M. Slater, who inherited them directly from her cousin Myrtle. Her donation letter stated, "it is my intention and wish to present as a gift to the Griffith Institute Archive this collection. The main purpose is to enable Egyptologists to study and make full use of the material and for all responsible researchers to have access herewith."

The letters arrived in shoeboxes, in which the letters were housed in their original envelopes. They were later chronologically ordered and numbered. Ultimately, they were rehoused into archival glassine pockets before being placed into archive storage boxes. There are now four boxes and one folder. With the Griffith's support, I transcribed the letters from 2013 to 2018, and they were digitally scanned between 2014 and 2015. They remain in good condition, with the digital scans helping to preserve them further and allow wider access. The slides show scenes from the Temple of Sethos I at Abydos and have been much studied by scholars over the years. The donation was made with the agreement that Miss Slater retained copyright until her death upon which copyright would revert to the Griffith Institute.

Bushey Museum in Bushey, Myrtle's hometown, hold the bulk of Myrtle's own archive, consisting of her paintings, photographs, as well as other miscellaneous items.

A NOTE ON THE CURLEW

[The page is heavily faded and mostly illegible. Only a title and fragmentary traces of text are discernible.]

ACKNOWLEDGMENTS

There are a few people and organizations I wish to thank for the invaluable assistance I have received in bringing Myrtle's letters to the attention of everyone.

Firstly, I have to thank the Griffith Institute Archive, which actually houses the letters in its wonderful archive in Oxford.

I would also like to thank Sybil Rampen, the niece of Amice Calverley, who contributed photographs of Amice, and I also enjoyed and appreciated Sybil's reminisces about her. She also donated one thousand color slides taken by her aunt to the Griffith Institute in 1986.

Bushey Museum in Bushey, Myrtle's hometown, holds the bulk of her archive, consisting of paintings, photographs, and other miscellaneous items. I have received so much help from them in my quest to find out more about Myrtle, and their unfailing assistance is very much appreciated.

INDEX